THE
PRESIDENT'S
PHOTOGRAPHER

★★★★★★★★★★★★★★★★★★★★★★★

Pages 2-3: When President Obama signed this wall on a tour of the International Brotherhood of Electrical Workers in Lanham, Maryland, he started a trend. His photographer, Pete Souza, reports that he's now asked to sign walls many places he visits.

Page 4: A curiously whimsical image of a man whose emotional expression could be volcanic. Presidential photographer Yoichi Okamoto took this picture of President Johnson when he and the First Lady posed among the wildflowers on his ranch. "He was a changed man in Texas," Okamoto said.

Pages 6-7: Considered by many to be one of his iconic images—so far—Pete Souza captured a private moment between the President and First Lady on a freight elevator in Washington's convention center, Inaugural night 2009 (left). A few weeks later, the President, First Lady, friends, and members of Congress (right) donned 3-D glasses while watching a commercial during Super Bowl XLIII in the family theater of the White House.

Pages 8-9: Clinton photographer Bob McNeely captured a contemplative President Clinton (right) looking out at the Zambezi River on a March 1998 trip to Africa. Cecil Stoughton was a lieutenant in the U.S. Army Signal Corps when he started working at the White House. His coverage evolved from making the typical ceremonial images of previous administrations to documentary-style pictures like this (left) of the President and his daughter, Caroline, aboard the yacht Honey Fitz off Hyannis Port, Massachusetts, in August 1963.

Pages 10-11: During the Reagan Administration, current chief photographer Pete Souza was a young staff photographer and snapped President and Mrs. Reagan (left) after a ride at Camp David in 1984. George W. Bush's chief photographer, Eric Draper, caught Barbara Bush photographing the Presidents Bush on January 28, 2001. "One thing I learned right off the bat," Draper said, "is that when you say, 'Mr. President,' they both turn around. Referring to them as 'President 41' or 'President 43' worked a lot better."

THE PRESIDENT'S PHOTOGRAPHER

FIFTY YEARS INSIDE THE OVAL OFFICE

JOHN BREDAR

NATIONAL GEOGRAPHIC

WASHINGTON, D.C.

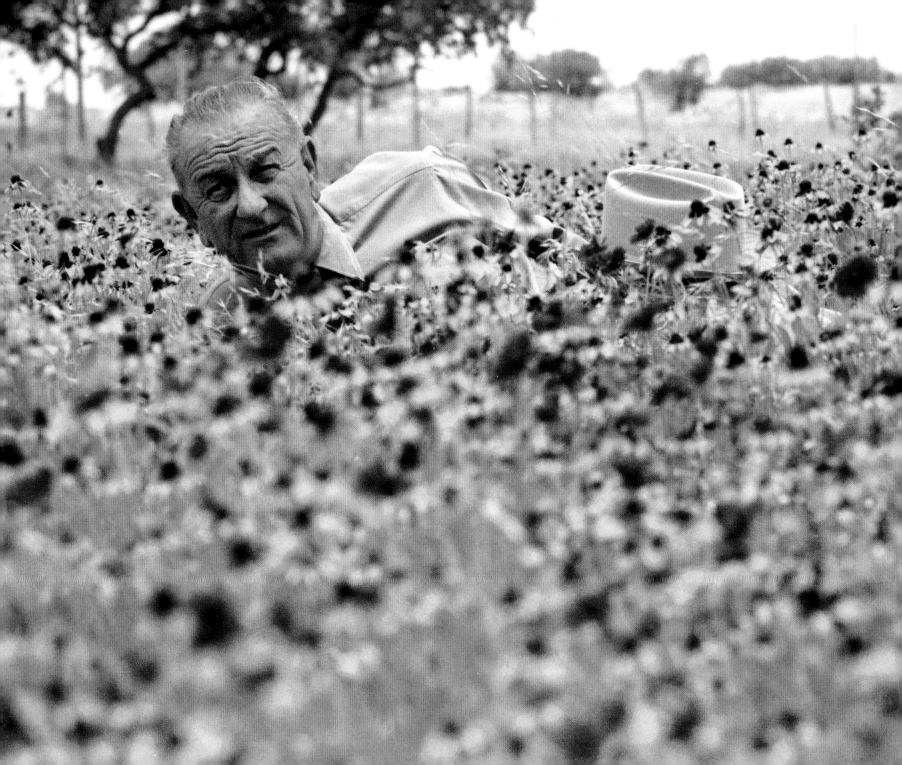

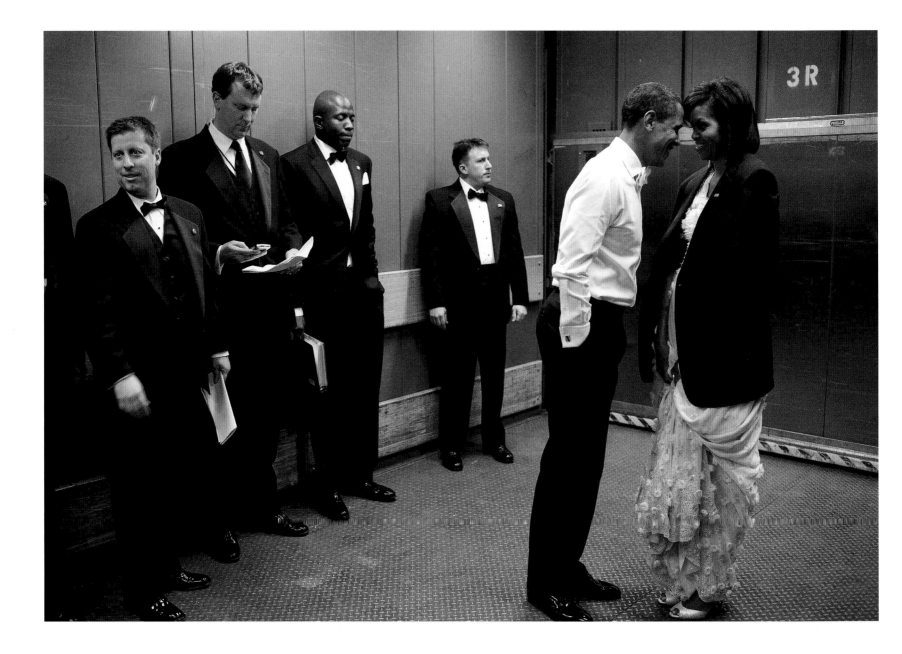

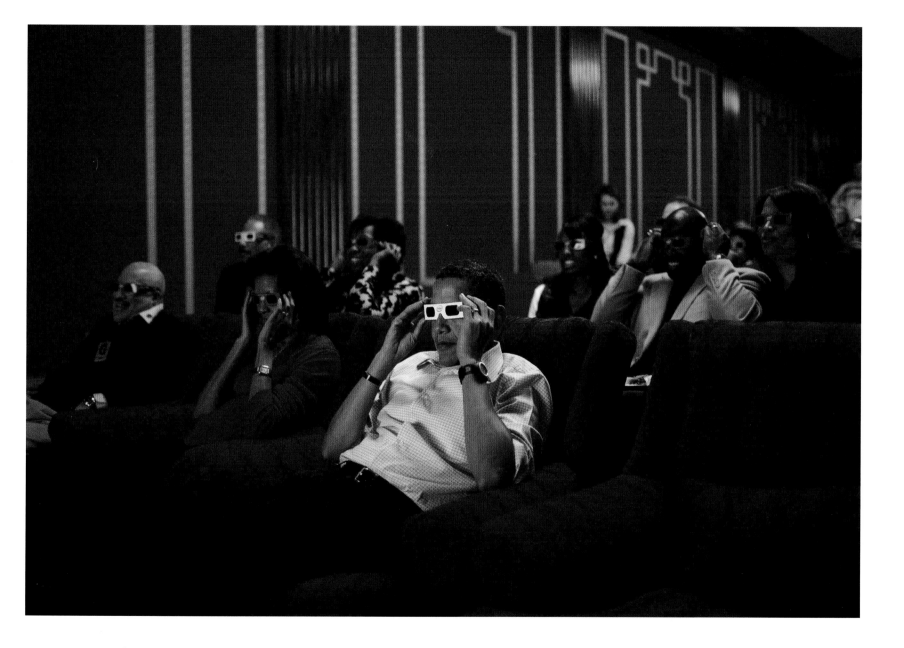

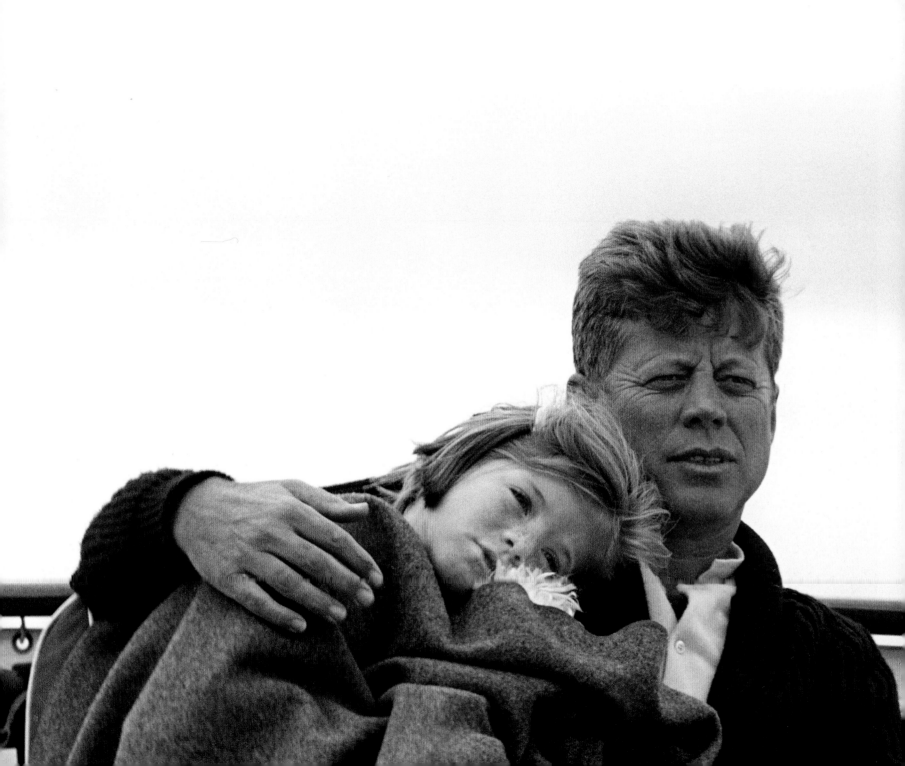

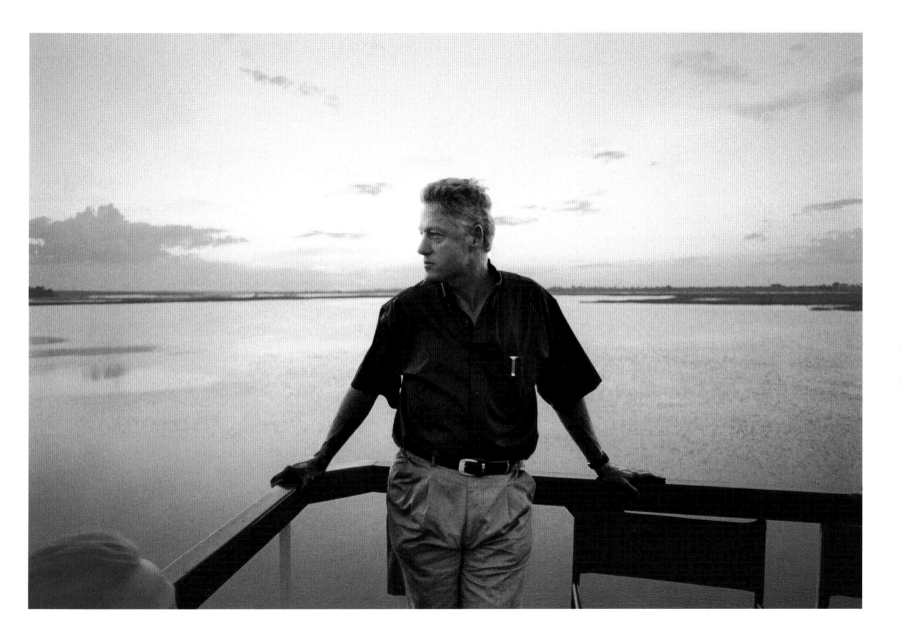

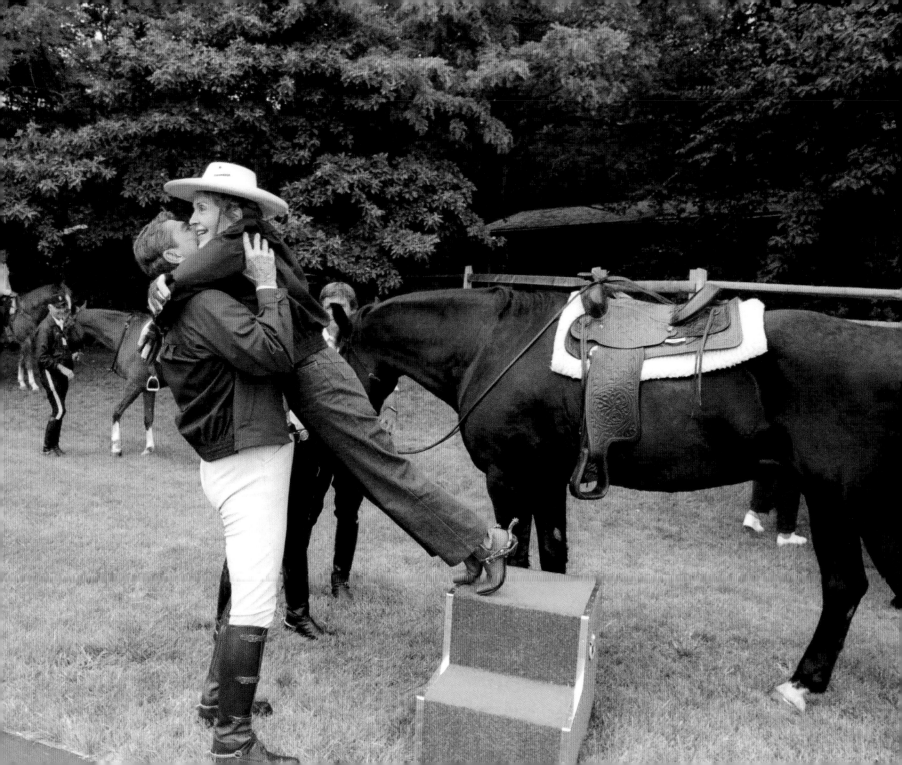

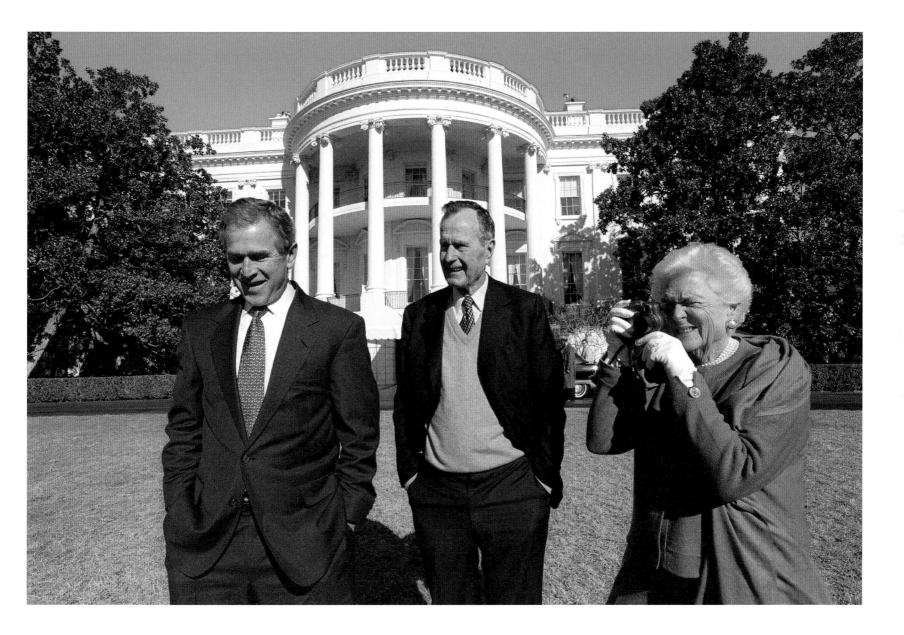

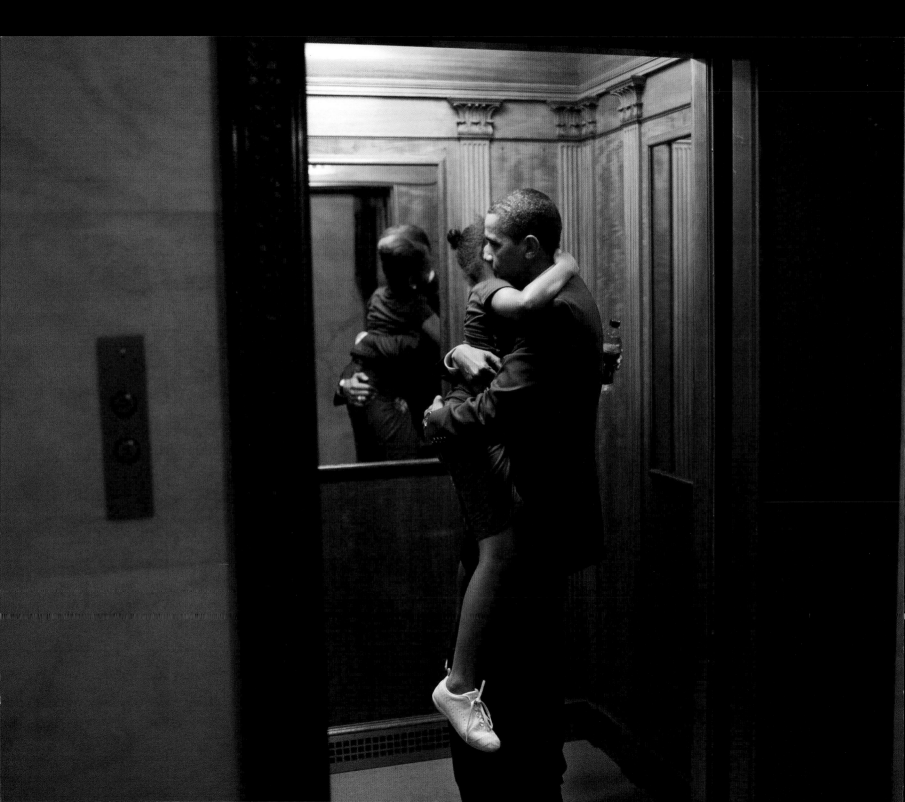

Foreword

When I was nine years old, my parents took my sister and me on a family vacation to Washington, D.C. The visit included a tour of the White House and, truth be told, I don't remember much about it. What I do remember, though, is purchasing a book called *The Living White House,* a softcover book coproduced by the National Geographic Society and the White House Historical Association.

The book contained a lot of text about the White House, and also many photographs. I wasn't much of a reader back then, but I loved looking at photographs. And there were beautiful photographs in this book. Some of them showed the rooms in the White House. The Red Room. The Blue Room. The Oval Office. The Cabinet Room.

There were also candid photographs of the then current President—Lyndon Baines Johnson—and past Presidents at work and play. At the time, I thought these were the coolest photographs I'd ever seen, and I wore that book out looking at those historic photographs again and again for the rest of my childhood.

Today, I am fortunate enough to be the chief official White House photographer for President Barack Obama. I make my living making candid photographs of the President at work and play, much like those I revered in *The Living White House.* I follow the President virtually everywhere, have unfettered access to the Oval Office, and travel the world with him on *Air Force One.*

As cool as this job is, it is also a grind. If I am not with the President, I am on call literally 24/7, with my Blackberry always by my side. I take what I do very seriously, knowing that the most important aspect of my work is creating a historic visual archive of this Presidency.

More than 20 years ago, I also had the good fortune of serving as a junior official White House photographer for President Ronald Reagan during his second term. That tenure gave me invaluable experience for my second go-around at the White House. I knew how things worked. I knew access and trust were the key aspects of being successful and making great behind-the-scenes photographs.

What really helped this time, too, was that I already had a professional relationship with President Obama, having extensively documented his first year in the U.S. Senate for the *Chicago Tribune.* When he launched his long-shot presidential bid, I continued my coverage of his campaign and compiled a book of photographs—*The Rise of Barack Obama*—that became a *New York Times* best seller after he was elected

Souza records one of the pleasures of working at home. The President (opposite) was leaving the main floor of the White House after an event when he found his younger daughter, Sasha, on the elevator about to head upstairs. "He decided to ride upstairs with her before returning to the Oval Office," Souza says.

President. I think it's safe to say that, in addition to him respecting my work, he also trusted me enough in agreeing to grant me the necessary access to adequately document his Presidency.

Between my two stints at the White House, I also had many life experiences as a photojournalist for magazines and newspapers. This included shooting photo essays for *National Geographic* magazine and covering war zones in Afghanistan and Kosovo for the *Chicago Tribune*. Where President Reagan had been almost 50 years older than I, now I am a few years older than President Obama. What I may lack in youthful energy, I make up in a more refined approach to photography and a much better sense of history thanks to all of my past experiences.

This experience also includes a better appreciation of those photographers who came before me. As you'll learn in this book, Yoichi Okamoto, LBJ's chief photographer, was really the first to have truly behind-the-scenes access to document the Presidency. He set the bar so high, had such a unique and uninhibited subject, and was such a great photographer that I'm not sure anyone can ever surpass the work that he did.

Some of my predecessors have done superb coverage that I also greatly admire (and arguably have reached the Okamoto bar): David Hume Kennerly with President Ford, Bob McNeely with President Clinton, and Eric Draper with President George W. Bush. You will learn more about them, and other official White House photographers, in the pages that follow. I am indebted to them for their seriousness to purpose and hope that my work can measure up to theirs. But more important, the American people should be indebted to them for the visual archives that they have created.

I usually tell my friends that, following in the footsteps of those who came before me, I am trying to make timeless photographs that people can look back upon in 50 years. But I recently listened to a long-ago presentation by Okamoto when, essentially making the same point, he said not 50 years but 500 years. Wow! I thought. Imagine someone combing through my photographs of President Obama in 2510. That really makes me realize that this is visual history I am recording with my camera. I will do my best to take that to heart every day. ★

—Pete Souza, Chief Official White House Photographer

Introduction

Do we really need someone following the President of the United States around every day with a camera? In contemplating this book and the documentary film it grew out of, we confronted a question that has arisen around leaders back to the ancient Romans: What's the value of a chronicler?

Legendary photographer Edward Steichen made the most compelling and perhaps briefest case for creating a documentary history of the Presidency to Lyndon Johnson. "Just think what it would mean," Steichen told Johnson, "if we had such a photographic record of Lincoln's presidency."

By the time Steichen spoke with LBJ, the President didn't need much convincing. He'd already seen perhaps the most powerful and important photo ever taken by a President's photographer: Cecil Stoughton's image of LBJ being sworn in as President on *Air Force One* shortly after the Kennedy assassination. Perhaps as a consequence, LBJ's Presidency was the first to have comprehensive, documentary-style coverage, a trend that has continued, to a widely varying degree, through to today.

Some might contend that if the objective is, as Steichen was implying, to record history, then certainly a video camera would do a more thorough job. And while that's true, it's also true that no one would watch it. The creep of history is so slow and so dense that watching a comprehensive record of it would make you catatonic.

Perhaps more important, we have been weaned on the still image, a form that, even in an age dominated by moving images, still carries remarkable power.

"There is something about a still image, especially of a President, that sort of sears in your mind over time," says Pete Souza, President Obama's photographer. "Whereas I don't think video does that. Maybe with video you can learn more about a particular situation because it has sound. But a still photograph can become more iconic and I think can settle in your mind."

It may also be that those indelible moments, like Stoughton's photo of LBJ, visual touchstones of history, are more likely to be captured by a talented still photographer than by a filmmaker.

"I think a still camera is less intrusive," explains Don Carleton, a historian at the University of Texas at Austin. "I think that a person taking still photographs has an opportunity to take more candid images because it's easier to forget that that person's taking pictures. With a camera crew, they bring in lights

and they bring in all these people with sound; it's a whole different atmosphere. It's less intrusive. Nothing captures an event or a moment, in my mind, like a still image."

The point about sound is especially important in politics. A picture is worth a thousand words, but most Presidents are going to be a lot more candid if the broader public can't hear those words. "Still photos don't talk," says David Hume Kennerly, President Ford's photographer, highlighting their chief virtue. "These sanitized day-in-the-life TV things where the correspondent comes in and walks around next to the President, surgically attached to him for the day, you know, into a meeting, and all that—it's all BS, it's all a show. The real work of the White House just can't happen with a video camera on. There's just no way. I mean you would have that stuff being subpoenaed every 20 minutes. Still photography I think very nicely conveys what's happening but in a more discreet fashion."

This implies that as presidential photographers make pictures of critical moments in history—arguments about whether to commit troops or not, about which legislators are holding up a landmark bill, about a foreign head of state who is worth less than his devalued currency—they are *not* carrying away a record of the discussion they overheard to share with the world.

"We do not come with running commentary about what's going on in the room. Photographers are not hired for their opinions, they are hired for their photos," Kennerly says, referring to the unwritten rule. "And it is a tried and true fact, not only for the White House photographers but for anybody who comes in to shoot. If I walked into a meeting with President Obama and photographed it you couldn't pull my fingernails out to get me to talk about it because it is unethical, unprofessional, and would result in those pictures not being taken any more. So you can't do it."

It is the reader who is left to appraise the image, to imagine what made the scene so intense, so funny, so exasperating. My hope here is that I have provided that same reader some background about what it took to get those pictures. The story of presidential photographers has never been told before and while this is far from a comprehensive telling, I hope that readers will find, as I have, that the work of these remarkable photographers is one of the most engaging and revealing tools we have for understanding the Presidency, one of the most complex jobs ever invented. ★

—JOHN BREDAR

Each chair in the Cabinet Room, where Pete Souza took this picture, is marked with a plaque engraved with each member's name, position, and date when he or she began to serve. The members get to keep the chairs when they leave.

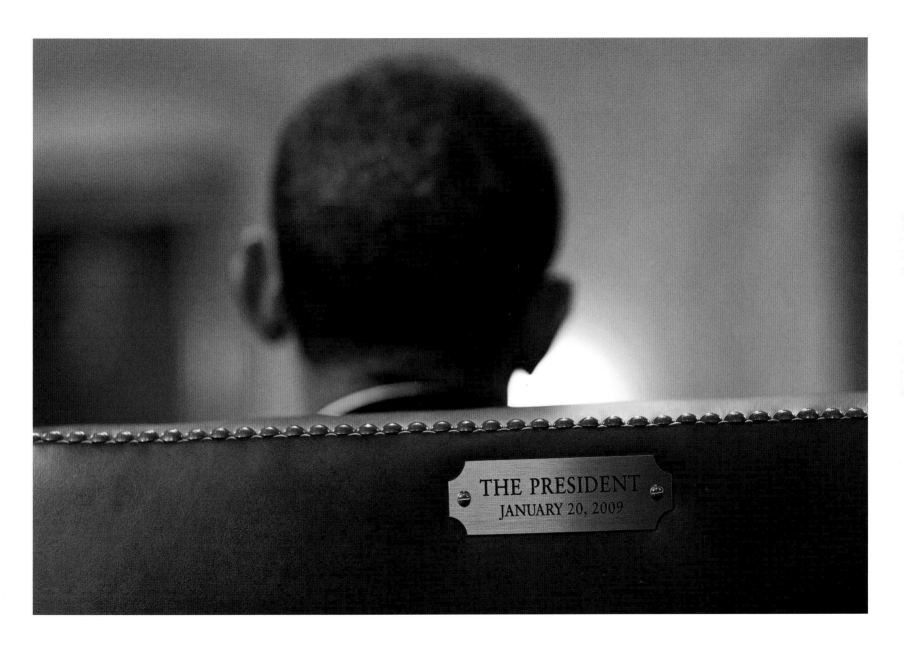

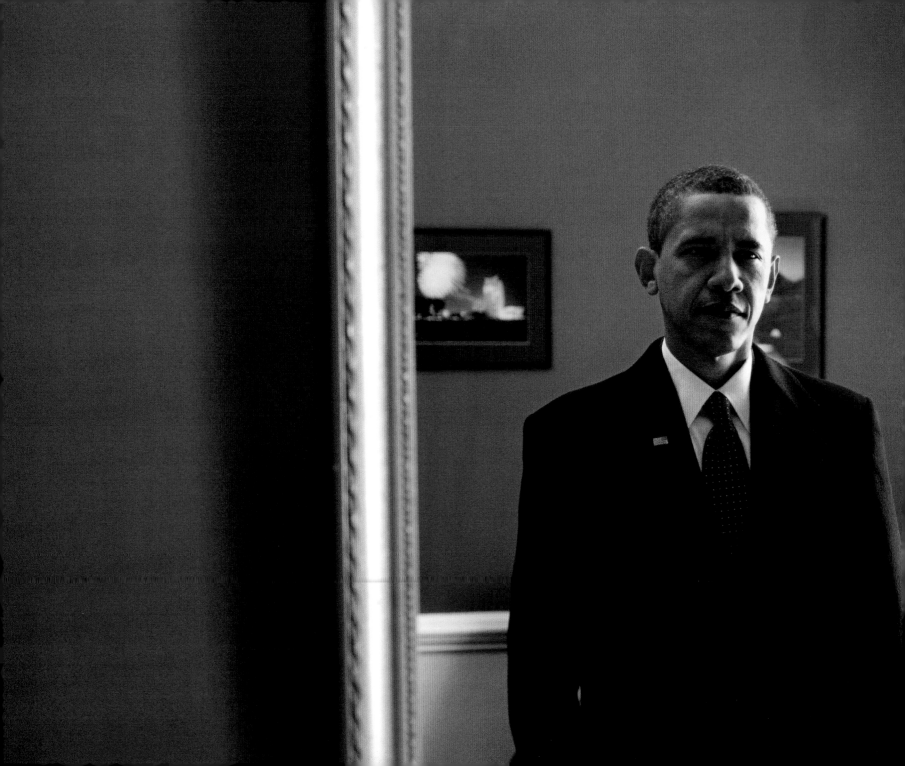

In the Barber Shop

PART ONE: *Pete's World*

PART TWO: *First Pix*

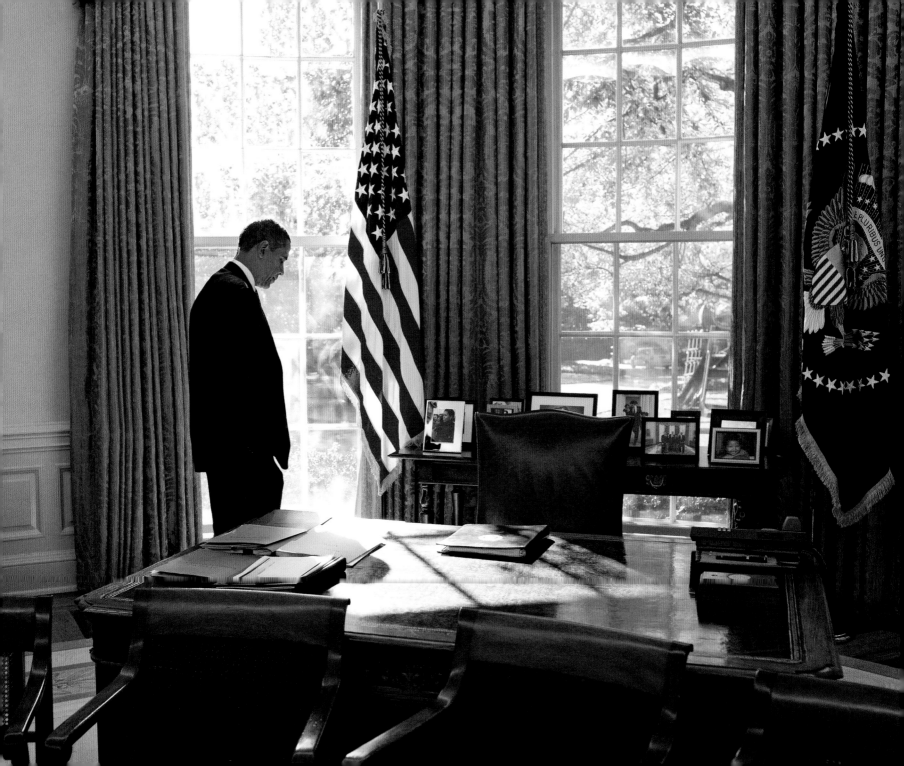

> ❝Creating a good photographic archive for history is **the most important part of my job,** creating this archive **that will live on.**❞

— Pete Souza

PART ONE | *Pete's World*

8:00 A.M. It is eight in the morning and President Barack Obama's official photographer is digging through a bag in an old barbershop. Until the Clinton Administration, there had always been a barbershop in the basement of the West Wing of the White House, but today, all that remains of the shop is a giant wall mirror in what is now photographer Pete Souza's office. For visitors this has an oddly balancing effect. You never see Souza in any of the photographs, but in his office, you see him double.

Souza sits at his computer, working a mouse on a round pad that boasts the presidential seal, cruising the website for the Executive Office of the President. This daily task is as essential as loading a memory card into his camera. From this website Pete downloads the President's daily schedule. Souza prints it at one-third full size, then cuts the pages out and staples them together into a pocket-size booklet: It will be his script for the day. The main act on today's playbill is a trip to New York City, where the President will make a speech on Wall Street.

No one tells Souza what to shoot—he simply looks at the President's schedule and, based on experience, knows. Pete is the first photographer to have officially served two different Presidents for extended periods, first photographing Ronald Reagan from 1983 to 1989 and now serving as chief official photographer to President Obama. He understands that the President's photographer has basically two jobs: 1) taking obligatory photographs of the President greeting dignitaries, visitors, and guests—what might be called the wedding photographer part of the job; and, no less important, but perhaps more

Working from home is an essential perk of the Presidency; from the Oval Office President Obama can look out on his daughters' playground.

Pages 18–19: President-elect Barack Obama just prior to taking the oath of office. "Backstage at the U.S. Capitol, he took one last look at his appearance in the mirror," Souza said, then walked into history.

Pete Souza uses light and composition to make mundane moments more interesting (above left), though the tranquility of morning sun can't undo the disquiet likely contained in this file (above right). The President talks with aides around the Resolute Desk (opposite), built with timbers from a British Navy ship rescued by U.S. whalers and later given as a gift from Queen Victoria in 1880.

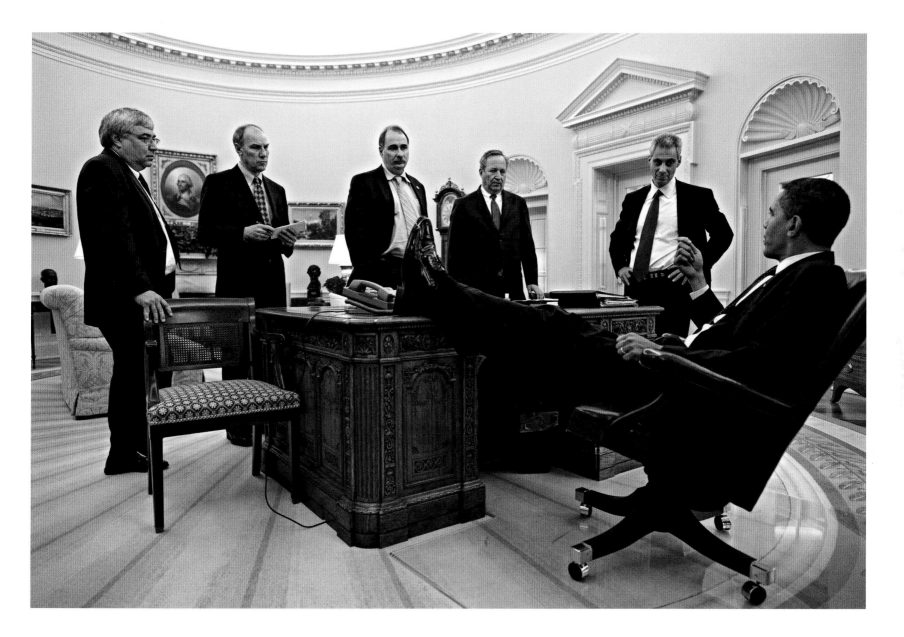

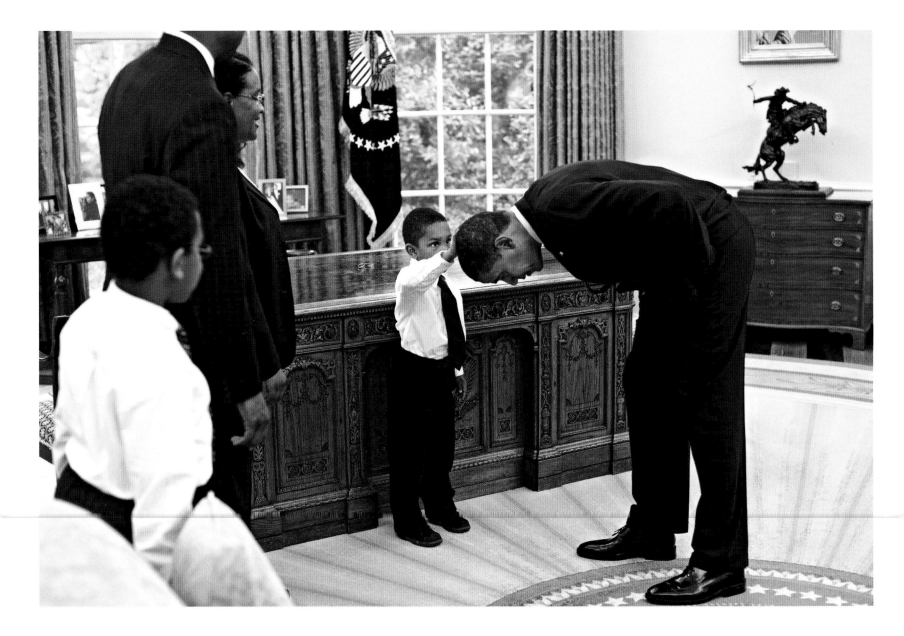

★ ★ ★ It *all* seems cool to the uniniti-ated. Simply walking onto the grounds of the White House comes with a buzz. Maybe it's the sobering security gauntlet one has run, or just knowing that few people actually do get to go inside anymore.

challenging and gratifying, 2) document-ing for history every possible aspect of the Presidency—the part where, Pete once explained, "[I] tried to put most of my energy."

"I think creating a good photographic archive for history is the most impor-tant part of my job," he says, while carefully reviewing the schedule, "creating this archive that will live on." Today he'll add to the archive, shadowing the President throughout the day, focusing on his talk with Wall Street bankers. With the country in the grip of a deep recession triggered by failures in the financial industry, Obama's speech to the bankers could be a little tense. Pete can't ignore politics, but his objective isn't to take a posi-tion, it's to take a photograph. Knowing what the mood is likely to be in a particular room where the President will speak may help him cover the day in a more interesting way.

Pete explains that the trip to New York looks routine, with one exception. "There's an OTR, which is off-the-record movement. I don't know exactly where it is, but it looks like he's gonna have lunch somewhere; it just says 'en route, local stop.' " Pete has looked at a couple thousand presidential daily schedules, so you could excuse him if he sounded the slightest bit bored. But he doesn't. His eyebrows perk up as he warms to the idea of the OTR, the one completely unpredictable event in the day. "Sometimes they won't even decide where they're going to go until a couple hours before, and they might have two or three loca-tions scoped out. But, for security reasons, it's better to wait until the last minute to decide where you're going to go; so that would be kind of cool."

It *all* seems cool to the uninitiated. Simply walking onto the grounds of the White House comes with a buzz. Maybe it's the sobering security gauntlet one has run, or just knowing that few people actually do get to go inside anymore. Or maybe it's just the nearly overwhelming realization of how much history has gone down here since construction first began on the White House in 1792.

Pete Souza made this photo, which the President has said is one of his favorites, when White House staffer Carlton Philadelphia brought his family in to meet the President. At one point, his son declared that he'd been told that he and the President had the same haircut. President Obama bent over so the child could get a better look, "and he helpfully pointed out all the gray hairs and then he decided to pat me on the head, just to get a feel for it," the President explained.

As you clear security at the Northwest Gate and walk deeper into the grounds, the sounds of the surrounding city retreat; it's surprisingly quiet here. And then the house itself comes into view to the left, its large-paned windows reflecting light in that odd, wavy style of antique glass, some of which dates to just after the White House burned, torched by British troops in August 1814.

Side on to the house and a little closer, you can see a view few enjoy: the beautiful half-moon–shaped lunette window on the second floor's west facade and the careful stonework of the Scots masons who cut and carved it. It is both simple and grand, the great stage of the American story, built with the labor of slaves and great statesmen alike.

As you get farther from the gate, the low-slung west terrace that connects the house to the West Wing comes into view. It's busier here, with reporters walking into the pressroom, whose entrance is below grade and can't be seen from the street. Straight ahead is the formal entrance to the West Wing, the office building part of the White House where the Oval Office is located. A marine standing stock-still in full dress uniform at the door hints at the power inside. But veer away from the main entrance and drop down some stairs to the right and you are on West Executive Avenue, first closed to the public in April 1917 at the start of America's involvement in World War I, and still closed today.

Along this former street, now a parking lot for senior staffers, is the workaday entrance to the West Wing, called the Awning Entrance. Enter here and you are on the basement level of a surprisingly small-scale and, except for the Secret Service agent on duty at the desk, homey-feeling office building. It's carpeted and the walls are covered with blowup photographs—called jumbos—taken by Pete and his staff. They depict a variety of events and action, a lot of it behind the scenes, that, surprisingly, most staffers only get to see in these images. Push on down the main hallway and you come to a heavy wooden door with a simple brass plate that reads "Photographic."

Pete is inside, still poring over the President's schedule. The appeal of an unscheduled event like an OTR for Pete, who has been schooled by photographing countless speeches and meet-and-greets, is obvious. "You don't know how that's gonna play out and so that makes it fun, because the speech itself is fairly routine. But the OTR, you just never know what's gonna happen, so I'm looking forward to that." It's a chance

The Oval Office, built by President Taft in 1909, marked its hundredth anniversary in 2009. Prior to that, the President and all his staff shared the second floor of the White House with the First Family. The trademark oval shape was inspired by the three oval-shaped rooms in the White House itself.

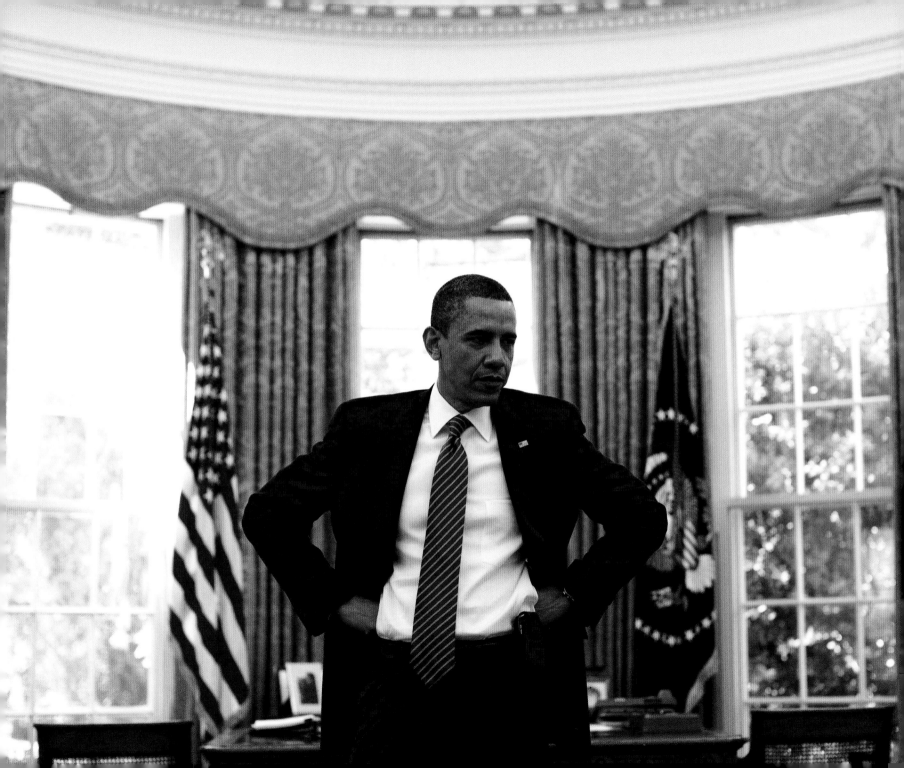

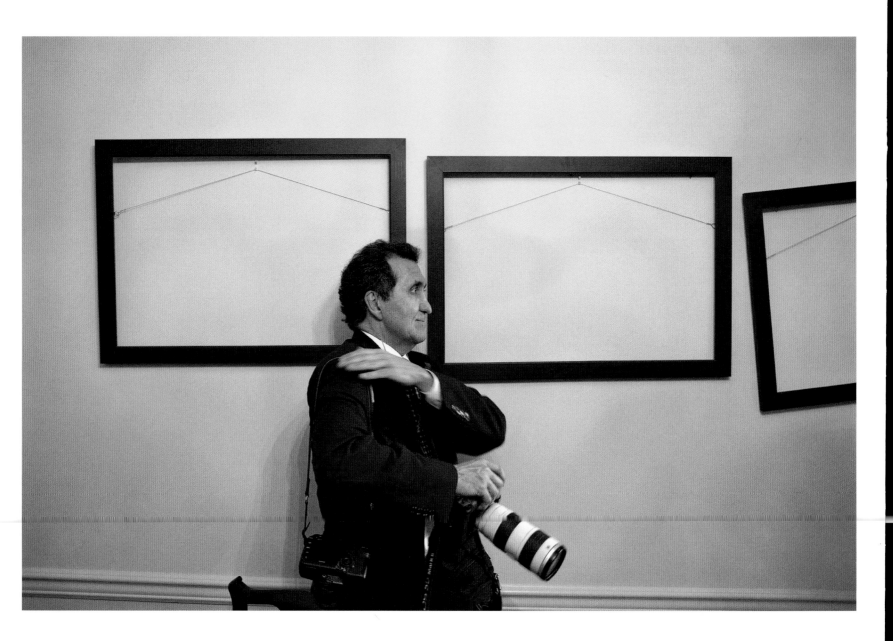

★ ★ ★ He's not the first to deal with the challenge of covering the President and managing an office. When Eric Draper, George W. Bush's official photographer, interviewed for the job with Bush's chief of staff, Andy Card, Card explained that "working at the White House is like trying to drink water through a fire hose."

for him to capture the President in unscripted moments, the pastry in what is often meat-and-potatoes photography.

The assistant director of the Photo Office, Chuck Kennedy, stops by Pete's office to talk about coverage of other White House events while Pete is in New York. They worked closely when Chuck photographed for Knight Ridder/Tribune. He's a 20-year veteran of Washington photography. In addition to photographing the President, Pete manages three other photographers, four picture editors, a photo archivist, and a videographer. This is an incredibly challenging job because Pete, shadowing the President, is almost never in his office. He's not the first to deal with the challenge of covering the President and managing an office. When Eric Draper, George W. Bush's official photographer, interviewed for the job with Bush's chief of staff, Andy Card, Card explained that "working at the White House is like trying to drink water through a fire hose."

The demands of Pete's typical workweek mean that he spends a lot of time at the hydrant. He usually works six to seven days a week, though his hours are shorter on weekends. During the week, he arrives at the White House by 8 a.m., an hour before the President comes to the Oval Office. He typically stays until an hour after the President leaves the Oval, usually around 7 p.m. But the President and First Lady have frequent, official social events in the evening each week and Pete suffers from "don't-miss-ititis," an affliction unique to photographers, so he almost never skips an event with the President. On average, he works roughly 12 to 15 hours a day. Add to that frequent trips out of town with the President and it's clear that the fire hose Draper described almost never turns off.

Pete's experience helps, but so does his staff of talented self-starters, all seasoned photojournalists. Samantha Appleton has covered the war in Iraq, Maoist rebels in Nepal, and malaria in Africa, and has

A rare photo of the photographer. President Obama was speaking in an adjoining room when photographer Callie Shell made this picture of chief presidential photographer Pete Souza. Shell, a longtime photographer for Time, *also did a stint as Vice President Gore's official photographer.*

been a contributor to *Time* and the *New Yorker*. Sam primarily covers the First Lady. Lawrence Jackson, who spent five years as an AP wire photographer and before that ten years in daily journalism, has contributed to the *New York Times* and *Sports Illustrated* among others. LJ alternates with Sam on coverage of the First Lady and also covers the President.

For his part, Pete is a seasoned vet. Before his six-year stint with Reagan's photo office, he worked for the *Chicago Sun-Times,* the *Chanute Tribune,* and the *Hutchison News,* the last two in Kansas. After his first White House tour, Pete became the national photographer for the *Chicago Tribune,* based in its Washington office. Just prior to coming to work for President Obama, he taught photojournalism as an assistant professor in the School of Visual Communication at Ohio University, from which he's on an extended leave of absence.

Pete was not a born photographer. He actually wanted to be a sportswriter but caught the photography bug as an undergrad at Boston University. He didn't develop an advanced case until he was working as a teaching assistant in graduate school at Kansas State, when he got a taste of the pressures and payoffs of shooting to publish. "I remember having a conversation with my mom and she said, 'How are you going to make any money?' And of course, I didn't know. I just knew I'd be doing something that I liked." Raised in South Dartmouth, Massachusetts, Pete's devotion to the Red Sox is serious, not quite problematic, though his license plate does read XOSDER, which speaks for itself.

Pete checks the time, turns in his chair, and begins to load his bag for the trip to New York. He shoots with a Canon EOS 5D Mark II digital camera. Pete typically works with two camera bodies, one with a wide lens—a 35mm or 50mm—for working in close, and the other with a long lens—either an 85mm or a 135mm—for tighter shots of the President at a distance. For working outdoors, he'll often bring one of two zoom lenses, either a 24-70mm or a 70-200mm. He packs extra batteries, a flash, and extra memory cards. He likes to travel light, carrying only a fanny pack.

About 40 percent of the time, Pete will go from the White House to Andrews Air Force Base with the President on the helicopter *Marine One*. But this morning he has to catch an 8:30 van that will take him and other staffers to the base, about 20 minutes away from the White House. Pete double-checks his

Variation means opportunity to a photographer. On a spring day when the President moved a key meeting outdoors, Souza caught an unexpected springtime stretch.

Page 32: Upon arriving at the Oval Office in February 2009, Vermont Governor Jim Douglas expected to talk to the President about the economic recovery. But first he went to work on a different government program: helping the President move his couch.

Page 33: Though he is the same man in the same room every day, changing light gives this most photographed place a different feel.

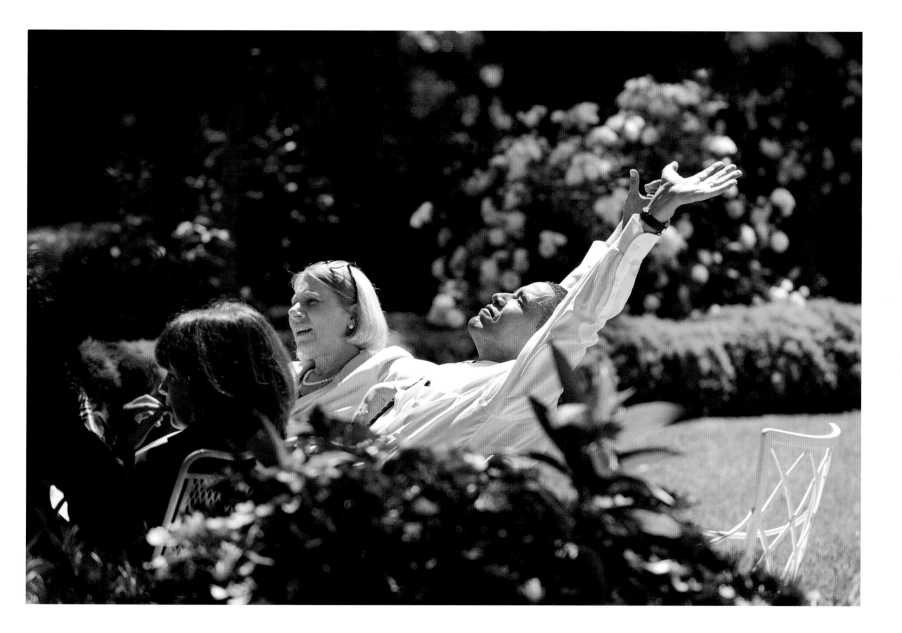

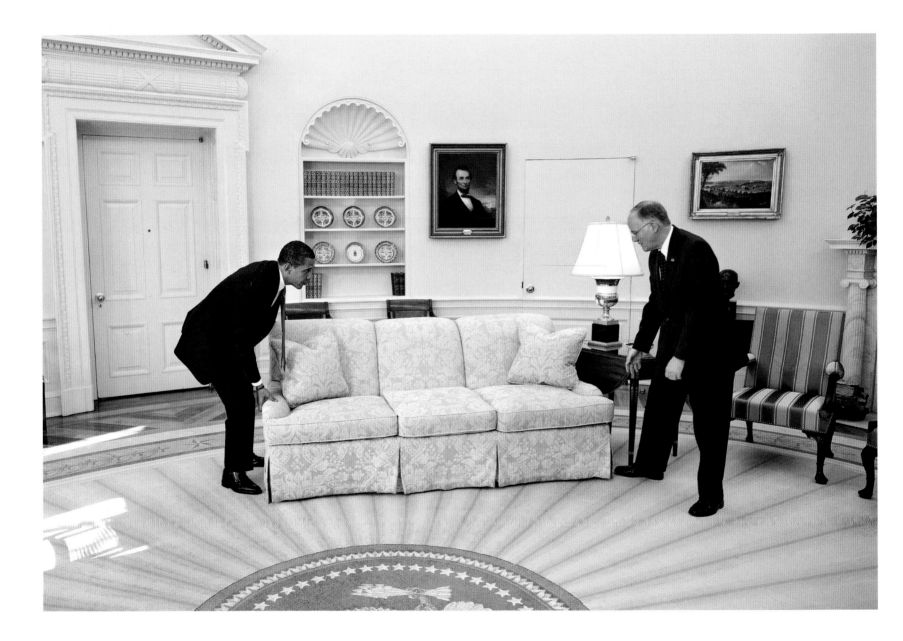

gear then takes a few minutes to review some shots from the previous day, when they were doing the official portrait of the President and his Cabinet.

The Cabinet photo is standard fare for each administration, but this one came with a twist. This time around, Chris Lu, the Cabinet secretary, wanted something different. His responsibility is to act as a liaison between the President and each Cabinet member; he was charged with getting the first Cabinet photo of the administration. Cabinet pictures can often look like a class photo, but without a class clown to leaven things. Working with pictures from the five previous administrations as a guide, Lu and Chuck Kennedy came up with their riff on the old standard.

They first set up several practice shots to test the light and various setups. Lu found staff from around the White House to stand in for the President and his Cabinet. The practice pictures reveal a curious group, a kind of "photo cabinet" made up of groundskeepers, electricians, kitchen staff, presidential assistants, and even Cabinet secretary Lu, who sits in for the attorney general.

The Cabinet photo is more than just an important record for history. Along with their Cabinet Room chair with their name and Cabinet position noted, it's something each secretary gets to keep after their service. They typically sign each other's photos, kind of like a yearbook.

There are 25 Cabinet positions in the administration and organizing the shot is complex, requiring careful coordination of each secretary's busy schedule. Lu planned for the photo to be taken after the third Cabinet meeting. Place cards were taped to the floor in the State Dining Room, with the idea that once each secretary had taken their place, the President and Vice President would be called in for the picture.

But in spite of the careful planning, when they'd gathered everyone for the shot and were just about to call the President to join them, they realized that one particularly busy Cabinet secretary—Souza is too discreet to reveal which one—had already headed back to work! A quick phone call and a flurry of texts and e-mails promptly brought the missing secretary back; President Obama and Vice President Biden were called, and the historic picture was taken.

It turns out that the busy secretary happens also to be a Nobel laureate. There's something comforting in knowing that even those with exceptionally large brains can occasionally forget something important. ★

"Living over the store" as President Harry Truman put it, has its advantages. The President's short commute takes him down the West Colonnade along the Rose Garden. Mr. Obama noted that he's spent more time with his family since moving into the White House than at any time in public life.

Pages 36–37: The President and Vice President pose with the full Cabinet in the State Dining Room on September 10, 2009 (left). The first photograph ever of a President in office was also a Cabinet photo (right), showing President James Polk, second from right, taken in 1846.

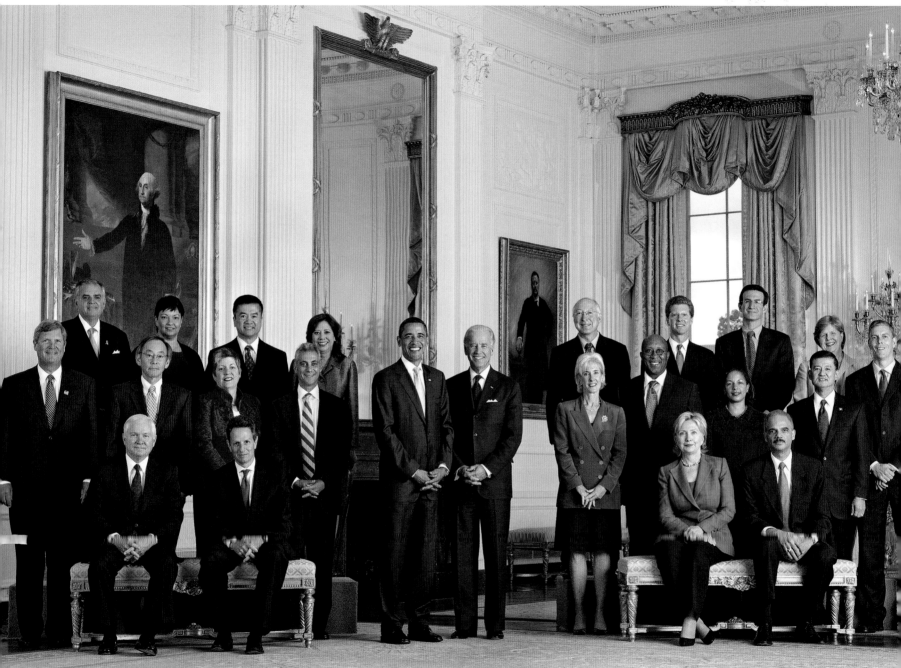

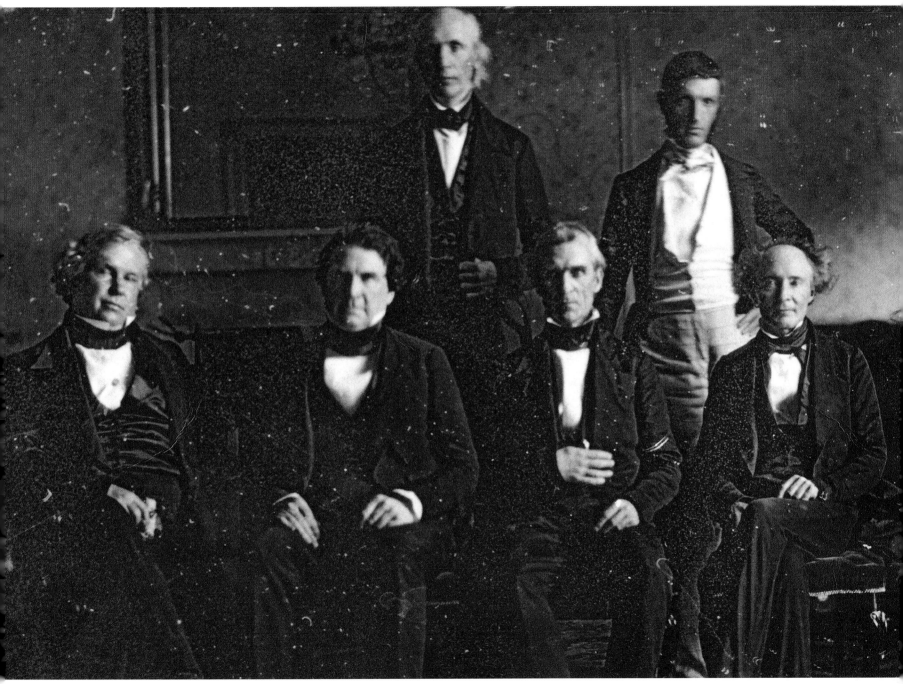

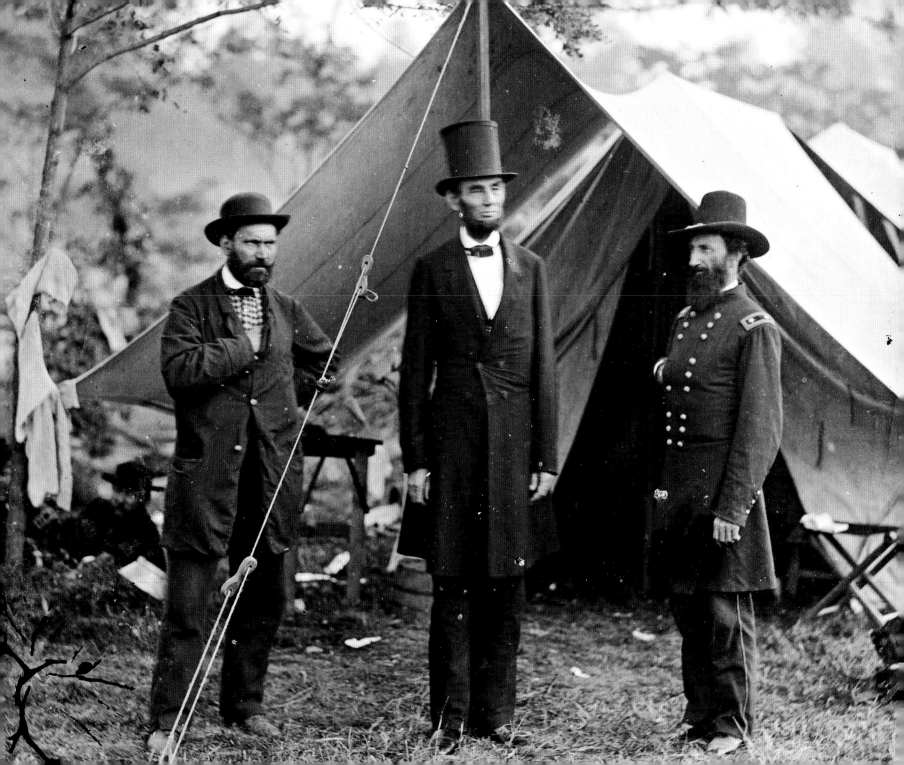

> **"Remember the first time you heard your voice recorded? That feeling of slight strangeness might give some idea of what it would have been like to see your own likeness for the first time."**
>
> —ANN SHUMARD

PART TWO | *First Pix*

Curiously, the first ever photograph of a President in office is also a Cabinet photo. Taken in 1846, it featured President James K. Polk and his Cabinet. It was the brainchild of First Lady Sarah Polk, who had an abiding interest in photography, which had been introduced to the world only seven years before, in 1839. Sarah Polk's interest and insistence that a picture be made—it's unclear why she was so keen—was prescient. Since the 1960s, photographic images have become an increasingly critical tool in how we understand our Presidents.

While the Obama photo team avoided a problem, Polk was not so well served. His Cabinet photo *is* missing a secretary. Somehow, Polk's secretary of state, James Buchanan, who would later become President, was a no-show. Ten years later, Buchanan was nominated to run for President by the Democratic Party, *in absentia*—he was apparently out of town then too. Consistently ranked at the bottom of American Presidents, some historians might argue that the country would have been better off if Buchanan had simply remained out of town, permanently.

That Buchanan wasn't in the shot probably didn't raise an eyebrow. In the 1840s the novelty of a photograph of the President would have been the story, not a lapse by his secretary of state. If it seems odd that a photograph like this would get a rise out of the public, it's only because it's hard for us to wrap our heads around the idea of a world *without* photography. Prior to invention of the process used to capture Polk and most of his Cabinet—called daguerreotype, developed by the Frenchman L. J. M. Daguerre in the 1830s—the few ways you could see your likeness was in a mirror, a puddle, or by the hand of an artist.

Allan Pinkerton, President Lincoln, and Maj. Gen. John A. McClernand at Antietam, Maryland, in October 1862, scene of horrendous fighting only two weeks earlier. Though posed, it foreshadowed the documentary-style imagery that would come to define presidencies almost a hundred years later during the Presidency of John F. Kennedy.

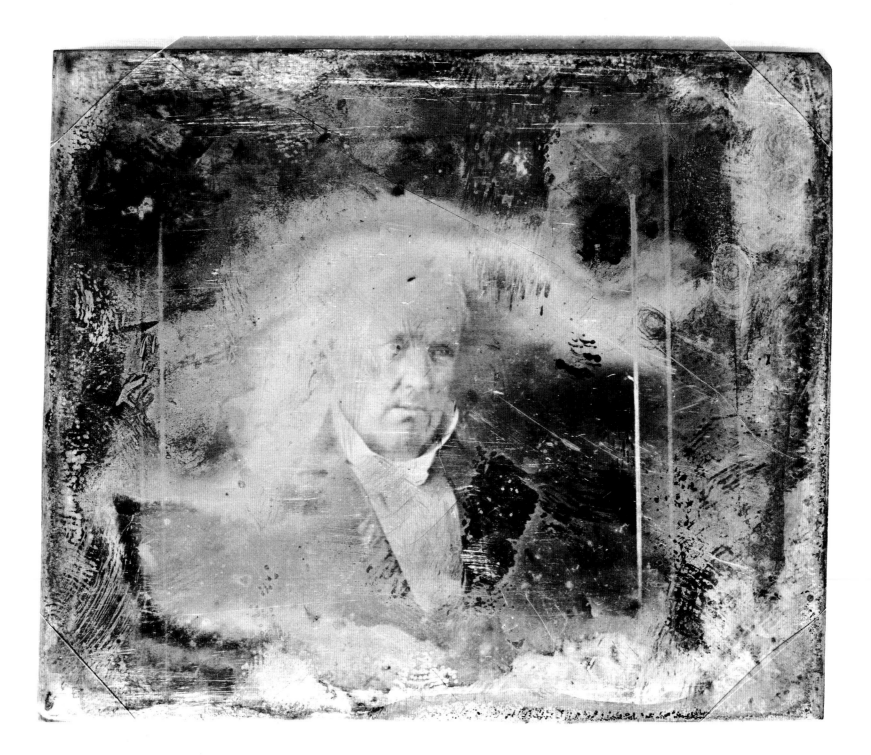

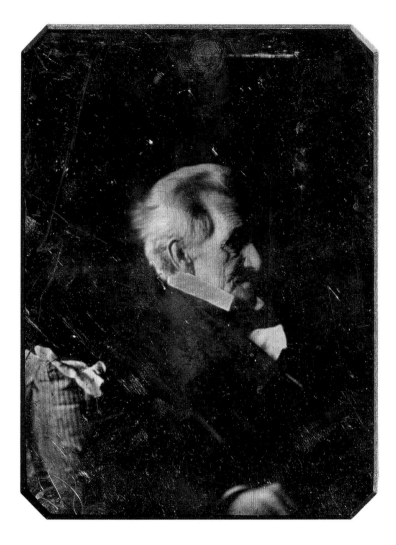

Daguerreotypes featuring three former Presidents, Buchanan (opposite), Jackson (above left), and John Quincy Adams (above right). Only eight Presidents were never photographed: Washington, John Adams, Jefferson, Madison, Monroe, Van Buren, William Henry Harrison, and Tyler.

Mirrors were expensive, artists more so. Remarkably, gazing at a perfect likeness of oneself would have been a rare, perhaps even unsettling experience.

"Remember the first time you heard your voice recorded? That feeling of slight strangeness might give some idea of what it would have been like to see your own likeness for the first time," says Ann Shumard, curator of photographs at the National Portrait Gallery in Washington, D.C.

In the early days of photography, the images were invariably daguerreotypes, positive, mirrorlike images, captured on silver-plated sheets of copper, chemically treated to be sensitive to light. The first daguerreotype studio opened in New York City in 1840, and by mid-century they were proliferating at a Starbucksian pace. In 1853 the *New York Daily Tribune* estimated that three million daguerreotypes were being made annually; most would have been private portraits like the Polk image.

During this period a wide variety of techniques emerged, each with a different name: ambrotype, tintype, panotype, calotype, and crystalotype, to name a few. Frustrated by the confusion, a daguerreo-typist in Philadelphia, James McClees, pushed for the standard term "photograph"—for as historian Alan Trachtenberg put it, "was not the medium a way of writing with light?"

At the time of Polk's picture, writing with light took far longer than the instant Pete Souza's cameras require today. Exposure times for the very first portraits taken in the United States—in autumn 1839—took *ten minutes*. American painter Samuel Morse, whose children sat for one of the first portraits, took an interesting tack. Since it was nearly impossible for sitters to keep their eyes open in brilliant sunlight for any length of time without squinting or having their eyes water uncontrollably, Morse had everyone pose with their eyes tightly shut!

Exposure times dropped very quickly as the commercial promise of the business grew, so by the time Polk and his Cabinet sat, it was in the range of five to ten seconds. Still, to insure a crisp image, particularly with a group photo, the photographer would employ a kind of head brace or clamp to stabilize his subjects during the exposure.

For Polk's Cabinet picture, Attorney General John Y. Mason refused the brace. This defiance was in protest of having to sit for the picture, something that Sarah Polk apparently sprang on the secretaries

after a breakfast Cabinet meeting and which Mason had previously resisted. Mason, far left in the picture, sits slouching in his chair, while the five other men look on, grim and head clamp–stiff. Their sobriety could have been due to something else: The image was taken just days after the United States declared war on Mexico.

Daguerreotypes of former Presidents John Quincy Adams and Andrew Jackson also exist, though these were taken after they had left office. Interestingly, we have photographs of all but eight Presidents; only Washington, John Adams, Jefferson, Madison, Monroe, Van Buren, William Henry Harrison, and

★ ★ ★ According to Ann Shumard, no photographic technique ever developed can rival the detail of a daguerreotype, what one 19th-century writer called "the mirror with a memory." In fact, when Daguerre first introduced the images to the public, critics were incredulous, believing instead that they had to be remarkably fine engravings. Daguerre responded by showing them the pictures with a magnifying glass, so the doubters could see details invisible to the naked eye.

John Tyler are missing. For those even mildly obsessed with direct links to history, having an image of John Quincy Adams, the son of John Adams, is significant. In part it's the way the images were made. When one looks at the Adams portrait, in the collection of the National Portrait Gallery, you are not looking at a print made from a negative, you are actually looking at the reflection of Adams as he sat in his chair. It's not just that Adams looks a lot like Anthony Hopkins, who portrayed him in the film *Amistad,* it's how phenomenally sharp the picture is. According to Ann Shumard, no photographic technique ever developed can rival the detail of a daguerreotype, what one 19th-century writer called "the mirror with a memory." In fact, when Daguerre first introduced the images to the public, critics were incredulous, believing instead that they had to be remarkably fine engravings. Daguerre responded

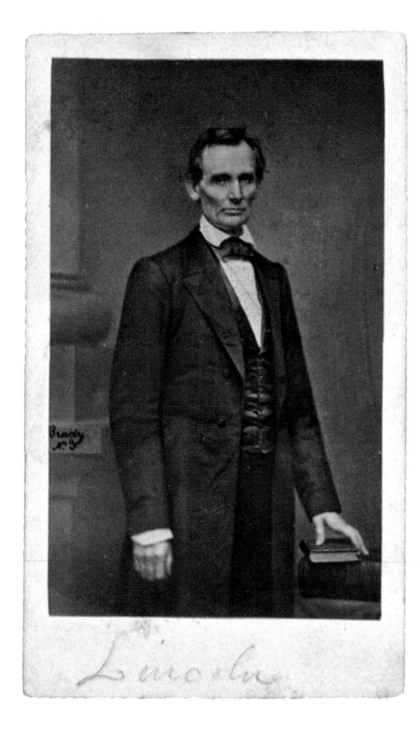

Lincoln

[SIII.02.0001]

196

0-17

PUBLISHED BY

E. ANTHONY,

501 *Broadway,*

NEW YORK.

FROM

PHOTOGRAPHIC
NEGATIVE,

FROM

BRADY'S NATIONAL

Portrait Gallery.

by showing them the pictures with a magnifying glass, so the doubters could see details invisible to the naked eye.

Daguerreotypes were difficult to reproduce, limiting their use for mass promotion or publicity. A breakthrough, almost immediately popularized by presidential politics, came in the late 1850s: Glass-plate photography had emerged, allowing photographers to create a negative image that could be easily transferred to paper. A wood engraving of the image would allow it to be published in mass publications like *Harper's Weekly*.

At the time, Republican presidential candidate Abraham Lincoln was willing to exploit this technology for political gain. Working at the direction of pioneering photographer Mathew Brady, Lincoln arranged to be photographed in February 1860 just hours before a major campaign address at Cooper-Union College in New York. The resulting picture—in which Lincoln is wearing a new suit with a collar that Brady elongated to make Lincoln's neck look shorter—helped dispel notions that Lincoln was a hick. It also was the product of a 19th-century variation of PhotoShop. Brady printed the image on paper, touched up the photo by removing lines on the candidate's face, and then rephotographed it. The final image was widely reproduced and distributed and often paired with the text of the Cooper-Union speech. Lincoln later credited the widespread distribution of the combo with winning the election.

The easy and relatively inexpensive reproduction of images from glass plates—it cost less than $3 for a popular, roughly 3¼ x 2¾–inch photo card—added to an already intense interest in photography. The rampant collection of cards featuring various luminaries, like the President, was further driven by the photo studios, which actively cultivated the trend by creating mini-galleries in their studios.

According to a *Harper's Weekly* article in 1863, "People used to stroll in there in those days to see what new celebrity had been added to the little collection, and the last new portrait at Brady's was a standing topic of conversation."

Kind of a precursor to baseball cards, these images were printed on albumenized card paper and called *cartes de visite*, taking their name from the European-style calling card typically left when making a visit to a home or business. Collecting the cards became a mid- to late 19th-century mania. "Like Beanie Babies

Small, collectible photo cards known as cartes de visite, such as this one of Lincoln, were immensely popular in the middle 19th century. Lincoln credited this image, taken by Mathew Brady and typically paired with his famous Cooper Union speech, with winning him the election.

in the 1990s, they were absolutely the last word in pop culture media. People would have their picture taken, and give it to friends and collect their friend's portraits in return," Shumard says. But they also sought images of heroes, statesmen, and leaders. Commercial industry saw green and the first photo albums appeared. Samples of these in the collection of the National Portrait Gallery reveal an eclectic mix of carte de visite images: family members mixed in with pictures of Lincoln and his son Tad, sculpture, and Queen Victoria and Prince Albert. To be the one whose card was highly sought after was to be a pop icon and may possibly be the root of the phrase "He's a card!"

Besides planting in the American psyche the seed of fascination for photography, other trends that become relevant to the work of later presidential photographers begin to take shape in the second half of the 19th century. The roots of portraiture are clear, but so are the beginnings of documentary photography, the pursuit of a narrative through pictures. A range of daguerreotypes referred to as "occupational portraits" are precursors to this type of photography. They are staged images, often using props, that attempt to reveal candid images of people at work. Brady's remarkable images from Civil War battlefields only a few years later presented powerful, sobering images—a dramatic leap forward in the development of documentary photography.

By the late 19th century, advances in technology allowed photographers like Jacob Riis and Alfred Stieglitz, whose images illustrate the desperate and beautiful reality of New York City life, to build on Brady's initial documentary efforts.

Curiously, we don't see this type of coverage at the White House for another six decades. Even though, for much of that time, the federal government sponsored the largest documentary photographic efforts in the nation's history. Photographers working for the Works Progress Administration and other government agencies created a vast body of work covering the day-to-day lives of Americans and made "the 1930s and early 1940s a golden age of documentary photography," according to Bruce Bustard, a photo historian and curator for the 1999–2001 National Archives exhibit "Picturing the Century."

Instead, the story at the White House is largely covered by the working press. Additional coverage of Presidents throughout the middle part of the 20th century is handled by official government photographers

This print on a stereo card of President Theodore Roosevelt would have been viewed with a hand-held stereograph. Shown in the Yellowstone Valley of California, TR understood the political value of photography.

Pages 48–49: Coverage of the Presidents in the late 19th and early 20th centuries was largely the domain of the working press (right). President Harding (left), a former newspaperman, understood the appeal of playful shots like this one, although coverage of the story of the Presidency was still 40 years away.

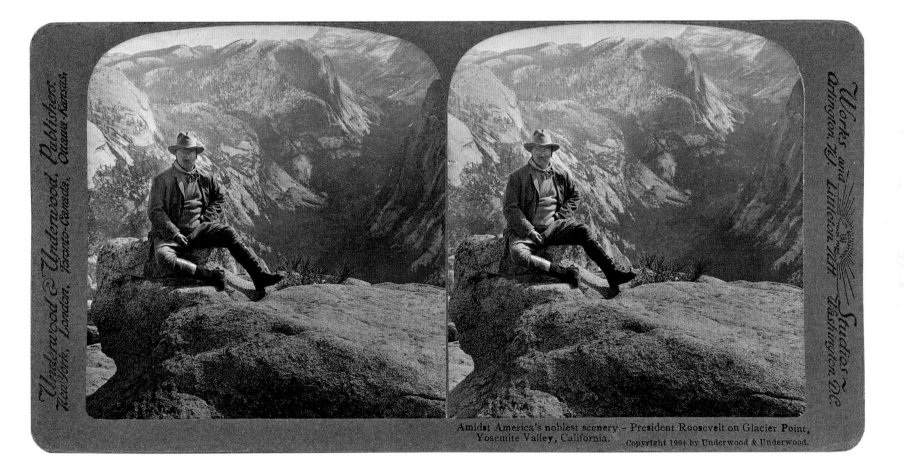

Underwood & Underwood, Publishers.
New York, London, Toronto-Canada, Ottawa-Kansas.

Works and Studios:
Arlington, N.J. Littleton, N.H. Washington, D.C.

Amidst America's noblest scenery – President Roosevelt on Glacier Point,
Yosemite Valley, California.

President Kennedy confers with Secretary of Defense Robert S. McNamara outside the Oval Office at the culmination of the Cuban Missile Crisis in October 1962. Cecil Stoughton's candid image signaled a significant change in coverage of the Presidency.

★ ★ ★ Stoughton was a combat cameraman in WWII, and his ability to cover spontaneous action came in handy, since the pace of White House life seemed breakneck. "When you are around here you have to eat fast, read fast, think fast, and sleep fast or else you won't get anything done" JFK once told his military aide.

from the U.S. Army Signal Corps, the National Park Service, and the U.S. Navy photo office. Almost none of them try to tell a complete story about a Presidency.

In 1961, when President Kennedy takes office, that begins to change.

Cecil Stoughton, a lieutenant in the U.S. Army Signal Corps, came to work for President Kennedy in 1961 at the request of the President's military aide, Gen. Ted Clifton. "Major General Clifton provided logistical support for the President and was present at all functions. He knew about my photographic abilities and told the President and Jackie that they would be in the public eye and needed someone in-house to capture various occasions and release the pictures to the press," Stoughton explained in a 2004 interview. Clifton saw beyond the immediate needs of the press and wanted Stoughton "to provide a visual record" of the experience. Stoughton was a combat cameraman in WWII, and his ability to cover spontaneous action came in handy, since the pace of White House life seemed breakneck. "When you are around here you have to eat fast, read fast, think fast, and sleep fast or else you won't get anything done," JFK once told his military aide.

To insure he didn't miss anything, Stoughton arranged with Evelyn Lincoln, the President's personal secretary, to have a special buzzer hooked to his desk so he could be quickly summoned. Stoughton's office, where he worked with another photographer, Robert Knudsen, was located directly beneath the Oval Office; a short dash up the stairs would bring him into range very quickly. As Hugh Sidey of *Time* magazine reported, Stoughton "became a fixture of the inner White House circle. He hovered outside the office door to catch family and business pictures."

His hovering led to some of the most famous pictures of the Kennedy Presidency, 12 frames made in about three minutes in October 1962.

★★★ There was a great deal of confusion about the President's condition. "I'd seen Vice President Johnson leaving the hospital," Stoughton recounted in 2005, "and I asked where he was going and someone said, 'The *President's* going to Washington.' So that meant that Kennedy had expired in the hospital where I was standing outside the operating room door there. And I said, 'So am I.' I picked up my camera and went out to the plane."

On that morning, John-John and Caroline came by for a visit with their father. After the obligatory stop at a candy jar on Mrs. Lincoln's desk, they headed into the Oval. "The next thing I knew I heard the President clapping and singing out, 'Hey, here's John-John!'" Stoughton peeked in and said, "This looks like a fun thing I should be making a picture of." The President waved him in and he captured the presidential romp as both kids danced and strutted around the presidential seal in the carpet, the President accompanying with clapping. When JFK authorized the release of one of the pictures to the press, it immediately went global, providing a rare glimpse of the young President and his kids at play and forever expanding our idea of a modern President.

In addition to covering the President's day-to-day activities, Stoughton was occasionally enlisted to perform extra duties, including shooting motion picture film. On one occasion, the President asked Stoughton to film him as he practiced driving golf balls. After the President would take a shot, he'd signal to the camera whether it was good, sliced right, or hooked left. That way, when he watched the footage later, he'd be able to determine how to adjust his swing.

Another time, in September 1962, Mrs. Kennedy asked Stoughton to go to New York to cover a fashion show at Chez Ninon. She explained that if she attended, it would be a distraction, possibly ruining the show. Instead, Stoughton would go, cover all the new styles, and bring back a visual report for the

Kennedy's photographer, Cecil Stoughton, had been hanging around outside the Oval Office when Caroline and John-John dropped by. When Stoughton heard the President clapping his hands and chanting to the kids he decided, "I'd better get this."

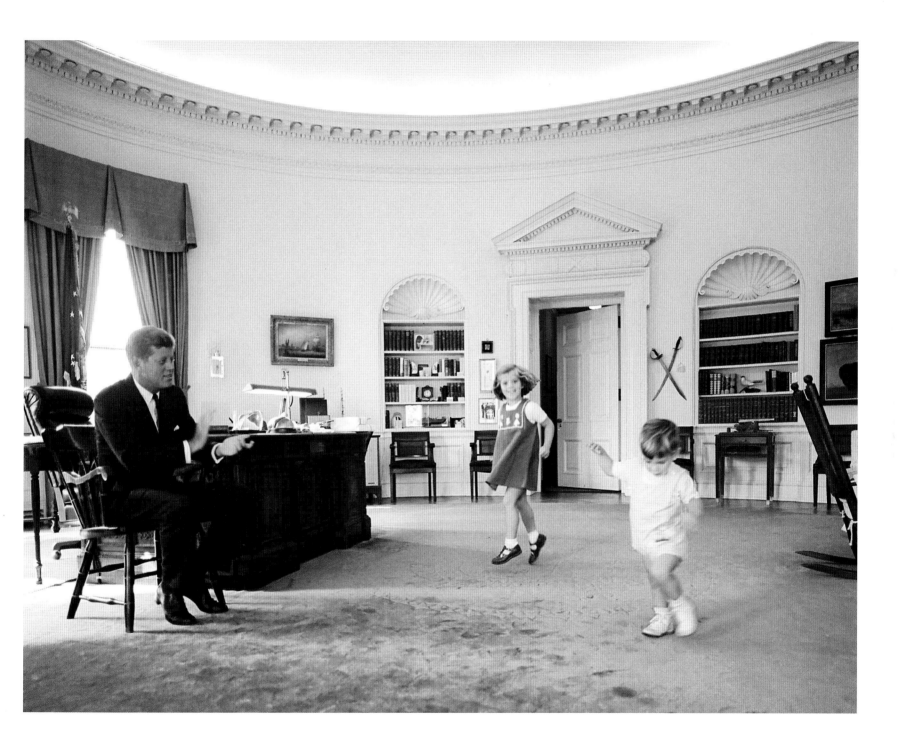

First Lady. In a thank-you note to Stoughton that praised his coverage, she wrote, "Don't leave us for *Harper's Bazaar.*"

Stoughton took almost 12,000 negative frames during his time covering JFK, and among them is perhaps the most profound image ever taken by a presidential photographer, though it doesn't portray Kennedy: It is of Lyndon Johnson being sworn in as President aboard *Air Force One,* a stoic Jacqueline Kennedy standing by his side. Stoughton almost didn't get the shot.

He'd been in the motorcade, five cars back, and had followed the race to Parkland Hospital in Dallas, where he waited for word about President Kennedy. There was a great deal of confusion about the President's condition. "I'd seen Vice President Johnson leaving the hospital," Stoughton recounted in 2005, "and I asked where he was going and someone said, 'The *President's* going to Washington.' So that meant that Kennedy had expired in the hospital where I was standing outside the operating room door there. And I said, 'So am I.' I picked up my camera and went out to the plane."

There'd been no announcement, no word from staff, just a stark revelation, buried in a matter-of-fact statement. Stoughton knew he had to be on the plane. He raced for the field, arriving just in time.

"When I got there, the acting press secretary, Malcolm Kilduff, said, 'Thank God you're here, Cecil, the President's going to take his oath on the plane and you're going to have to service the wires with the photograph.' So I took the only photograph of the swearing-in."

There is a grim intensity to this image. This ritual of state, typically surrounded by boundless hope and joy, is stripped of all its trappings of pomp. The hallowed oath is now a necessary chore, a painful punctuation mark at the end of a diabolical sentence. Everyone seems to be gritting their teeth, and they probably were. But as a record, it captures a phenomenal moment and, as the only photographic record—Stoughton was the only photographer on board *Air Force One* that day—it is almost like a national monument of sorts, something to be visited, looked at, and contemplated for all its meaning.

Curiously, one of the only taped interviews Stoughton ever recorded about the photograph was for a segment of the PBS program *Antiques Roadshow,* during which the iconic image of LBJ's swearing-in was valued at $50,000. ★

This kind of candid and ultimately unfamiliar image reinforces the value of presidential photography.

Pages 56–57: Stoughton's images of the trip to Texas by the President, seen greeting a crowd in Fort Worth (left), provide key beats in the story on the fateful day. Later, Stoughton made perhaps the most famous—and important—image ever taken by a presidential photographer as LBJ is sworn in on Air Force One (right).

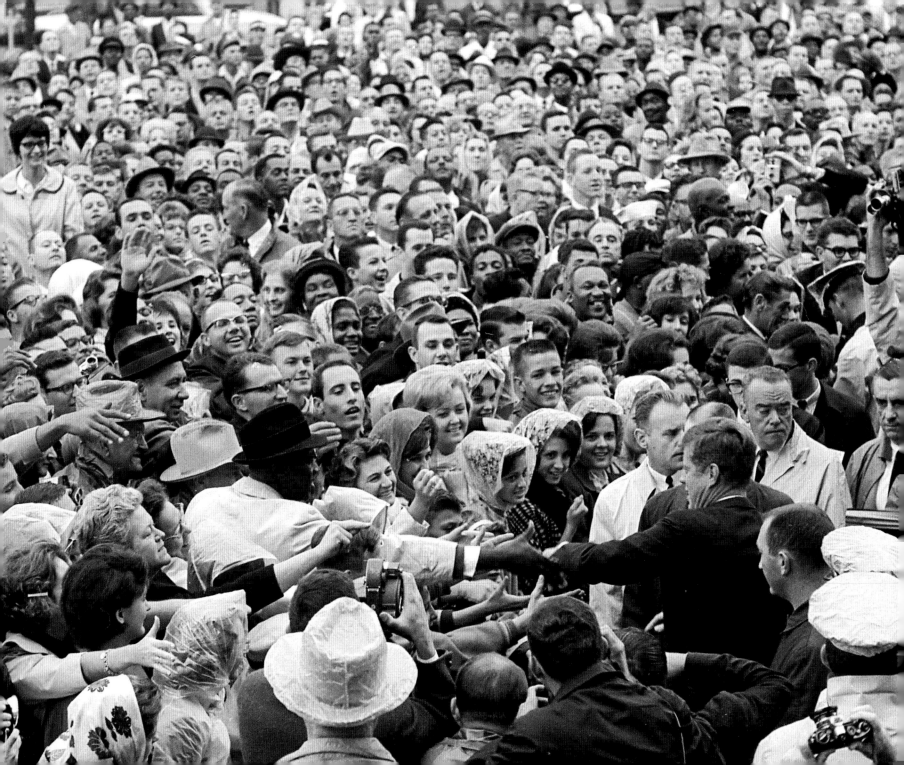

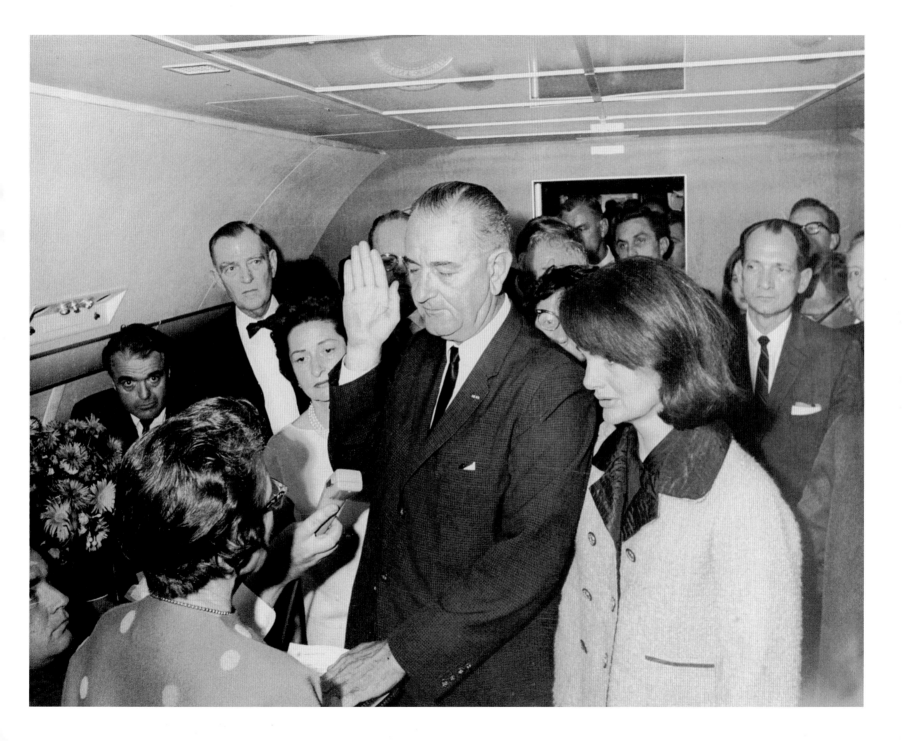

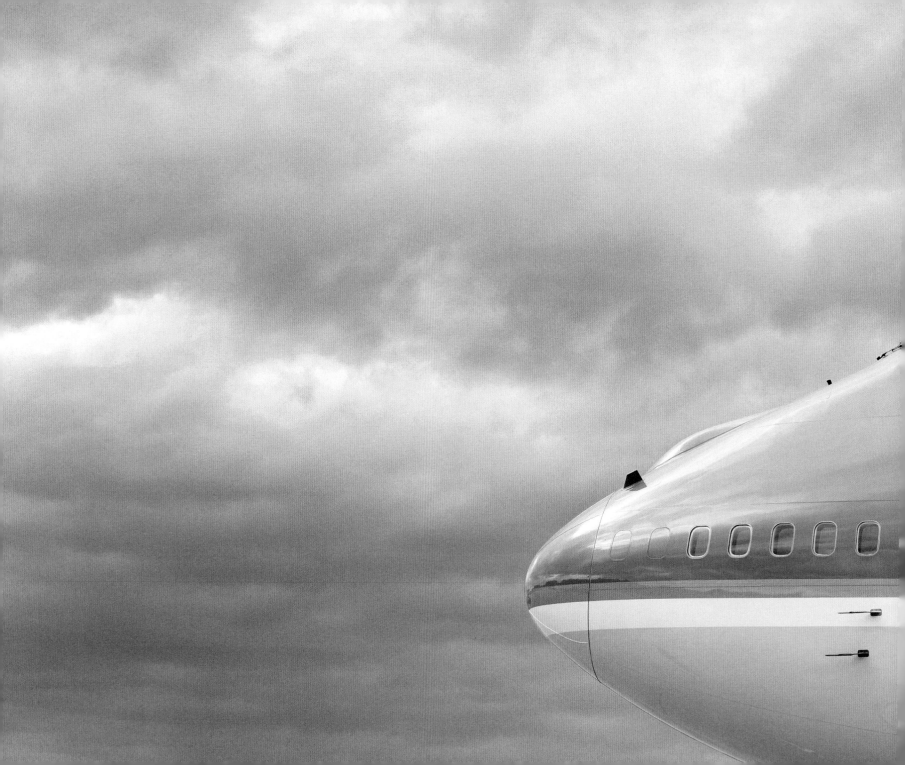

The Old Couple

PART ONE: *Road Trip—Air Force One*

PART TWO: *The Relationship*

"You know, I think at this point Pete and I are like an old couple. We sort of know each other."

— BARACK OBAMA

PART ONE | *Road Trip*—Air Force One

8:50 A.M.

The van Pete Souza is riding in passes through a final security gate at Andrews Air Force Base and rolls onto the tarmac. Through the windows, *Air Force One* comes into view in the distance.

For outside observers, the idea of riding on the plane is thrilling. Pete knows this, viscerally, so he sounds a little sheepish when he admits, "Flying on *Air Force One* is still *kind* of fun." And then—was that a guilty smile?—he adds, "So, I'm maybe a little jaded." But he found an elixir to remedy this condition on his last trip just a week ago, when a group of staffers who never travel with the President got their first chance. "To see them be so excited was kind of neat, and I had lost a little bit of that—sort of taking it for granted. But at the same time, you don't ever forget, this is carrying the President."

When you first glimpse the plane up close, it is an overwhelming sight. We are used to seeing airplanes through terminal windows and typically at eye level thanks to the Jetway. But you encounter *Air Force One* from the ground and it looms over you. Initially, two things come to mind—how could something this big be so shiny and who was the poor guy who shined it?

There is, literally, an air force of shiners who are, more precisely, skilled mechanics, technicians, and pilots who see to its care and handling, part of the 89th Airlift Wing based at Andrews. There are two identical planes that, in practice, are called *Air Force One*, though technically, any Air Force plane carrying the President carries that official designation. Both planes are Boeing 747s; when you see them together, parked nose-to-nose in their shared hangar at Andrews, it is a jaw-dropping tableau of gleaming power.

Pages 58–59: President Barack Obama leaves Air Force One *at Andrews Air Force Base after a trip to New Mexico, May 14, 2009.*

Only four months into his term, Pete Souza made this picture of the President en route to Arizona State University, where he gave the commencement address in May 2009.

Air Force One *is the ultimate backdrop for the drama of the Presidency, and Souza has put it to spectacular use, whether as sunshade as the press pool gathers under the wing at sunset in Houston (opposite), a fog-shrouded scene in England (left, top), or the President boarding and waving in departure (left, middle and bottom) dwarfed by the huge aircraft.*

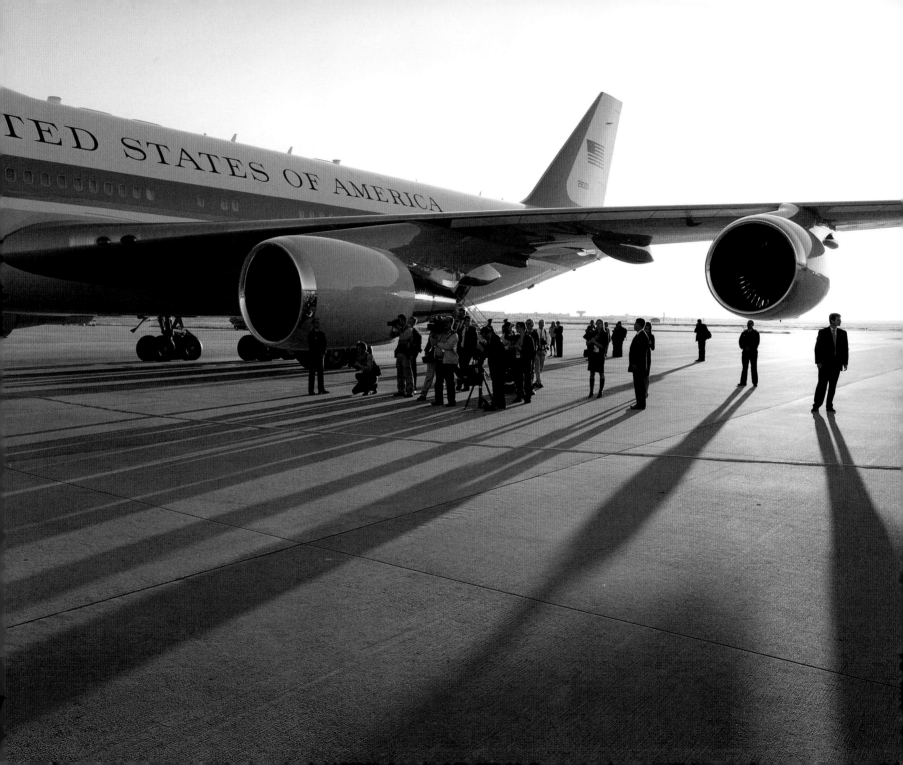

★★★ FDR was the first sitting President to fly in a plane and the first to fly an official, purpose-built plane for the Commander in Chief. The plane was nicknamed *Sacred Cow*. Equipped with a special elevator to lift the wheelchair-bound President in and out of his cabin, the plane was used only once by FDR, to fly to the Yalta Conference in 1945.

The van carrying Pete pulls up at the front of the plane—no long walk through the terminal here. He and most of the staff traveling with President Obama enter the plane through a lower doorway, 12 steps above the ground, about the same level where your bags would go on a commercial flight. This is the working entrance to the plane; it's stripped down, perfunctorily beige, and reveals a hint of the plane's utilitarian core—this is a military transport after all. Pete heads up an interior staircase to the main floor of the aircraft, where the feel of the plane changes. It's hushed, richly carpeted, and feels like the area outside the Oval Office. Pete walks aft, heading for his seat.

FDR was the first sitting President to fly in a plane and the first to fly an official, purpose-built plane for the Commander in Chief. The plane was nicknamed *Sacred Cow*. Equipped with a special elevator to lift the wheelchair-bound President in and out of his cabin, the plane was used only once by FDR, to fly to the Yalta Conference in 1945. The military referred to this type of plane as a VC-54A—a Douglas DC-4 in the civilian world—a long-range, propeller-driven airliner. President Truman put the plane to more vigorous use and, in 1947, actually signed the legislation that formed the Air Force aboard this same plane.

The name *Air Force One* didn't come into use until 1953, prompted by an airborne coincidence. One day, President Eisenhower was flying cross-country in his official Air Force plane, a four-engine Lockheed Constellation with the nickname *Columbine*. Mrs. Eisenhower had named the plane after the state flower of Colorado, her adopted home state. It carried the designation Air Force 8610. At some point during the flight, an Eastern Airlines commercial flight bearing the same number, 8610, entered the same airspace,

Pages 66–67: Air Force One, *with roughly 4,000 square feet of living space, boasts a full conference room, the focal point for most long flights, whether as a place where the President can spend a thoughtful moment, en route to Afghanistan (left) or share a laugh with his senior aides while on the long transpacific haul to Singapore in November 2009 (right).*

creating confusion for traffic controllers. Afterward, the Air Force introduced the call sign *Air Force One* to designate any aircraft that carries the President of the United States.

The current paint job, or livery, for *Air Force One* is a little retro—Jacqueline Kennedy's doing in the 1960s. When the first jet version of *Air Force One* was built, the Air Force proposed a color scheme that JFK deemed too regal. At Mrs. Kennedy's suggestion, the President enlisted the help of designer Raymond Loewy to come up with something more appropriate. Loewy was considered one of the most influential industrial designers of the age. Industrial designer suggests that his specialty was conceiving interesting looking factories and stunning pipe fittings. But the term really refers to a designer of products and logos. Loewy made his name with sleek conceptions for locomotives in the 1930s, a refinement of the original contoured Coca-Cola bottle, and the logos for Shell, Exxon, and Nabisco. He also thought up the classic orange stripe that graces all U.S. Coast Guard vessels. In researching a design for *Air Force One,* Loewy came across the first printed copy of the Declaration of Independence, which featured "United States of America" printed across the top in a widely spaced typescript called Caslon. Loewy incorporated this distinctive historic font into the plane's design and, in a stroke, grounded its design in one of our loftiest documents.

On the way to his seat, Pete moves through the roughly 4,000 square feet of living space inside the plane. He passes the doctor's cabin with seats for the physician and nurse who always travel with the President. He explains that this cabin can be quickly converted into a full operating room, no doubt a reverberation from the events that prompted Stoughton's historic photo on board an earlier version of *Air Force One.* Farther aft, there's one of several bathrooms and a cabin for senior staffers with four, first-class–size seats that face each other in the form of an *X.* Everyone on the plane has an assigned seat, designated by a printed card on the armrest.

A little farther down the hall, toward the rear of the plane, is a full-size conference room with a giant-screen TV and a large conference table surrounded by big chairs that swivel, though they are fixed to the floor. The presidential seal is a popular form of decoration on the plane, adorning even the buckles on the seat belts.

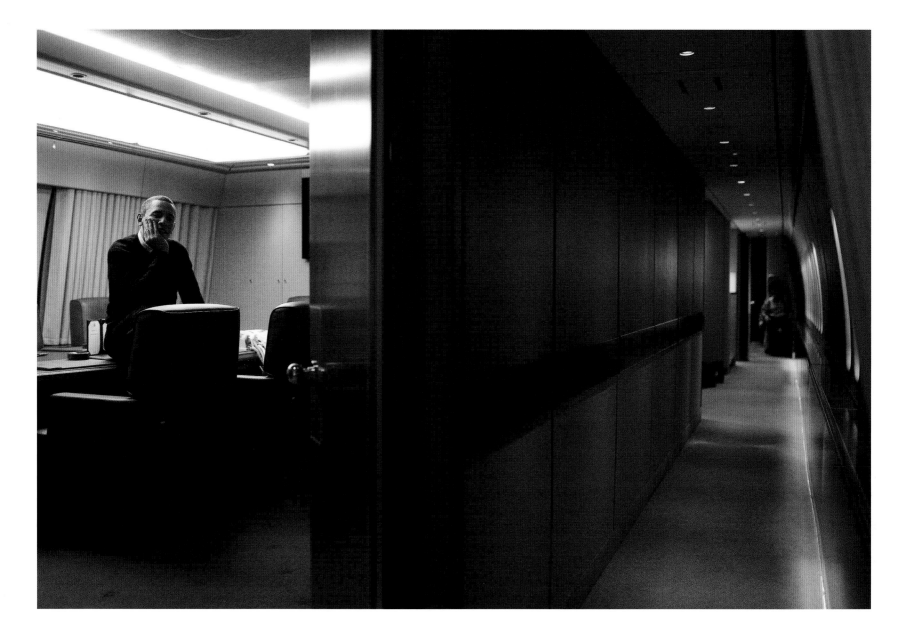

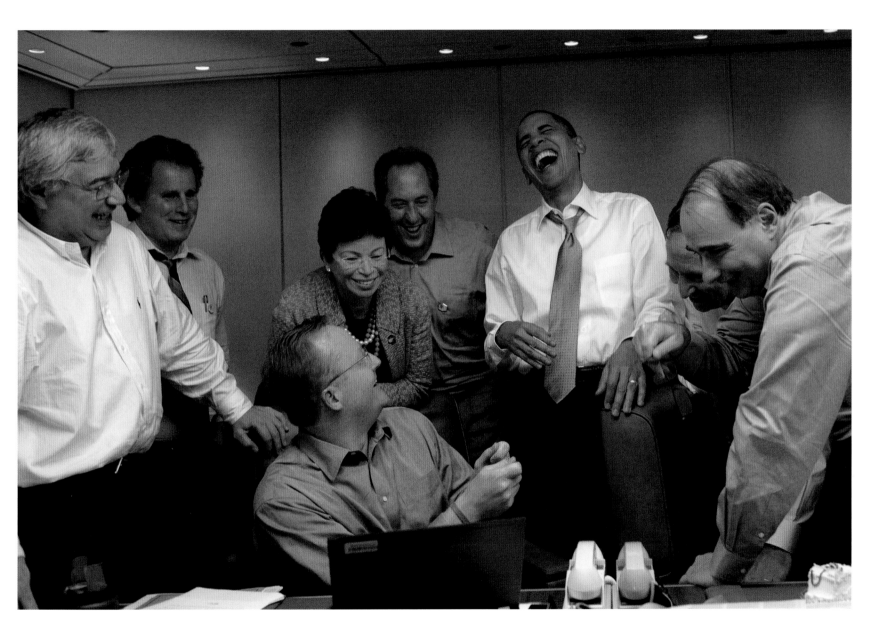

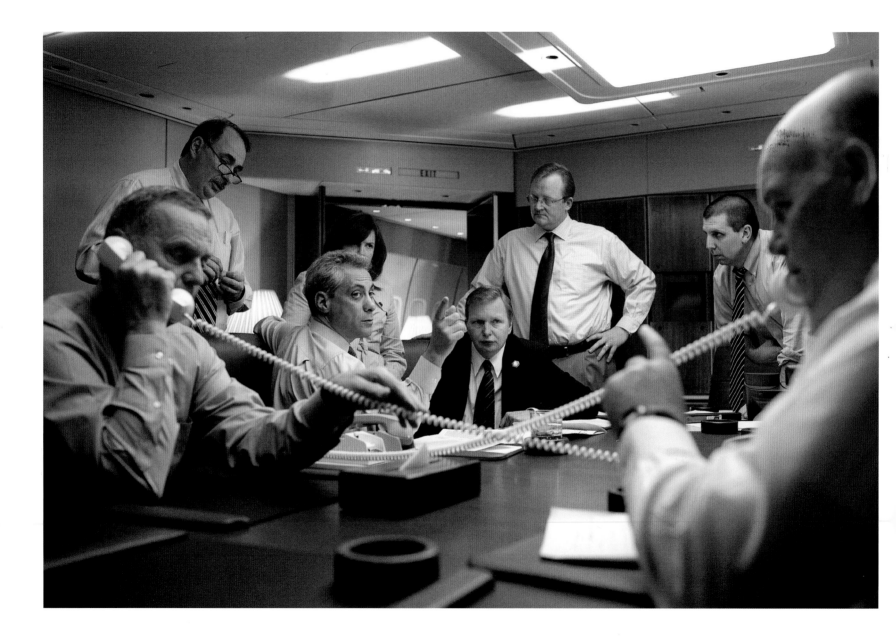

Pete comes to the staff cabin, roughly 14 seats, 8 of which face each other across a table, and finds his place card: "Mr. Souza. Welcome Aboard Air Force One." Beyond this cabin, there is a large galley—the crew can serve 100 people at a time—a cabin to carry about 16 guests, a cabin for the Secret Service detail, and, at the back of the plane, a cabin for the working press traveling with the President. There is a separate entrance at the back. The plane can carry approximately 70 passengers and a crew of 26.

Pete settles into his seat, nibbling on grapes cadged from a fruit bowl nearby, and starts prepping his cameras. At the White House Pete is often hard-pressed to find the time to eat. It's the opposite on *Air Force One*, where the kitchen is always open and where, along with bowls of fruit, there are small boxes of red, white, and blue M&Ms, bearing both the presidential seal and his signature, always within reach. Because it's a small space, there's a more intimate feel here and the welcome is extremely warm. Pete talks over breakfast options and life with chief flight attendant Reggie Dickson. The avuncular Dickson knows Pete from way back and straightens Pete's tie as they chat—just part of the familial feel on board.

The President's cabin is toward the front of the plane and consists of two spaces. The personal quarters have two couches that can be converted into twin beds, a bathroom, and shower. There's a table and two big chairs. Nearby is his office with a large desk, a chair for a guest, and a long, slightly L-shaped couch.

Up the stairs from the main floor is the flight deck. Here the plane looks and feels like the military aircraft it is. The conditions are spartan, the decor aircraft-aluminum chic. The only apparent luxury here are bunks for the backup pilots and crew, though these look like what you'd expect on a submarine. The rest of the upper deck is dedicated to communications equipment. Looking down the long nose one sees an unexpected bump, part of the aircraft's midair refueling equipment. Like long-range combat bombers, *Air Force One* can take off and remain airborne almost indefinitely.

The design of the interior, though custom crafted, is understated, mostly dark wood and cream-colored carpet and leather. There is a preponderance of phones (over 80), computer screens, and TVs. The design objective seems to have been to take the essential parts of the West Wing and elegantly cram them into a 747. "*Air Force One* is a flying White House," said Eric Draper, President George W. Bush's

"The President's aides gathered in the conference room to make the final decision on whether to secretly head to Baghdad," Souza reported about this April 2009 moment. Tense minutes passed "as Gen. James Jones, the national security adviser [left], and Secret Service agent-in-charge Joe Clancy talked on different phone lines to their representatives on the ground."

Pages 70–71: Air Force One allows the President to project American power across the world. President Obama, press secretary Robert Gibbs, and National Security Council chief of staff Mark Lippert glance out the window on Air Force One's arrival in Cairo, June 4, 2009 (left). About a month later, the President and First Lady Michelle Obama, along with Malia and Sasha, depart amid great fanfare at the airport in Accra, Ghana, July 11, 2009 (right).

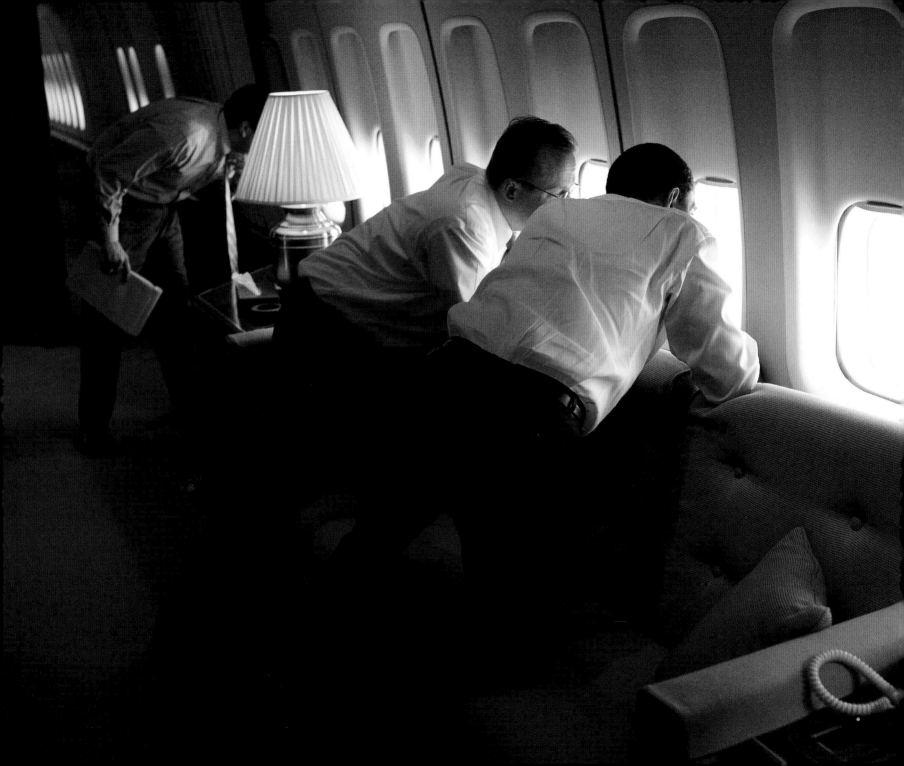

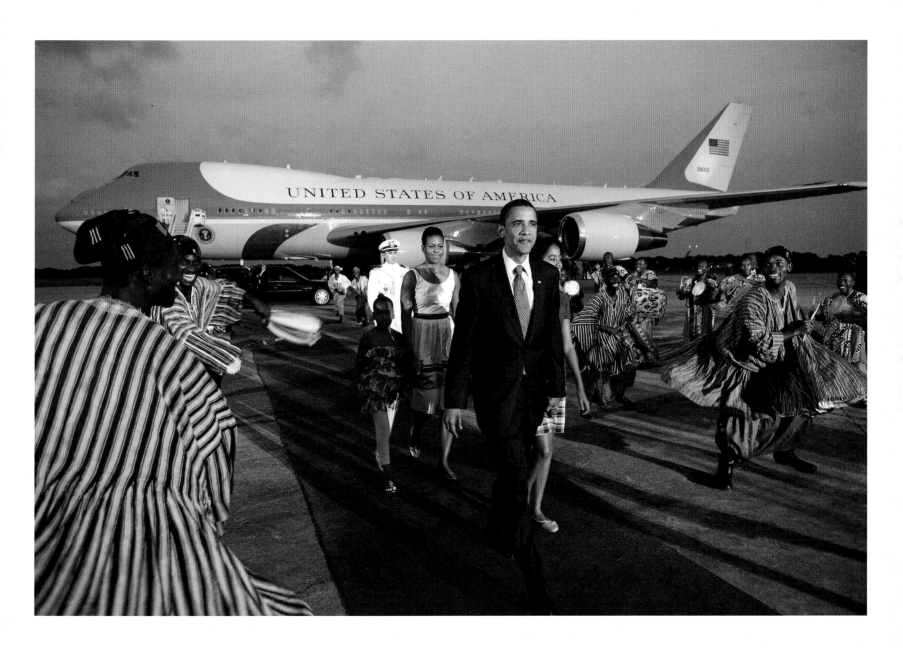

photographer. "Conference rooms, and computers, Internet, everything's on the plane. It's almost like you're not even flying. It's like you're in an office and all of a sudden you show up in China."

Today, the flight will be shorter. Before the President arrives at Andrews for the trip to New York, Pete has a chance to read the paper and carouse a little with the trip director, Marvin Nicholson, and the personal assistant to the President, Reggie Love. Marvin and Reggie are both huge—somewhere over six five—and in fact, both are regulars on the basketball court with the President. Reggie, a member of the 2001 NCAA championship Duke Blue Devils, first came to work for Senator Barack Obama as an intern in 2006. As the personal assistant to the President, also known colloquially as his "body man," he takes care of all the little things the President may need—a pen for an autograph, a snack, gum, a coat. When people hand things to the President, they're immediately handed off to Reggie. He also serves as a kind of walking notepad should the President want to remember a key detail about a guest or person he just met. Consequently, Reggie probably spends more waking time with the President than anyone, including the First Lady.

Marvin, who helped manage Senator John Kerry's campaign trips in 2004, is the President's trip director. The person in this position is kind of like a personal travel agent for the President, managing the practical aspects of the President's travel itinerary and ensuring he's in the right place at the right time. To do that, Marvin also has to make sure that everyone traveling with the President is also in sync.

On *Air Force One*, Pete stays in close touch with Reggie and Marvin to know if the President plans to come back into the staff cabin or to say hello to a guest, often a congressman or senator who may have been offered a ride on the plane as a courtesy. But typically, being in touch with Marvin and Reggie quickly devolves into kidding banter. Today they are discussing how Pete's wardrobe has improved since Pete's girlfriend got involved.

"There was a point in time where he was still buying his ties, but she's now started to pick out more of his ties. It's totally stepped his game up," Reggie explains, then adds a little context. "Obviously we're not as well dressed as the East Wing staff," referring to the part of the White House where the First Lady's staff is based, "but, you know, we want to have a good image over in the West Wing."

★ ★ ★ It's the antithesis of modern air travel—there's almost no delay. Over the course of multiple interviews with former presidential photographers, without fail, every one of them mentioned that one of the things they missed most after leaving the job was flying on *Air Force One*.

But for all the ribbing Pete gets, and he's long-suffering in this category, they have a kind of mutually beneficial relationship. Pete relies on Marvin, and especially on Reggie to know what the President's next move might be—not so much in terms of the official schedule, but what you might call his "informal schedule." For Pete, keen to capture the things that happen in the less structured, more revealing parts of the President's life, this information is gold, and Reggie has a lot of it. "He probably knows what the president is going to do before anybody, especially on the weekends," says Pete. "Sometimes you have to beat it out of him, but he knows the president probably better than anybody, in terms of his daily moods and his daily schedule. So he is such a good resource. He is a great guy."

On the flip side, Pete's experience comes in handy on a daily basis, but especially when they are all on the road.

"He's traveled so much, he's dealt with so many foreign governments," Marvin says, "like when we were in Moscow and you know, we make all these plans and agreements [with the Russians] and everything before we get there, and then when we get there, everything always changes. When all of us get held up, Pete has this ability where he just somehow goes around the whole thing and gets us in."

Just then, the PA comes alive: "Attention on the aircraft, the President is five minutes out." Pete, whose job depends on timing, is on this one. "See, but, two minutes ago they said he was ten minutes out. So, the math just doesn't add up," he says, feigning upset.

"That's right!" Marvin says, getting Pete's back.

As the President's arrival gets closer, there's a slight uptick in the sense of excitement on board. Pete heads to the front of the plane and walks out the main door. From the height of the stairs he scans to see if there's a crowd but finds none, so Pete knows the President will likely go straight onto the plane. He heads down

Page 74: "Family dinner is usually private time," says Pete. "But I heard they were having dinner atop their hotel in Moscow, which overlooked the Kremlin," an unprecedented combination.
Page 75: The windows of Air Force One *frame both President and the Air Force officers seeing him off from Andrews as he heads to a summit of North American leaders in Mexico in August 2009.*

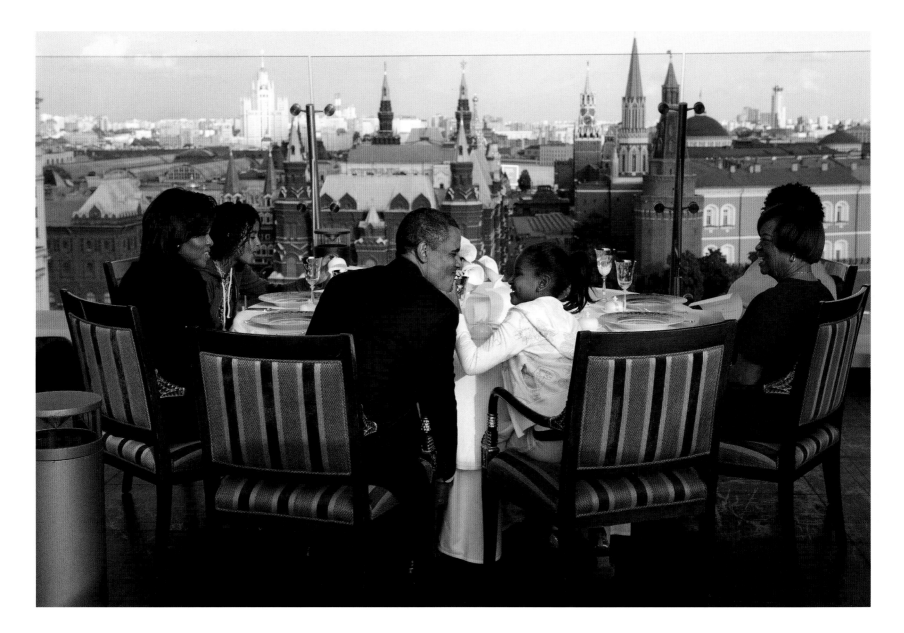

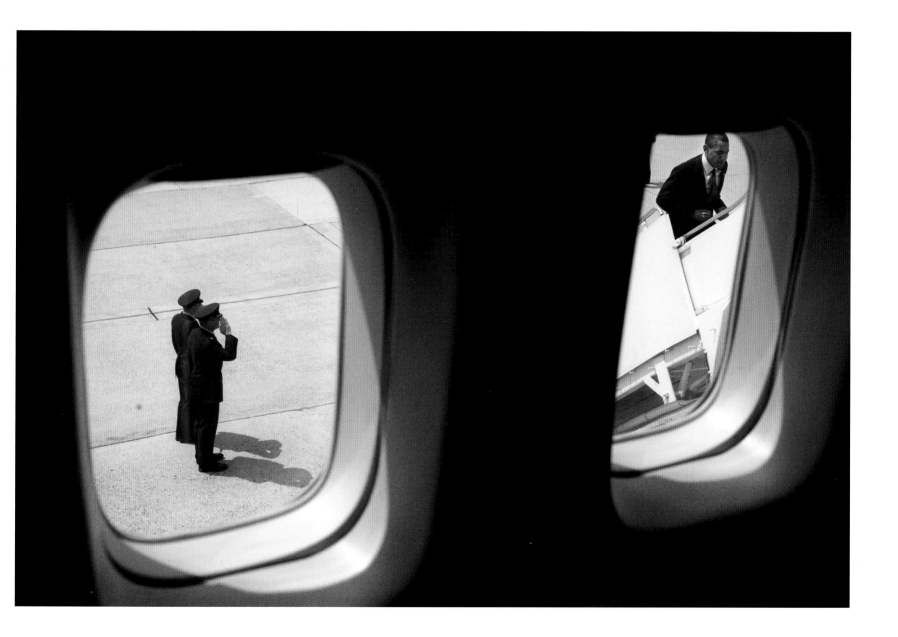

the red-carpeted stairs to the tarmac to wait for the arrival of *Marine One,* the official presidential helicopter.

As two Marine helicopters circle to the south—there are always two, one a decoy, one carrying the President—Pete spies a Secret Service agent he knows and walks over. Just like when Pete worked as a photojournalist, it pays to see everyone as a potential source and from this agent Pete learns that the OTR—the off-the-record stop on the schedule—is actually going to be a lunch with former President Clinton in Little Italy. With that nugget stowed, Pete knows what to be ready for.

Meanwhile, *Marine One* has landed and is taxiing toward *Air Force One.* When the chopper stops, the President emerges, greets the Air Force general there to meet him, and walks across the tarmac to the plane. He salutes the airmen and officer at the foot of the stairs and up he goes. Pete is on his tail. Once inside, Pete works his way back to his seat. Less than three minutes after sitting down, the plane is taxiing to takeoff.

This is one of the most striking things about flying on *Air Force One*—it's the antithesis of modern air travel—there's almost no delay. Over the course of multiple interviews with former presidential photographers, without fail, every one of them mentioned that one of the things they missed most after leaving the job was flying on *Air Force One.*

During the short flight Pete hangs in his seat. Because there are no VIP guests on board, the President is unlikely to walk back. Pete's chooses not to hover outside the President's cabin, but instead gives him space. Over time he's developed his own guidelines for how to approach the President.

"The only restrictions are really trying to let him have some privacy," he says. "So if he's in a holding room and there's not really much going on, I'll probably step out. Last week, he was in a holding room and there was a nice picture of him with Senator Brown from Ohio. You know, that was sort of a nice situation, so I stay in for those kinds of things. But if he's just hanging out, or is eating lunch, you know, I just step outside the room. And that's just common sense more than anything." Pete's not just being polite, he's exhibiting a savviness of presidential life gleaned from experience and his sense of propriety. Everyone wants a piece of the President. That leaves precious little time where he's on his own, time when he can just think. This sensitivity has allowed Pete to develop a remarkable rapport with the President, without which he couldn't do his job. ★

President Obama talks with veteran Air Force One *flier Secretary of State Hillary Rodham Clinton en route to France in April 2009. While First Lady, Secretary Clinton logged hundreds of hours on the plane.*

Page 78: Presidents since FDR have used aircraft to meet the world and especially to engage on issues of international security. President Obama works with senior advisers in preparation for meetings in Cairo, Egypt, in June 2009. Page 79: LBJ met with his advisers—including Admiral John McCain, Senator John McCain's father—on board an earlier version of Air Force One *roughly 40 years earlier in 1968.*

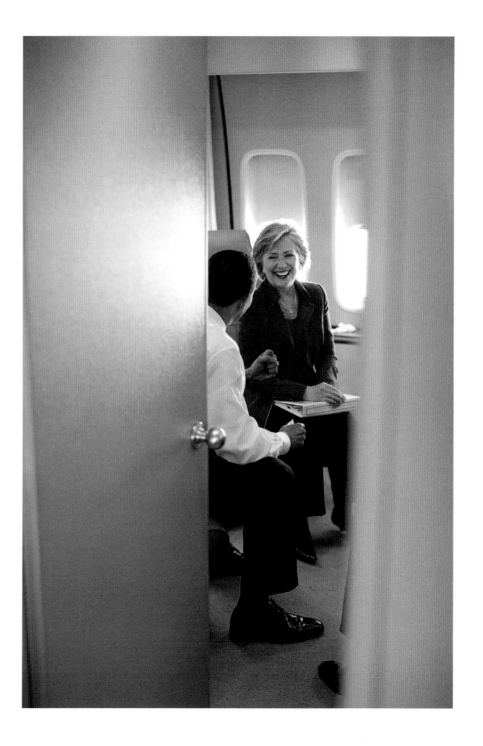

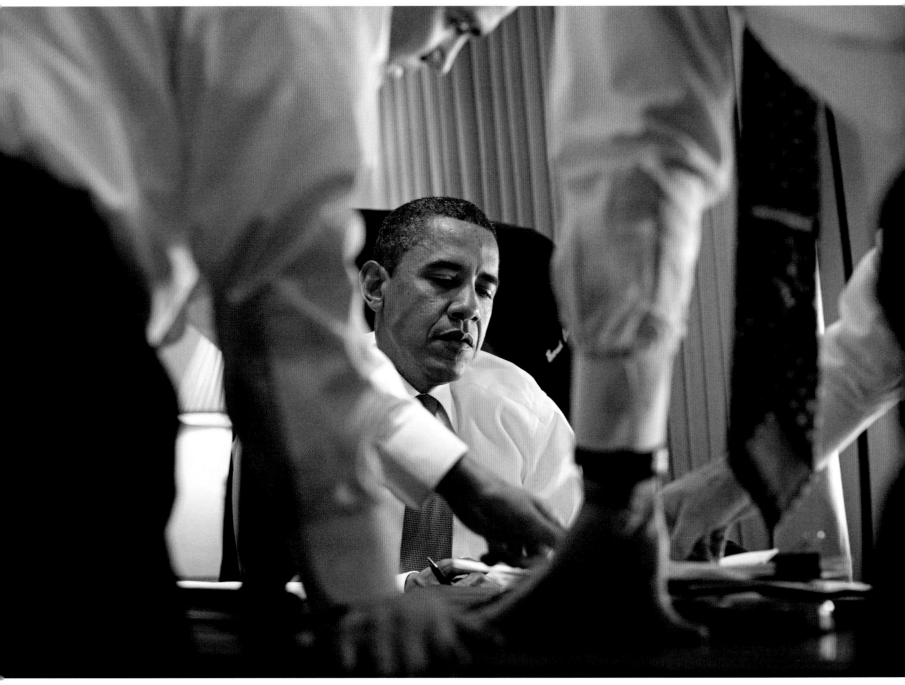

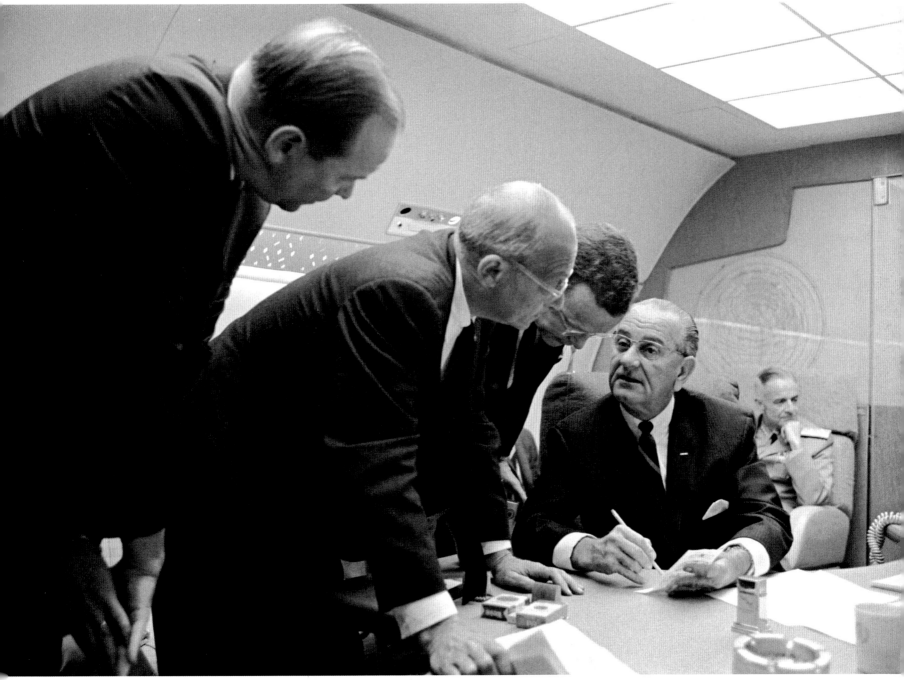

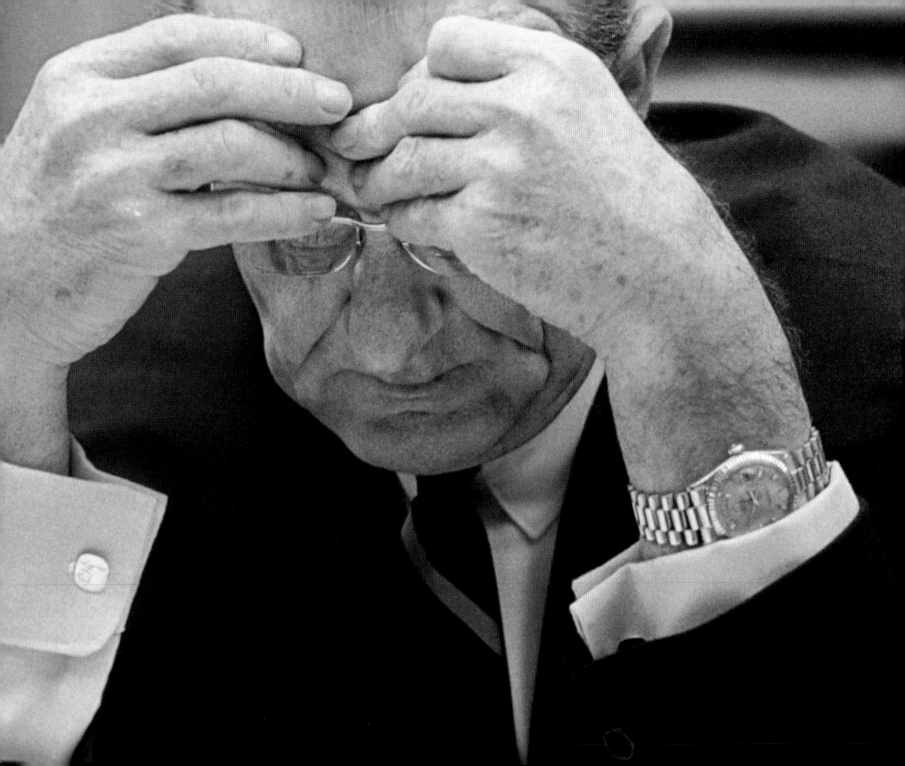

"He was the first person who had basically unfettered access to Johnson's Presidency. Oke didn't work for anyone except the President."

— MIKE GEISSINGER

PART TWO | *The Relationship*

On the fifth of January 2005, the *Chicago Tribune's* national photographer, Pete Souza, was on assignment covering Senator Barack Obama's first day in office. On that day, he began developing a relationship that would come to fruition almost exactly four years later.

The type of relationship a photographer has with the President is a major factor in determining the flavor of the coverage. Style and technique impact the quality of the images, but if you can't get close, you can't get the images to tell the story. And to get close, you have to have a relationship based on trust.

"I think both he and Robert Gibbs (the senator's press secretary) learned that they could trust me, in that they let me photograph in behind-the-scenes-situations, meetings," says Pete. "I tried to do it in an unobtrusive way, but it was also that I didn't share anything that I overheard—I didn't share that with a reporter."

So he was discreet and he was good. Pete has explained that he felt like Obama was "one of a kind" and he appealed to both Gibbs and the senator for further access, saying that he was shooting this for history. Whether they bought that or not, it does have a certain irresistible appeal for a politician. And Obama liked the work Pete was doing, once complimenting him on some images he'd taken of the Obama daughters, Malia and Sasha, and asking for copies. Pete was happy to oblige.

He produced a 2008 book called *The Rise of Barack Obama* based on that early coverage, shot mostly from 2005 through 2007. Souza could see, perhaps more than most photographers, a dramatic "before" and "after" appeal. A number of these images were interesting on their own, but they would take on a lot more meaning three years and a presidential election later. In one, a line of prominent politicians appears

Photographer Yoichi Okamoto accompanied Lyndon Johnson on two trips to Germany when he was Vice President, winning Johnson's respect by way of his discretion and talent. Okamoto had a remarkable ability to make photographs that put you right at the table with the President.

★ ★ ★ In one, a line of prominent politicians appears in half profile, with President George W. Bush in the pull position, closest to the camera in the right foreground. Obama is last in the line of faces, left background, and he's looking down the line toward the President with a mysterious expression, a look that might make you think twice about challenging the man in poker. Pete clearly saw some kind of tell.

in half profile, with President George W. Bush in the pull position, closest to the camera in the right foreground. Obama is last in the line of faces, left background, and he's looking down the line toward the President with a mysterious expression, a look that might make you think twice about challenging the man in poker. Pete clearly saw some kind of tell.

Pete got back in touch with the senator's office in 2008, after spending time teaching photojournalism at Ohio University. Hired after the election, Pete has spent a significant percentage of the President's waking hours in his company. "I think at this point Pete and I are like an old couple. We sort of know each other," the President says. "He's seen me on difficult days, he's seen me on happy days. He has gone with us when my family takes trips and has gotten to know Michelle and the girls and so Pete really does feel like part of the family."

Pete's experience in covering Senator Obama in 2005 and 2006, including visits to seven countries such as South Africa and Russia, was invaluable in setting the stage for his second turn as an official White House photographer. It gave the President and some of his closest advisers a chance to get a full measure of what kind of guy Pete was. The same pattern—working with a man who is not yet President—has been a feature of several other presidential photographers, including the man widely considered the best, Yoichi Okamoto, chief photographer to President Lyndon Johnson.

Born in Yonkers, New York, in 1915 and a graduate of Colgate University, Okamoto was a photographer with the U.S. Army Signal Corps in World War II. He followed Gen. Mark Clark through Italy, ending up with

Pete Souza, like Okamoto and other presidential photographers, had a chance to develop a rapport with future President Obama by covering him extensively before he became President. In this image, Souza catches the future President glancing down the row at the then current President, an inscrutable expression on his face.

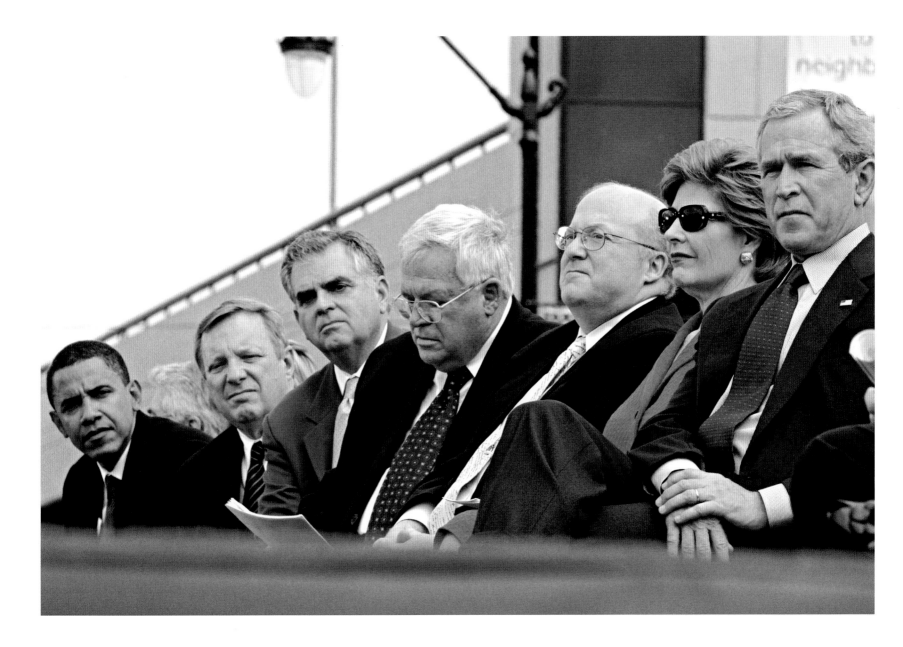

President Lyndon B. Johnson's official photographer, Yoichi R. Okamoto, photographed at home in January 1968, just as Johnson was leaving office. Unflappable, Okamoto was once fired by Johnson but continued to photograph the President even as he was letting him go. He was rehired several months later.

the general at the end of the war in Vienna, where he worked for the United States Information Service.

In 1961 Okamoto covered Vice President Lyndon Johnson on an official visit to West Germany. Johnson was so impressed with his work that he invited Okamoto to photograph several other trips, where he developed a sense of trust in Okamoto. When Johnson became President, Cecil Stoughton, JFK's photographer, was still on the job. According to the book *Eye on Washington*, by legendary Washington photographer George Tames, LBJ wasn't happy with the coverage. Tames describes a scene in the Oval Office when LBJ was working through a stack of pictures made by Stoughton. Those he liked, he placed on his desk. The rest he flung to the floor, which was covered with discarded pictures. "Goddamn it!" he exploded, "Why can't they make good pictures of me like they did with Kennedy?" Then he yelled at Andrew T. Hatcher, the associate press secretary, "Get me that Jap photographer!" Okamoto, then the director of photography at the United States Information Agency, was summoned to the White House, where Johnson asked him when he could start. Okamoto explained that he had his cameras outside.

Okamoto, who went by the diminutive "Oke"—pronounced o-kee—seemed to take Johnson's derisive style in stride. Johnson famously despised the official portrait that painter Peter Hurd had done of him and the President's feelings were widely published in the press. "A couple of weeks after that I sent some of my pictures up to him," Oke explained in a 1970 slide show for the National Press Photographers Association. "And he sent one of them back [saying,] 'It's the worst picture of me I've ever seen, except one.' And I sent a note back: 'I'm still the best damn Japanese photographer you have on your staff.' "

Upon taking the job, Okamoto told Johnson that his goal wasn't simply to make portraits but also "to hang around and try to document history in the making." Rare motion picture footage of Okamoto at work in the Oval Office shows a man of about 50 with two Nikon camera bodies doggedly working the room. This was unprecedented. JFK allowed Cecil Stoughton to cover briefly some meetings, but he always held a tight rein. According to Stoughton, JFK listened for two clicks—then considered that enough. That was often followed by "a nod of the presidential head," which meant leave.

Mike Geissinger already knew of Okamoto's reputation for extraordinary coverage when he came to work as his assistant. A 23-year-old private in the Signal Corps, Geissinger quickly learned that Oke's

coverage relied on a direct line to the source. "He was the first person who had basically unfettered access to Johnson's Presidency. Oke didn't work for anyone except the President. He didn't work for the press office, he didn't work for the special assistant to the President, his secretaries, or anyone else. Oke was able to walk into the Oval Office when he thought or knew something was going on and begin photographing. And he would stay as long as he wanted."

Okamoto built on that access by developing a kind of invisibility, which, according to Geissinger, was a reflection of his personality and demeanor. "He wasn't an in-your-face kind of person, he was very laid-back; he was very quiet and I think that translated directly into his photography so that he was able to work in that unobtrusive manner. And quietly. I don't want to say behind the scenes, because he wasn't behind the scenes. He was right up front."

That meant, ultimately, the public was too. In 1966 the Reverend Martin Luther King, Jr., met with the President. In one Okamoto photograph, Dr. King is prominent in the foreground, the President, head in hand, is over his shoulder, out of focus. It looks as if Okamoto was sitting right at the table with them, part of the obviously intense conversation that centered on the potentially explosive civil rights move- ment. This kind of image places you right in the moment and brings the power of the meeting to the fore. There is a kind of political artistry at work as well—King is sharp and in focus, he's the power broker in this scene while the President is in the background and blurry.

President Clinton's photographer, Bob McNeely, agrees that the relationship with the President is an important factor in enabling coverage like this, but that in charged situations—and a good many presiden- tial meetings are electric—something else is at work. "It's amazing how much you can be involved in a situation without affecting it. You know, you think, Oh, I gotta stay back here against the wall of the room because otherwise I'm going to be in the middle of the picture. Well, it's not true. You can get out there and get close, and make good pictures and it's such an intense moment in what they're dealing with that they'll pretty much ignore you."

Still, you've got to be comfortable even being there. The Oval Office is an intimidating place and, ini- tially, making photographs there can be daunting. McNeely's baptism came when he was working for Vice

Okamoto explained that he had "trained" President Johnson not to see him. It paid off in images like this one taken of the President and Martin Luther King, Jr., in the Cabinet Room in March 1966, deep into a meeting about the civil rights movement.

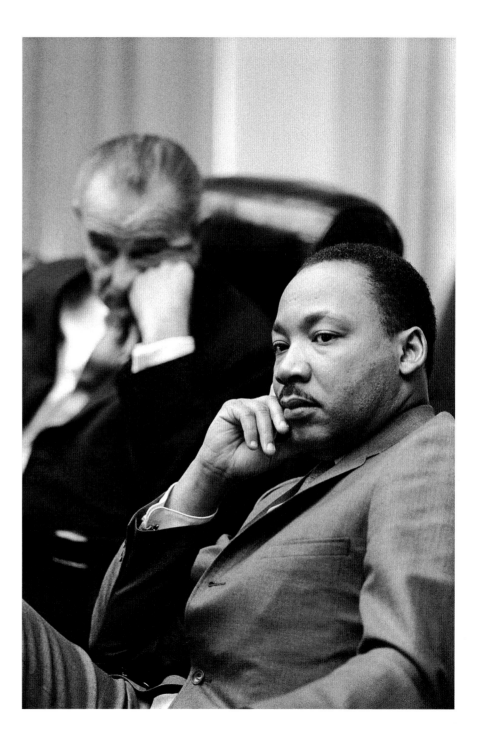

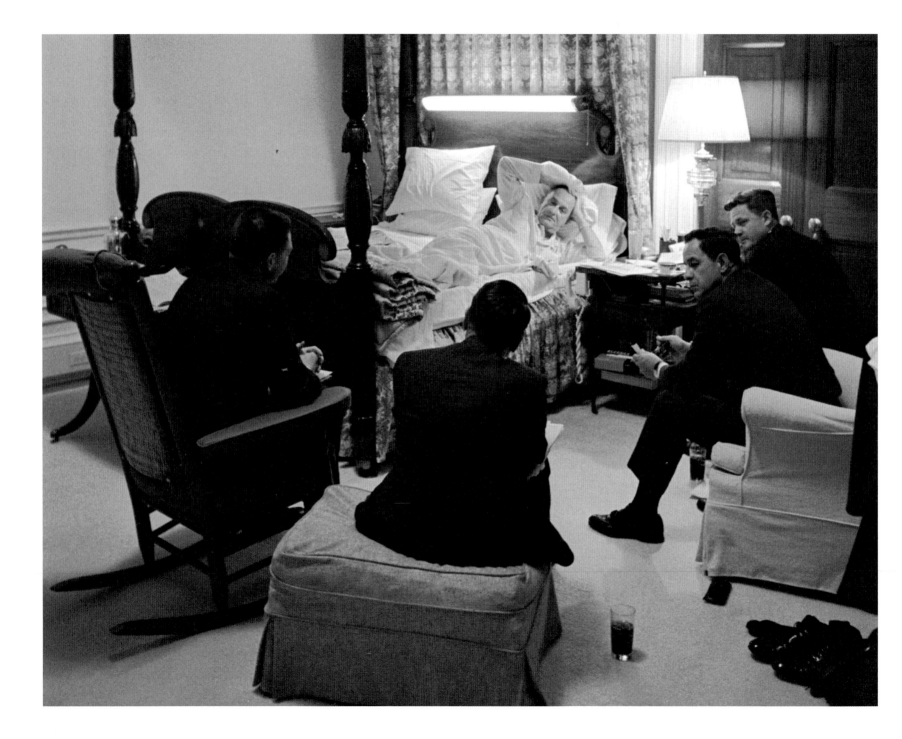

President Mondale, who took him to the Oval to cover a meeting with President Carter. "I walked in there and it was like my hands were shaking, the first time. I can literally still remember it, knees knocking, hands shaking, you know, trying to take the pictures, but obviously that goes away after a couple [times]." It probably helped that McNeely had served in the Vietnam War and had experienced intensity before. It's interesting to note that Stoughton, Okamoto, Souza, and Draper had all photographed in war zones and Ford's photographer, David Kennerly, won a Pulitzer Prize for his war coverage of Vietnam.

Whether it was his war experience or something else, Okamoto seemed to have the kind of steely quality required to get some of these images, a confidence that allowed him to be completely at ease in the presence of power. His sense of entitlement, tempered by a naturally unobtrusive demeanor, led to some of the most remarkable access and subsequent images in the history of White House photography.

Not that there weren't any problems. About three months into Okamoto's White House tenure, and on the heels of a series of news columns that claimed Johnson had spent $5,000 on photographs of himself in a single weekend, *Newsweek* reported that Okamoto was about to be named Johnson's personal photographer. LBJ was already upset with the situation and the *Newsweek* story about Oke put him over the top. According to George Tames's account, "Johnson fired Okamoto to prove the media wrong."

That resulted in one of Mike Geissinger's prized possessions. As he tells it, the President brought Okamoto into the Oval Office to tell him he was fired. Maybe it was just a reflex or maybe he thought it was just another moment of history that had to be covered, but after the deed was done, Okamoto couldn't help himself. "Oke didn't stop photographing. Johnson fired him and then he kept photographing Johnson, at which point Johnson put his hand up to his face and kind of looked at him this way. Okamoto made a wonderful photograph of Johnson, just after he fired him. That's gotta be my favorite photograph of Oke's. As a matter of fact, I have that one signed by Oke, because it was one of his favorites too."

Apropos of the Johnson Presidency, the story just gets better. In a brief essay on the topic, Joanna Steichen, the wife of legendary photographer Edward Steichen, recounted how her husband, who knew Oke, confronted Johnson about it. "Several months later, we were invited to tea at the White House. Steichen took advantage of his introduction to the President to tell him he had made a terrible mistake in

Being President has no set hours. Neither does being his photographer.

firing 'that young man.' I have a memory of Steichen grasping the lapels of Johnson's jacket, but this may be simply a visual translation of the force of his argument. 'Just think what it would mean,' Steichen concluded, 'if we had such a photographic record of Lincoln's Presidency.' Okamoto was rehired promptly." Whether the part about the lapels is apocryphal or not, it's delightful to imagine the 85-year-old artist giving Johnson the business he himself was so famous for dishing out.

According to Tames's account in *Eye on Washington,* when Johnson rehired Oke, he laid down the law. Tames said that LBJ told Oke "to keep his nose clean and to mind his own business and not to talk to the media and to always remember that the President had Oke's pecker in his pocket and could rip it out at any time and throw it to the dogs."

For all the bravado, Johnson undoubtedly respected and, more important, trusted Okamoto. Still, Johnson ultimately rehired Okamoto to service his legacy, to satisfy his ego. Being compared to Lincoln has to be heady stuff for a President.

Clearly, the essential component of any photographer-President relationship is the President's understanding of history and his willingness to gamble that photographs will help him come out on the right side of it. If that sounds naive—perhaps that should be, If that sounds naive *for a politician*—then it has to be tempered by knowing that Johnson had total control over the release of any photographs taken by Okamoto and his staff. For every chief photographer since Okamoto, the President's press secretary or the communications director has been doing the vetting. But in the Johnson White House, it was the President himself who reviewed and signed off on every single photograph released.

Copies of these sign-off sheets, kept at the LBJ Library at the University of Texas at Austin, reveal a President fully engaged in the process. It was a recognition on Johnson's part that he was giving Okamoto unprecedented access and that he was aware of how compromising some of that coverage could be, if released to the press. History was one thing, current press coverage quite another. So Johnson was hypervigilant.

When there was a request for a photograph, it was included in the President's evening reading that was sent up to the residence for his review. Okamoto would present an image with a one-line explanation

The President had a wonderfully expressive style, at least if you were a photographer. Here, Senator Richard Russell of Georgia, who was not a supporter of the Civil Rights Act, gets a better understanding of the President's position.

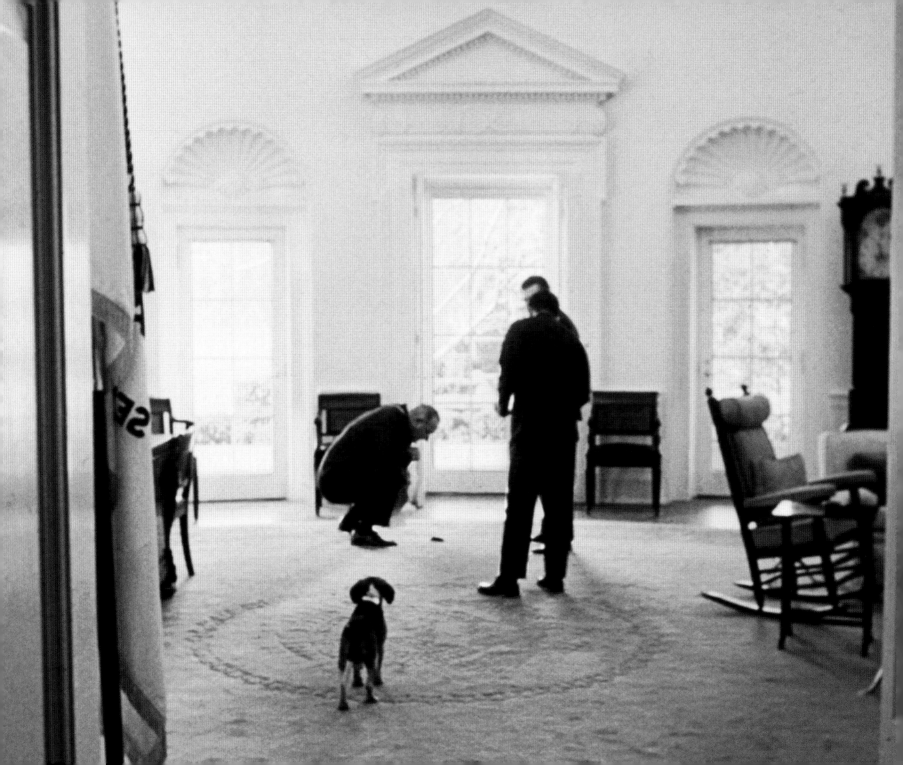

explaining who wanted the picture and for what purpose. At the bottom he'd conveniently provide two options: approve or disapprove. For a portion of the year 1966, archives records show that Okamoto's approval percentage is pretty high. From a sample of 21 requests involving a couple hundred photos, the President approved 17—so Okamoto seemed to have a pretty good sense of the President's sentiments. What's remarkable in these records is the evidence of the close attention Johnson paid to the release of photographs. On August 17, 1966, shortly after the Johnsons' daughter Luci was married, Oke writes, "May I have your permission to send copies of the wedding coverage to Mrs. Johnson for the following albums: Luci and Pat, West Sitting Room, The Nugents." Even Lady Bird was not exempt! The President had been explicit with Oke—*every* image had to be approved by the President for, as one draft memo to the White House photo staff made clear, "All pictures taken by Mr. Okamoto are considered to be the personal property of the President."

If Johnson's caution seems extreme, perhaps we are the richer for it. He revealed himself as few other Presidents have and was far too savvy a politician to have allowed that to happen unless he knew that he could control that content—at least when he was alive. As a consequence, the photo record of Johnson, the man, is unparalleled in its variety and detail. In one dramatic image taken in the Oval office, Oke captures Johnson at his most persuasive as he utterly invades the space of Senator Richard Russell of Georgia, who was strongly opposed to the civil rights movement. In that moment, the President is towering and leaning over the shorter man, inches from his face. You're certain that Russell knew not just where Johnson stood on the issue but exactly what the President had had for lunch.

Still, as Oke put it, "He was a very human guy," and the photos reveal an earthy man comfortable on the ranch, even when he was in the Oval Office. One day Okamoto happened to capture the moment just after Johnson's dog had desecrated the Great Seal of the United States on the carpet in the Oval Office. Oke's shot shows the rancher cum President looking down at the deposit, preparing to investigate the stool for worms. Only a trusting relationship between President and photographer would have allowed for that kind of truly comprehensive coverage. ★

Okamoto was unflinching in his coverage of the earthy LBJ. He had to be—whether showing reporters a scar, conducting interviews from the toilet, or, in this case, examining an illicit deposit from his dog, Yuki, on the Oval Office carpet, life with Johnson was unpredictable.

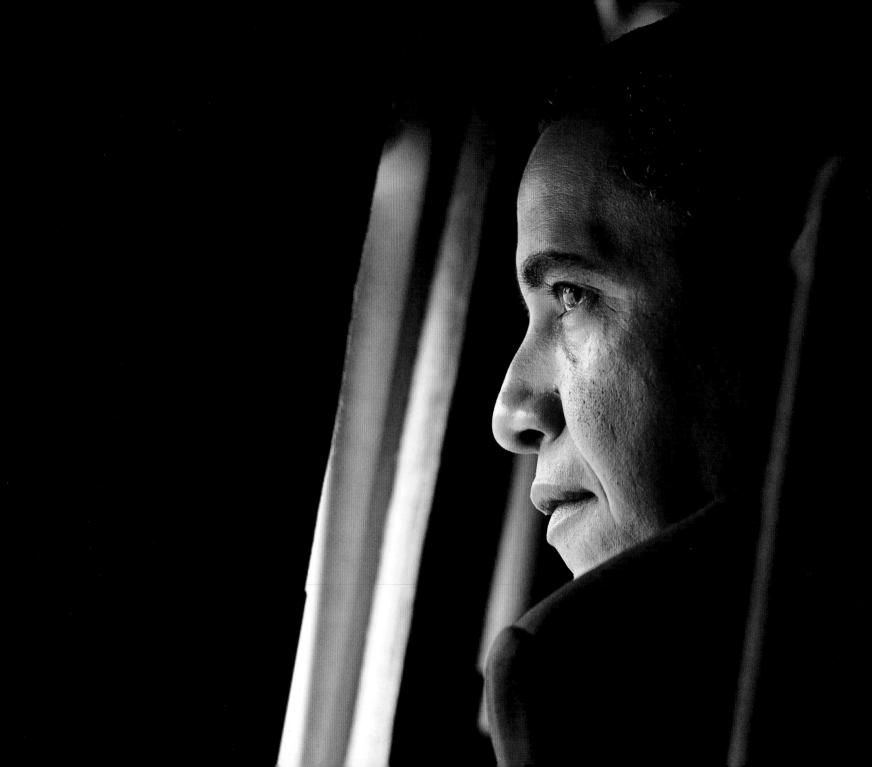

New York Road Show

PART ONE: *Moving in the Bubble*

PART TWO: *Getting Invisible*

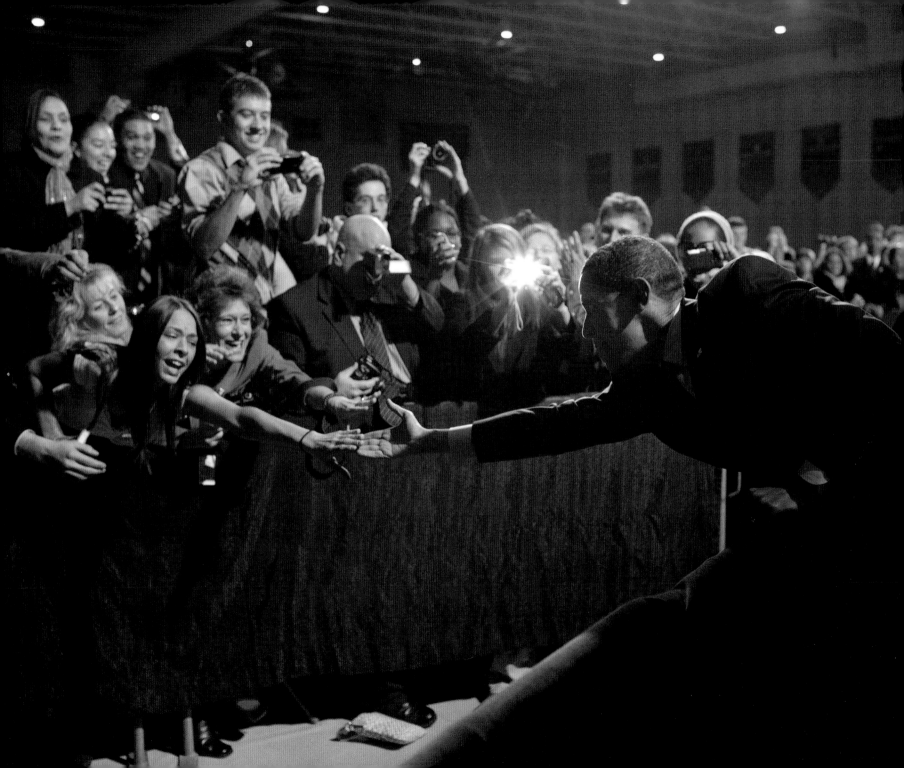

> **"**We call [it] the 'grip and grin' and my job is to get it in focus and make sure it's a halfway decent photo, because that's their one chance to meet the President— so you don't want to screw that up.**"**
>
> —PETE SOUZA

PART ONE | *Moving in the Bubble*

10:40 A.M. On the ground at New York's JFK Airport, Pete walks from the rear entrance of *Air Force One* across the tarmac toward the front of the plane, waits for the President to exit, snaps a few shots when he does, then turns and starts walking quickly toward a couple Marine CH-47 Chinook helicopters waiting a few hundred yards away.

To make the journey from JFK to Manhattan for this morning's speech, the President will board a Marine helicopter almost identical to the one he left the White House in. Like the plane, *Marine One* is so designated only when the President is on board.

Pete and most of the staff traveling with the President will precede him on these twin-engine choppers, troop carriers whose interiors have been only slightly modified to carry people in suits. Padded walls reduce the noise, but the Marines also provide earplugs, which are perfectly placed on top of each seat belt. Everyone boards through a ramp at the rear, works their way to the front, and then sits down on two benches that run the length of the fuselage, facing each other. Big, circular windows momentarily frame *Marine One* before it lifts off with the President.

Pete slides in about midway down the bench and puts in his earplugs as the engines spool up. There are about 12 people on each side. To Pete's right, toward the front of the cabin, it's mostly staffers. On his left are six Secret Service agents who are so big, they actually look like the bench for, say, the Minnesota Vikings defensive line; heavily muscled and even more heavily armed, these agents form part

Pages 94–95: President Obama looks out the window of Marine One *as he leaves the U.S. Naval Academy commencement ceremony in Annapolis, Maryland, May 22, 2009.*

President Barack Obama reaches out to greet members of the audience following remarks at Lehigh Carbon Community College in Schnecksville, Pennsylvania, December 4, 2009. For Pete Souza, who has shot hundreds of the President's speeches, the story "is in the faces of the crowd."

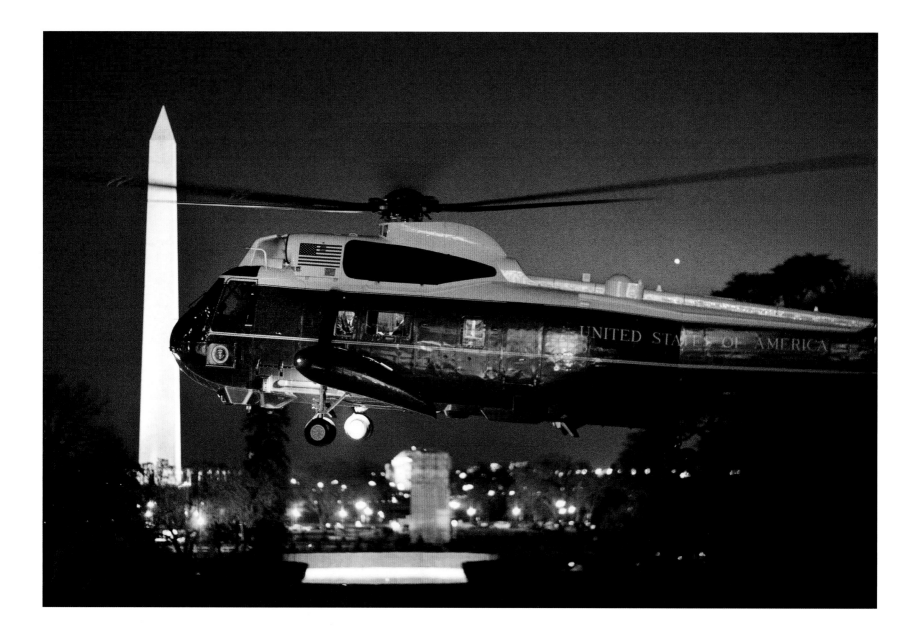

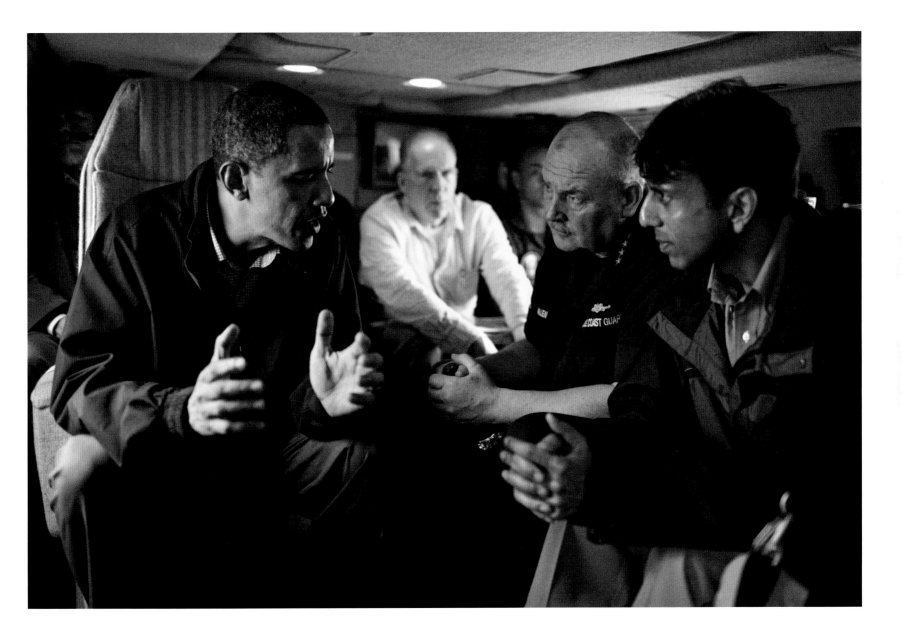

★ ★ ★ Most members of the President's Secret Service detail are pretty subtle. . . . But there's no missing the CAT team, nor their intentions should you make a wrong move toward the President. That's sobering because you realize it's necessary. At the same time you can't help but be impressed—they reek of competence and the phrase "bad ass" just keeps coming to mind.

of a specialized detachment called the CAT team. Wearing SWAT-type fatigues and carrying suspiciously long, black gym bags, each agent's shirt bears a circular patch with a hawk's head in the middle. In an arc above the hawk's head, it reads "U.S. Secret Service," below, "Counter Assault Team"—CAT. That explains the bags. Protruding out of one is the ominous butt of some type of hellacious weapon.

Most members of the President's Secret Service detail are pretty subtle, identifiable only by the transparent, corkscrew cords connected to their earpieces and the occasional, furtive moments when they talk into their wrists. But there's no missing the CAT team, nor their intentions should you make a wrong move toward the President. That's sobering because you realize it's necessary. At the same time you can't help but be impressed—they reek of competence, and the phrase "bad ass" just keeps coming to mind.

A marine wearing a flight suit, helmet, and dark goggles stands at an open door in the front of the cabin. Behind him, through the door to the cockpit, the helmeted heads of the pilot and co-pilot occasionally bob into view. It looks like the military mission it is, tempered somewhat by the hanging garment bag marked "The President," which moves a little in the wind coming in the door. When everyone is boarded and the equipment loaded, the marine reports into his mic and the chopper then lifts off.

Looking aft, the rear ramp is open and Long Island rolls out below. For anyone who has ever suffered the commute on the Long Island Expressway, you realize that there cannot be a simpler nor more secure way to get into Manhattan.

Pages 98–99: When the President moves outside of the White House, hundreds of support people move with him. Called the bubble, it's isolating but frees him to work, virtually nonstop. Staff photographer Chuck Kennedy catches the President reading as Marine One lifts off from the South Lawn of the White House (left). He meets with Louisiana Governor Bobby Jindal (right) and Coast Guard Commandant Adm. Thad Allen as they fly the coastline hit by the Gulf oil spill of early May 2010.

Trip director Marvin Nicholson looks out the window of a helicopter transporting White House staff to Osan Air Base (top), following President Barack Obama's official state visit to South Korea in November 2009. Staff learn to move in unconventional ways, such as exiting from the rear of a CH-47 Chinook helicopter (middle) and riding with a team of heavily armed Secret Service agents (bottom) known as CAT, the Counter Assault Team.

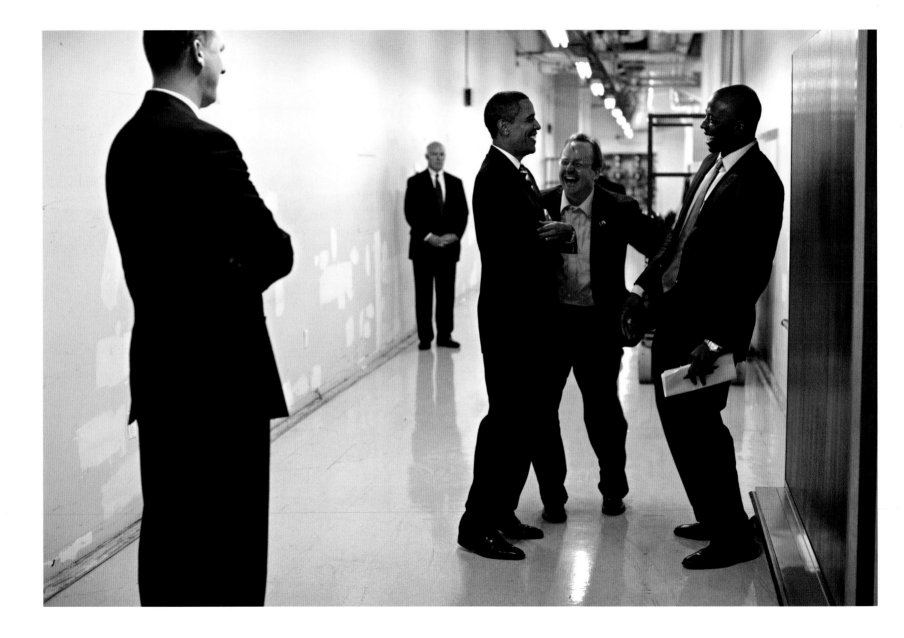

Pete checks over his cameras, then spends the rest of the short flight running the Photo Office from his Blackberry. The office doesn't just take the photos, they make sure copies get to the people featured in them. "Actually the meat and potatoes of what we do is hand out pictures," says Alice Gabriner, the official White House photo editor and the deputy director of the Photo Office. "Each time the President shakes a hand, that picture gets sent to the person he's meeting with and that happens every single day, and there are a lot of pictures." Gabriner reviews around 50,000 pictures a month, in volumes fluctuating between 8,000 and 20,000 photos a week. Roughly 5 percent of that total is a greeting shot—some 2,500 pictures a month.

Photographs with the President are a kind of currency and every White House is smart to spend wisely. "On a trip like this he'll do a series of photos backstage, what we call the 'grip and grin,' " Pete explains, "and my job is to get it in focus and make sure that it's a halfway decent photo, because that's their one chance to meet the President—so you don't want to screw that up."

These "greets" have various purposes—most are political, of supporters or elected officials. But some have a far more practical use. Nothing is simple when the President travels and the administration and the Secret Service are dependent on numerous different groups to make the trip work. At some point during every trip, in addition to the images he makes of all the more prominent figures with whom the President will pose, Pete will also make pictures of the President with the motorcade drivers, first responders standing by, and then several images with local police leaders without whom the trip just wouldn't happen.

Taking the pictures is only the front end of the job. People can brag about having posed with the President, but it's all talk until they actually get the photograph. While reviewing the image, identifying the individual, and getting them the picture is tedious, it ultimately spares these people the humiliation of being called liars. "We're responsible for getting those photos to the right office in the White House," Pete says, "so the police photos go to the Secret Service. The political greets go to political affairs." Then these images are sent out in an envelope with a return address that says "The White House." Inside is an inevitably good picture with the President and at that point, a kind of subtle payback takes place, a less well-known but essential lubricant, critical for a successful presidential trip.

The President operates in such a crucible of intensity, a little levity is essential for survival. Here he shares a laugh with press secretary Robert Gibbs, center, and personal aide Reggie Love, at right, prior to a reception at Miami's Fontainebleau Hotel in October 2009. The President has worked with both Gibbs and Love since his days as a senator.

Pages 104–105: Souza's eye for detail helps give the public a better sense of moments in the President's day. Whether a toe mark indicating where the President is to stand for an event announcing the Recovery and Reinvestment Act (left) or a glimpse of the President backstage at Denver's Fillmore Auditorium (right), Souza is building a cumulative portrait of life as President.

★ ★ ★ Pete walks over to a fire truck and sets the stage for the next image. "You do a lot of waiting around. But the reason I want to be ready is last week when we were in New York, he went over and shook hands with all the firefighters. So you just never know what he's going to do," he says, scanning the sky to the south.

Over Pete's shoulder, out the oversize round porthole, the skyline of midtown Manhattan comes into view—not many people enter the city this way.

On the ground at the Downtown Manhattan Heliport, Pete walks over to a fire truck and sets the stage for the next image. "You do a lot of waiting around. But the reason I want to be ready is last week when we were in New York, he went over and shook hands with all the firefighters. So you just never know what he's going to do," he says, scanning the sky to the south. "So here comes the helicopter."

The twin Marine choppers approach, landing in a cloud of Manhattan dust. Firefighters hold helmets on, Pete braces his sunglasses, and everyone turns away from the prop wash. Standing only blocks from ground zero, it's hard not to remember another, profoundly dark cloud of dust—so it makes perfect sense that the best people to welcome the President to the city should be firefighters.

The President comes down the stairs and heads right to them—Pete walks an arc around the gathering, making pictures with each step. The firefighters give the President a navy blue T-shirt that says "Rescue 1 NYFD." He thanks them quipping, "This is gonna be my workout T-shirt. . . come on, let's get a picture!" Pete snaps a few. The President turns and wonders, "How many Jets fans here? Giants fans?"

The President finishes and Pete starts heading for his ride: "Now we have to run." The first of many runs today. The President doesn't wait. If you miss the motorcade you risk the ultimate punishment: You'll be frozen in post-motorcade gridlock, unable to catch up, and if you're Pete, you might commit the ultimate sin—missing a shot. Pete climbs into a 12-passenger van marked "support," joining trip director Marvin Nicholson and press secretary Robert Gibbs. It doesn't take long for the ribbing to begin. As the

With a seemingly endless slate of rallies and speeches, Pete Souza surprises with his fresh angles and ways of seeing the President. At a health care rally at the University of Maryland in September 2009, he gets the President entering the arena like an athlete before the game (opposite, left). At a town hall meeting in Belgrade, Montana, the President is framed by popular local footwear (opposite, right).

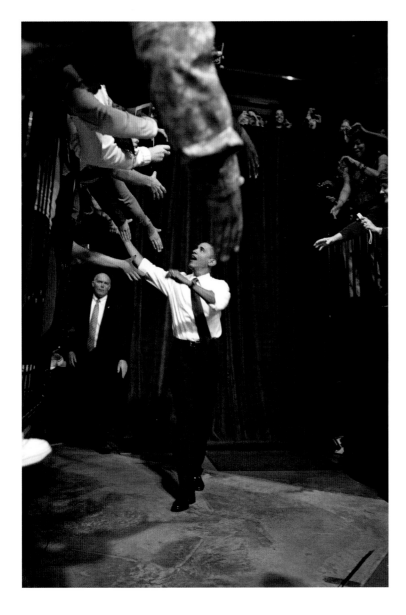
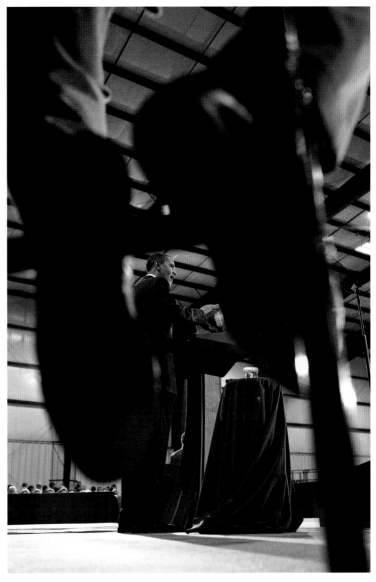

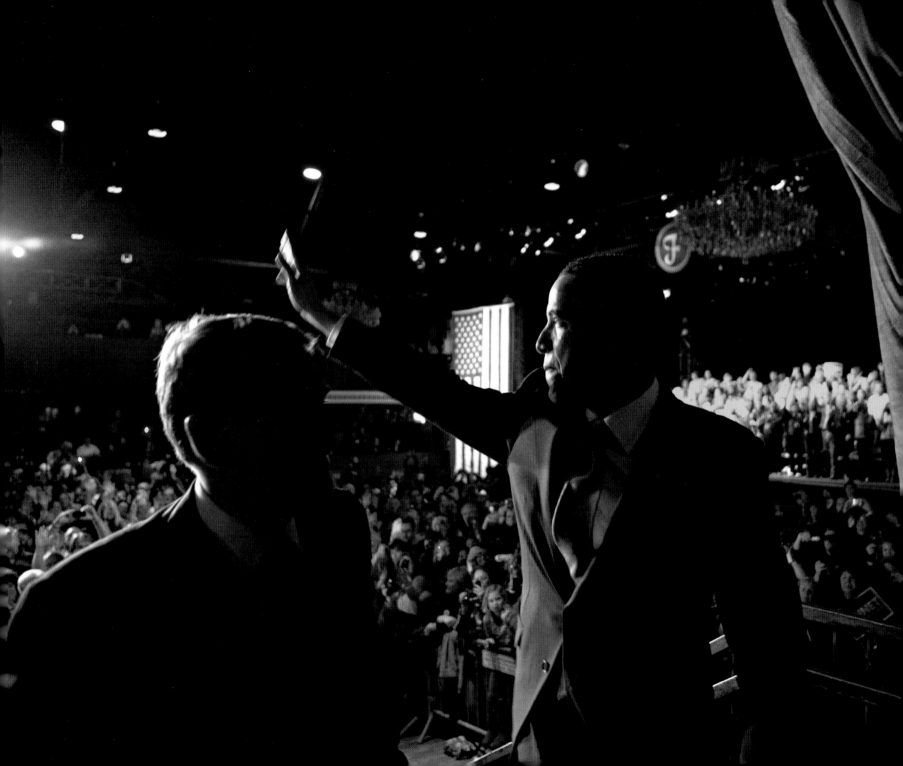

motorcade works its way through lower Manhattan's financial district toward Federal Hall, crowds line the route. Marvin observes in wonder: "It's amazing how many Pete Souza signs are being held up." Other voices pipe up from the back of the van: "They *love* him here!" Then Gibbs chimes in, "He's *huge* here." A little farther on, Marvin feigns an overheard conversation along the route: "His compositions—perfect!" Pete, always the subject of a certain amount of teasing, is being filmed for a National Geographic Special and the presence of a small film crew is provoking more than the usual dose. He visibly cringes from the attention. After all, this is a guy who makes his living by avoiding the limelight. But you also get the feeling that he gives as good as he gets, but, in a twist, has been defanged by the cameras.

The view out the windows of a car toward the rear of the motorcade reveals a curious presidential wake. There's a lot of excitement on the faces in the crowd; by now people have seen the President pass and are already talking with their friends, eagerly sharing the screens of their phone cameras. In the crowd, three teenage girls have been completely undone by having seen the President. In rapid-fire conversation, they explain the experience, freely finishing each other's sentences in the telling.

GIRL 1: "Me and her were walking and we saw flashing lights, so then we were like, Oh my God . . ."
GIRL 2: "It's Obama!"
GIRL 3: "I mean, I've always wanted to see him 'cause, you know, he's the President of the United States and stuff, so. . ."
GIRL 2: "'Cause you know like, oh my God, I got to see Barack Obama, you know, it's just. . ."
GIRL 1: "Awesome!"
GIRL 2: "Exactly!"
GIRLS IN CHORUS: "We saw Obama!"
GIRL 3: "*I* made eye contact with him."

As the motorcade approaches Federal Hall, Pete watches and listens to cues from the Secret Service driver. He opens the door before the van stops and, as soon as he gets the word, jumps out,

Pages 108–109: Rock concert or political rally? Or maybe a little of both. University of Maryland students (left) gaze at the President during a health care speech in September 2009, while the blur of the crowd at a fund-raising reception in Denver (right) aptly defines the intensity of the administration's first year.

★ ★ ★ It's a curious and unexpected face-time bonus for the individual meeting the President, Lev Dassin, the acting U.S. attorney at the time. Most people get about five seconds with the President, just enough for a hello and smile. But suddenly Dassin found himself in a 26-second handshake with the most powerful man in the world.

running toward the front of the motorcade in hopes of getting the President as he emerges.

For security purposes at the arrival location, the President's limousine typically pulls into a garage-size white tent, where he can emerge from the cocoon of the limo unseen by anyone nearby. Pete approaches the tent at a run, an agent holds back the flap, and he's through. But he's a beat behind today; he has to race through the tent to catch up to the President, arriving just in time to make a photograph of the first person the President greets right inside the door.

After several rounds of preliminary greetings with local elected officials and other players in the financial recovery, the President delivers his speech. During his talk, Pete shoots from a variety of angles, but one has to wonder, How many interesting images are possible here?

Afterward and backstage, the President poses with a steady stream of figures—police and fire chiefs, prosecutors, political volunteers. He thanks them, immediately flashes a smile, Pete snaps the shot, the next person steps in. There's a rhythm going until an unprecedented thing happens. Pete has a malfunction. He suddenly notices that the memory card in the camera with the portrait lens is full. "Gotta switch cameras here," Pete says as he cradles the offending camera and swings the backup into his hands. "Sorry about that, Sir," he says to the President, changing the portrait lens and flash onto the camera with more memory. Pete is unfazed, quickly remedying the situation. It's a curious and unexpected face-time bonus for the individual meeting the President, Lev Dassin, the acting U.S. attorney at the time. Most people get about five seconds with the President, just enough for a hello and smile. But suddenly Dassin found himself in a 26-second handshake with the most powerful man in the world.

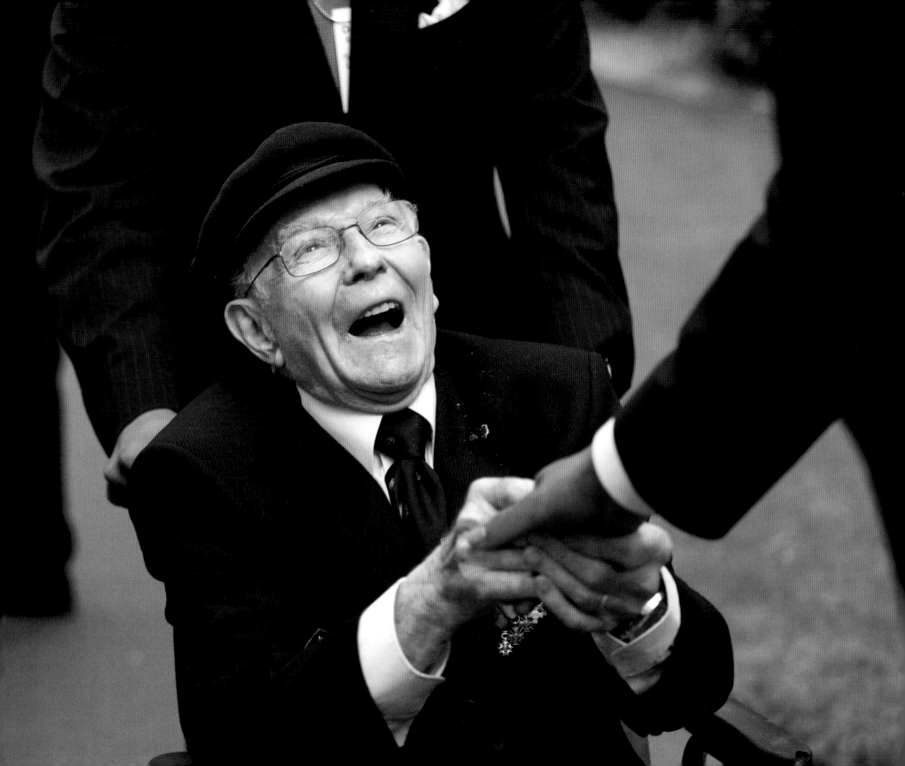

A few minutes later Pete is animated, explaining what happened. "He caught me in an embarrassing moment!" Pete says, his eyebrows rising up in excitement. "Where, like that *never* happens to me! Totally unprepared!" he says, looking over his shoulder at the President, who is standing just a few feet away talking to Reggie, Marvin, and Robert Gibbs. "How could I fill an eight-gig disk from just a regular speech?"

He looks at Reggie, who is smiling and laughing, making the "what gives?" gesture with his arms. Pete steps closer as the President turns. "I'm sorry about that, Sir," he says again, smiling. The President is smiling too. "Yeah, that was a little embarrassing, especially right in front of National Geographic!" the President says, referring to the film crew. Pete chuckles, shaking his head as the President adds, putting his arm on Pete's shoulder and looking right at the film camera, "He's usually much better than this, I promise you." "You gotta take the lens cap off," Gibbs suggests. "The lens cap is important," the President adds, piling on. "No, it wasn't the lens cap—I filled the disk," Pete protests, then sees his opening: "The speech was so exciting, I *filled* the disk!" Obama cracks up, puts his arm around Pete, then, laughing, turns and starts walking: "All right, are we ready to go?" Souza is back in gear, and ten seconds later, he's already clicked off a few more frames as the President leaves the hall.

Back in the motorcade, they head to lunch with former President Clinton at a place in Little Italy. On the way Pete hears that President Clinton is waiting out front. "I should have ridden in the spare," Pete says, referring to the second, identical limo that always moves with the President. That would have given him

★ ★ ★ Pete chuckles, shaking his head as the President adds, putting his arm on Pete's shoulder and looking right at the film camera, "He's usually much better than this, I promise you." "You gotta take the lens cap off," Gibbs suggests. "The lens cap is important," the President adds, piling on. "No, it wasn't the lens cap—I filled the disk," Pete protests, then sees his opening: "The speech was so exciting, I filled the disk!"

Pulled from the crowd. On the 65th anniversary of the Normandy landings, President Obama delivered a speech there. Afterward, a crush of people tried to get close to shake his hand. Pete Souza noticed an elderly French veteran waiting patiently but who was pushed to the side. He mentioned it to trip director Marvin Nicholson. "Marvin pulled the guy out of the crowd, found him a wheelchair, and brought him over to meet the President."

about a five-second advantage over riding in the support van, because the spare is usually just in front or behind the limo the President rides in. "Messing up today," he quietly laughs. Marvin and Robert Gibbs, in the seat just behind Pete in the van, are relentless, crediting the large crowds along the roadside to Pete's presence. "Souza! Souza! Souza!" they mock chant. "What's that sign say?" Marvin wonders, looking at the crowd—" 'I love Pete!' " Gibbs modifies the chant: "Yes *Pete* Can, Yes *Pete* Can!" riffing on the Obama campaign slogan. "It's nice it hasn't gone to his head," Marvin opines. Pete's laughing now, shaking his head, hating this kind of attention, and groaning in desperation.

As they approach the restaurant, Pete is determined to beat the President to the spot. Before the van even comes to a stop, he jumps out, runs a gauntlet of police barricades and a handful of agents, and gets to the entrance before the President's limo door opens. "Clinton *isn't* outside," he says. He quickly ducks in, greets the former President, and gets in position for a meeting of Presidents.

Later, after lunch, back at the helipad, Pete gets wind of a problem. One of the President's key advisers, Patrick Gaspard, the White House political director, is stuck on the wrong side of the police line at the entrance to the heliport. He's supposed to be riding back with the President in *Marine One.* Pete goes to the Secret Service agent in charge on the helipad to let them know.

For security reasons, *Marine One* has to leave, but Pete's intervention seems to have helped spring Gaspard who, minutes later, joins Pete on board one of the Chinooks preparing to head back to JFK.

He comes down the aisle in a sweat and high-fives Pete, exclaiming, "Never ran like that before, Pete! Oh man, that was intense!" He's been spared a major ordeal—getting back to D.C. on his own, which effectively would have killed the rest of his day. Pete's intervention may seem a trivial thing, but not if you're Patrick Gaspard. Pete is so helpful because he has what you might call "bubble savvy." The bubble refers to the rarefied, isolated, and protected world in which the presidential entourage moves. Because he knows the intricacies of how it works, who the key people are, and who to tap if there's a problem, he is invaluable in a hundred little ways that have nothing to do with photography. As a consequence, at the end of this leg of the journey, there's at least one person on the staff who probably *is* chanting "Souza! Souza!" ★

On the heels of a speech at Federal Hall in lower Manhattan in September 2009, the President took time for lunch with former President Bill Clinton. The ability of a sitting President to tap the experience of his predecessors is a substantive asset. Situations like these often mean Souza can eat at the same place—and the photographer reported that the appetizers were impressive.

Pages 116–117: Tables turned. President Obama turns photographer backstage prior to making remarks about mortgage payment relief in Mesa, Arizona (left). When President Ford introduced his new photographer, David Hume Kennerly on August 11, 1974, Kennerly was just 27, though he'd already won a Pulitzer Prize for his coverage of Vietnam.

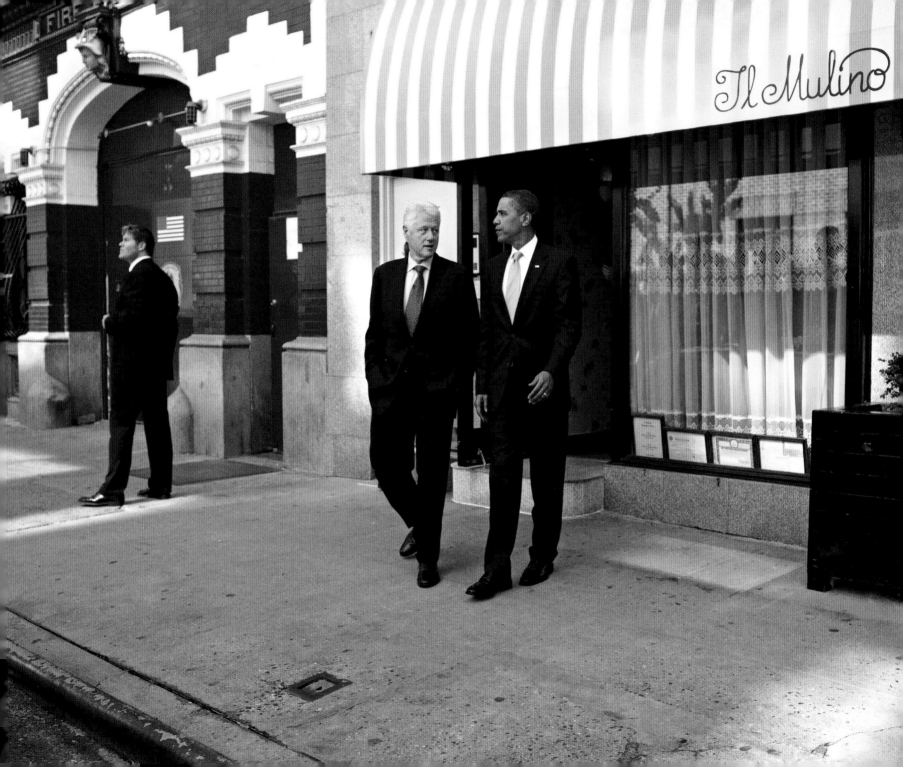

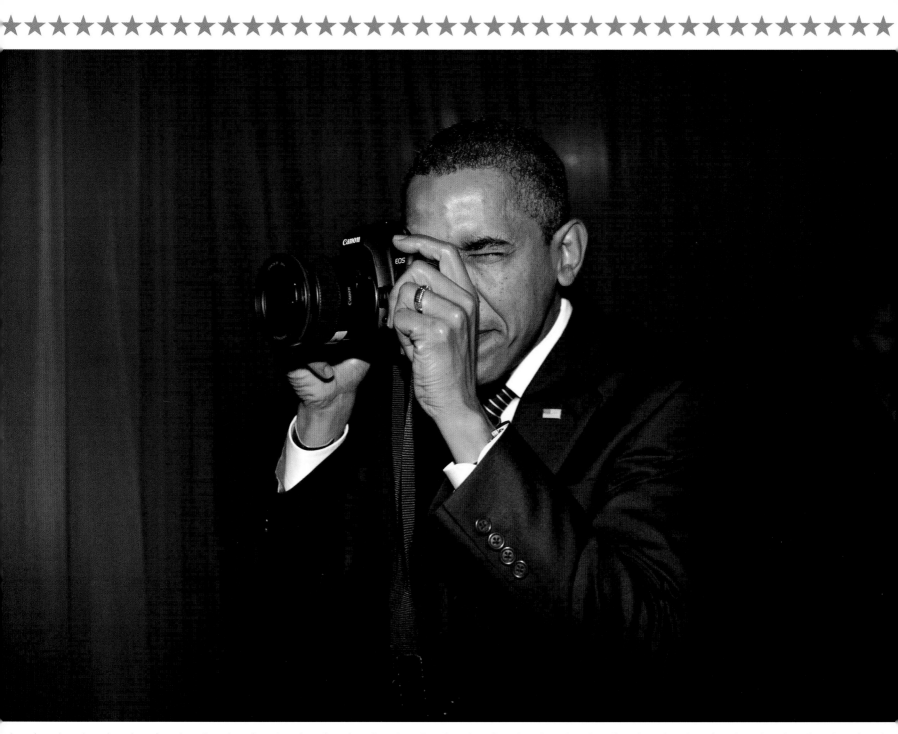

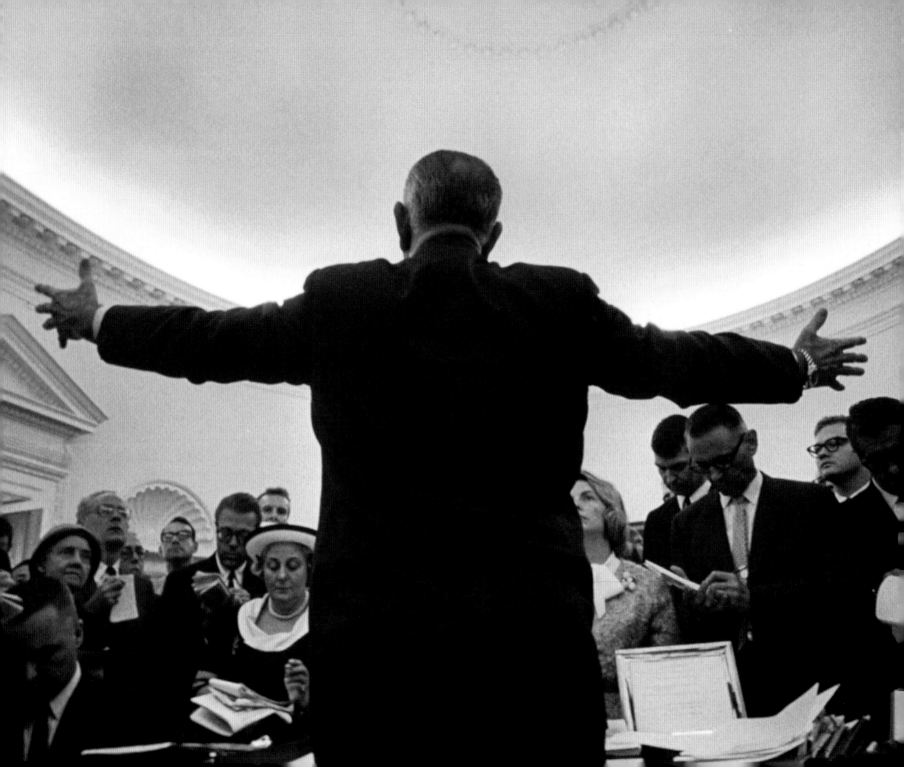

> ❝My personality suited his.
>
> I was a kind of a cynical, wisecracking person.
>
> He got a kick out of me—
>
> I made him laugh all the time.❞
>
> —DAVID HUME KENNERLY

PART TWO | *Getting Invisible*

It isn't just Pete's experience that sets him apart, it's also his approach to the job. To him, doing it right means having a relationship with the President that promotes easy access but which doesn't undermine his well-honed sense of objectivity. "I'm not sure how I would describe my relationship with the President," he says. "I would say that he would call me a friend and yet my relationship is more as a professional." Pete, like every presidential photographer, works in the shadow of Okamoto and defines "professional" in terms set by Okamoto. While Oke was not friends with LBJ, he had the kind of access a friend would have enjoyed, perhaps even more. He did this by actively developing a kind of invisibility that allowed him an invaluable sense of detachment when he made pictures.

At a recorded talk in 1970 Okamoto explained that he had worked hard "training the President" to see right through him. "I made a point to be in his office when he walked in the first thing in the morning and I intentionally did not say good morning to him unless he said good morning to me. The main purpose of that was that he'd consider me as part of the furniture. After a while he never saw me." This worked so well, Okamoto seemed to literally disappear from the President's day.

Studied invisibility. LBJ photographer Yoichi Okamoto disappeared behind the President to make this image. Note the low angle. Okamoto would have been below the eye line of almost all of the reporters in the room. Okamoto knew that to successfully vanish, it helped to have a substantive diversion like Lyndon Johnson.

Several times, I would go into the Cabinet Room and the people were there before he arrived and I'd take pictures because people behave differently before the President arrives and after he is in the room and I found that interesting. And then he'd come in the room and I'd cover the whole bit, take pictures from both sides and even take a 21mm or 20mm (a very wide-angle lens) six or seven inches from the back of his head and then I'd figure I'd shot my wad and go down to the office. And I'd get

there and the buzzer would buzz and I'd dash back upstairs. As I walked in with my camera he'd say, "All right now, everybody comb their hair and look good cause this fellow's going to take your picture." And everybody in the room of course had already seen me.

Johnson, obviously, had not.

Pete has also developed this kind of invisibility. "You know it is actually a very difficult thing for anybody who occupies this office to be under that kind of constant observation," President Obama explained. "That's one of the hardest things to get used to in being President. But when you have somebody like Pete Souza who you trust, who is a friend and who is able to purposely fade into the background so that at a certain point you don't notice he's there, then it makes it a little bit easier."

The First Lady goes a step further. During an interview for an article about the Obamas' marriage, the *New York Times'* Jodi Kantor asked a question about photographs that revealed the Obamas' relationship, wondering whether they worried about seeming like they were marketing their marriage. Mrs. Obama, slightly taken aback, told Kantor that they weren't marketing their marriage, that instead, "Pete was always around" and that "she didn't even know he was there."

"I think they have become so used to my presence that they don't even pay attention," Pete says, adding that this gives him opportunities to get unguarded moments. Samantha Appleton, another official staff photographer, sees it as almost biological: "I'm sure the President probably goes days without noticing Pete. They're so symbiotic now." Pete has become so much furniture to the senior staff as well. Phil Schiliro, the President's top legislative adviser and a person who assiduously avoids the limelight, told Pete that he didn't even notice him taking pictures anymore, "even when you're two inches away from me." For a presidential photographer, there is no higher praise than to be utterly ignored.

To Pete, the job has less to do with friendship and more to do with things we associate with friendship. "This job is all about access and trust and if you have both of those you're going to make interesting, historic pictures. And I think I have both of those," he says. "The kind of relationship I have with him, how close I am to him, I don't think it is as important as those two." Pete is free to go into the Oval Office any

With a feel like some kind of presidential album cover, Okamoto's uncanny portrait of the Johnsons stands out because he did so few like this. This photograph of President Lyndon B. Johnson and Lady Bird Johnson with their daughters Lynda (far left) and Luci (center left) was taken at the White House.

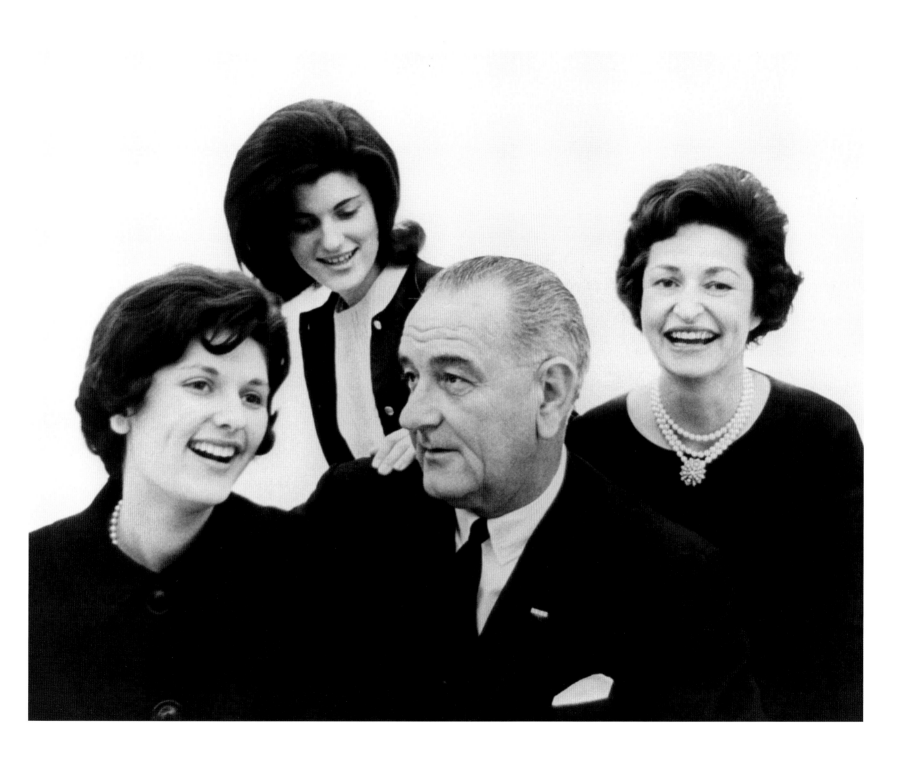

time he wants to. Unlike for Okamoto, with whom the ground rules were established in advance, Pete explains that for him, the rules have evolved. "I pushed at the start. But I pushed gently. I don't think it phases anyone anymore."

On only one occasion has Pete had to push for access. When the President was interviewing candidates to fill the vacancy on the Supreme Court when Associate Justice David Souter retired, concerns over maintaining secrecy looked like they might trump history. "I had to explain why I should be there. I thought it was important for the archive, for history, to have a record of it." He said the President got it. Still, as a precaution, Pete couldn't share the contents of his camera's memory card with anyone in the Photo Office until after the nomination of Sonia Sotomayor was settled. Once she was nominated, the White House released a picture of the President with the nominee.

For presidential photographers, most of whom considered themselves working photojournalists before they took the job, there is a little bit of a rub here. They are trying to maintain the objectivity demanded by their profession while recognizing that they are now on the inside, working for the President.

"I definitely am a part of his team, his staff," Pete says, explaining that it would be naive for him to think that he was totally removed and shooting as he would for a newspaper. "I don't know that I would take pictures any differently but clearly I'm *his* photographer—I'm not working for the *Chicago Tribune* covering his administration."

Most of the presidential photographers echo Pete's sentiment. "I don't think I did anything differently than when I was a news photographer," said David Kennerly, Ford's photographer. "There are images we don't release," Pete says, acknowledging the main difference, "but not many things that we don't shoot." Still, in their pursuit of access and trust, the handmaidens of invisibility, they have to be careful not to push it too far.

These aren't usually nuanced situations. Both Presidents Ford and Clinton asked their respective photographers not to shoot when they were about to fire someone. "I remember he actually asked me ahead of time," Kennerly recalled. "He said, 'Look, I prefer you don't come into this meeting because I've got to fire the guy.' So I said, 'OK, thanks for warning me,' cause I didn't want to be in there." President Obama

and the First Lady have also drawn a line. They are rightly concerned about images of their children, just as the Clintons were with Chelsea, so the number and type of images are limited. "There are situations involving family where I'll ask if he wants pictures—say if he's playing in the pool with the girls," says Pete. There are also moments when the President would prefer he not be photographed, such as when he's being made up for a TV interview. But as Pete points out: "Not shooting in a situation like that doesn't sell history short." On the other hand, pictures that they shoot but don't release—the President body-surfing or walking on the beach in Hawaii with the First Lady—may, in time, be images that will provide context about Obama and his Presidency.

Then there are some instances when the photographers draw the line themselves. Pete explains that he's very careful about lingering when the President is in a one-on-one meeting. He'll typically get the top of the meeting then leave. "The point is that I've recorded that the meeting happened. If I stay too long, the President might give me a look." Pete doesn't want that. In effect, he's "training" the President in the same way Oke "trained" LBJ, in a phrase, to accept me and forget me. If the President has to ask Pete to leave, then Pete's invisibility has been compromised—and he is understandably protective of that.

This isn't photojournalism as much as it is photo-history and the standards are different. It's important that they are because, historically speaking, we have a lot to gain if Presidents open themselves up to this type of coverage. But not all of them have liked the idea.

Richard Nixon continued the tradition of appointing a personal photographer, naming a *Saturday Evening Post* veteran, Ollie Atkins. While Nixon was true to tradition, the *practice* of giving access to his photographer was another matter. *New York Times* photographer George Tames recalled in his book *Eye on Washington* that Atkins had hoped to continue the unprecedented coverage Okamoto began with LBJ. "But Ollie's dreams died aborning when he was placed under the direct thumb of the president's press secretary, Ronald. L. Ziegler. No top-secret clearance, no personal and direct access to the president, all picture opportunities cleared with the press secretary." Consequently, Atkins's images of the Nixon White House appear bland, perfunctory, and completely shorn of the verve that comes with even the most mundane moments in the West Wing.

With Johnson you had a man extremely comfortable in his own skin. If there was any wariness about "warts and all" coverage, it was compensated for by his trust in his photographer and the firm knowledge that he had total control over the pictures. But with Nixon, that confidence seems to have been displaced by fear. In a revealing piece of videotape, shot during the sound check just prior to the President's resignation speech to the nation, Nixon's attitude about his photographer is obvious. A few minutes before the speech, with Atkins snapping pictures, the President shoos him out of the room.

"That's enough!" Nixon says gruffly, then, perhaps realizing he might be recorded, catches himself; he looks straight ahead into the TV camera, slightly smiling, shaking his head, and says, "My friend Ollie, always taking my picture. I'm afraid he's going to catch me picking my nose." He pauses, looks off camera, now oddly serious, strangely plaintive, "You wouldn't print that, though, would you, Ollie?"

We can't hear Atkins's response, but we assume that he says no, then asks if he can remain to cover the speech. The President responds very brusquely, "No, no Ollie, only the CBS crew will be in the room." Nixon seems to grow more annoyed as the exchange continues. "No, there will be no picture. No. After the broadcast. You've taken your picture! Didn't you just take one? That's it. You got it? Come on!"

That's a long way from Okamoto-style access.

The University of Texas' Don Carleton, the director of the Dolph Briscoe Center for American History and a student of presidential photography, thinks there was something more fundamental going on: "It's weird, but you don't think of Nixon being a navel-gazer, you know, that he was that self-aware. But actually I think Richard Nixon was very self-aware. I think there's a lot of evidence that he had a full understanding, particularly of his dark side. And I think he struggled with his dark side his entire life, frankly. And I think he was scared to death to reveal that to people and I think that's why he was afraid of a camera. I think that's the reason he was such a control freak with his White House photographer."

When you review Atkins's images in his book about his time at the White House or online at the Nixon Library website, almost everything was taken at an official event or when the press was also present. There is nothing documentary about it. It feels like a body of work from any time before JFK, with not even a whiff of the candor of Okamoto's coverage of LBJ. Curiously, the most famous image Atkins took— and one of the most requested images from the Nixon Library archive—is of the President with Elvis.

The King meets the 37th President of the United States, Oval Office, 1970. This is perhaps presidential photographer Ollie Atkins's most famous photograph from his time at the White House.

"Shortly before resigning, the President suggested I shoot a family picture [left]. He urged everyone to smile, but Julie had trouble smiling through her tears," wrote Ollie Atkins, the President's photographer. In his book Triumph and Tragedy, *Atkins presented the image on the right tightly cropped, showing only Julie Nixon and the President. The actual image might be more revealing, suggesting a rather awkward and poignant moment for the President and his family.*

It didn't help that Atkins and Ziegler didn't get along. George Tames recounted a story told to him by one of Atkins's young staffers. One day, apparently, Ziegler called Ollie's office and demanded to see him immediately. "Ollie was in the men's room when a young staffer rushed in and yelled at the top of his voice, 'Ollie! Ollie! Come quickly! Ziegler wants to see you and he's really mad!' Ollie's voice rose from a stall, saying, 'Tell him I can only handle one shit at a time!' "

There is only one exception to Atkins's limited coverage. In his book *The White House Years: Triumph and Tragedy,* Atkins describes how, mostly by chance, he was able to get some of the most candid images of his entire term.

On the night of August 7, 1974, the President and Pat Nixon, Julie and David Eisenhower, Tricia and Edward Cox, and the President's personal secretary, Rosemary Woods, gathered for dinner in the solarium, a family den with an arc of big windows on the top floor of the White House. Atkins received a call from press secretary Ron Ziegler that he was to go up and take some pictures of them having dinner.

Atkins knew that things were coming to a head for the administration and rumors were flying that the President was about to resign. But no one, Atkins included, knew the President planned to announce his resignation the next day—except for everyone in the room where Atkins had been sent to make pictures. Unannounced, Atkins showed up and was welcomed in by the family. Here, for a moment, Nixon seemed to drop his guard and the images, while still posed, mark an unprecedented moment in a Presidency. The next day, he would announce that he'd resign, disgraced by the Watergate cover-up, and leave the world of politics forever. The family is all holding on, arms intertwined, as if bracing for the coming storm. When the pose broke, Julie and the President embraced and Atkins captured it, a touching moment unlike any other frame in his Nixon work.

Afterward, when Atkins explained what he'd shot, Ziegler said, "Oh, my gosh, that's exactly what we *don't* want." When the images were printed, Ziegler took a look and threw all into the trash can.

Images like these define their times as historical documents, not just because of what they show, but the circumstances surrounding how they were used—or disregarded. The Nixon White House was attempting to manage a message to the bitter end. Luckily, Atkins saved the negatives, setting aside

★ ★ ★ Theirs was a remarkable relation-
ship, the by-product of an extraordinary
moment in U.S. history, the personality of
President Gerald Ford, and the remark-
able alchemy that evolved between Ken-
nerly, Ford, and the entire Ford family.

his usual deference to power, and the record of a powerful, personal moment was preserved.

"Deference to power" was an unfamiliar phrase to David Hume Kennerly, the 27-year-old Pulitzer Prize winner Gerald Ford hired as his personal photographer. Theirs was a remarkable relationship, the by-product of an extraordinary moment in U.S. history, the personality of President Gerald Ford, and the remarkable alchemy that evolved between Kennerly, Ford, and the entire Ford family.

"My personality suited his. I was a kind of a cynical, wisecracking person. He got a kick out of me—I made him laugh all the time," says Kennerly describing the root of their rapport.

In October 1973 *Time* magazine assigned Kennerly to cover Ford, who was then the dark horse contender to replace embattled Vice President Spiro Agnew. The evening of Kennerly's very first day covering Ford, Nixon named Ford Vice President. From that point on, Kennerly closely covered the Vice President, in the process getting to know both him and his family.

In the space of only a few months, Kennerly had developed a surprisingly close, enduring relationship with the Fords. "It was a very warm, personal relationship but the foundation was professional. I never—to this day—called him 'Jerry Ford,' you know, he was always an elder. There was a very respectful relationship there." And playful. In winter 1974 Kennerly followed the Fords to Vail, Colorado, for their annual ski vacation. At one point during the trip, Kennerly threw the Fords a dinner party at a Chinese restaurant. The Vice President opened and read his fortune, then casually tried to hide it under his hand. Kennerly managed to pry it away and read it aloud to the table: "You will undergo a change of residence in the near future." "I hope not!" Ford said. The anecdote is astonishing, not because of the prescient fortune, but because it reveals a level of familiarity that no presidential photographer has ever enjoyed.

Roughly eight months later, in August, President Nixon resigned. How Kennerly got the job as the new President's photographer defined how he did the job. On the evening of the day that Ford took the oath of

President Ford, in his pajamas, meets with staff members Steve Todd (military aide) and Terry O'Donnell in the President's suite in the Akasaka Palace Guest House, Tokyo, Japan, on November 19, 1974.

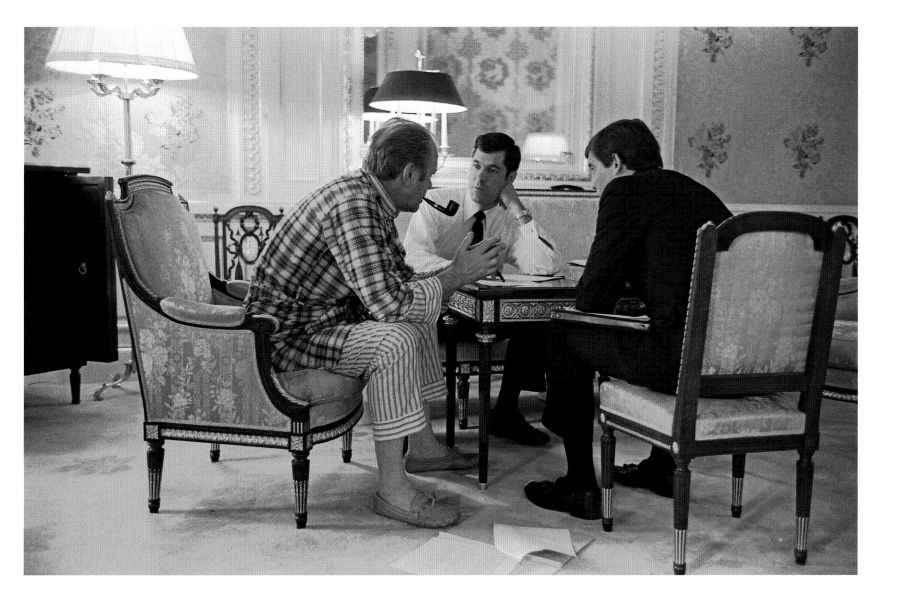

Because of the Nixons' sudden departure, the White House was not yet ready and the Fords continued to live in their modest Alexandria home for several days (left). David Hume Kennerly's coverage of the Fords revealed a family most Americans had no trouble recognizing, right down to this breakfast table scene (opposite). It took a while before their new status sunk in. One of their sons, Steve, remembered his mother cooking dinner in the kitchen shown here the night the President had been sworn in. "Jerry, something's wrong here. I'm still cooking and you're President of the United States."

office, the Fords had a small party to celebrate. David Kennerly was invited to take some photos. At one point in the evening, the President asked Kennerly to stick around after everyone else had left. "We were sitting on this couch in their living room, just the two of us—you can imagine what that was like. I mean, the guy hadn't even been President for nine hours essentially, and there I am having a talk in there! He had not offered me the position at that point, but he asked how did I see the job." The two previous presidential photographers had a profound influence on how Kennerly answered the question. At one end of the spectrum was Okamoto with his unfettered access. And at the other end was Atkins, whom Kennerly saw as "the poster child for what I didn't want to happen to me if I became chief photographer."

"I couldn't envision myself working in a situation where the press secretary or the assistant sitting outside the Oval Office would tell me when I could go in or out. So I just put it right to him, I said, 'In order to do that job I would have to work for you directly not for anybody else and plus, have total access to everything that's happening. And that's about it.' And he kind of smiled, just looked at me as he's puffing on his pipe and he said, 'What, you don't want *Air Force One* on the weekends?' "

By dint of the relationship between Ford and Kennerly, the coverage is dramatic in its scope, eye-popping in its access. Don Carleton thinks this was a conscious and very canny decision on President Ford's part.

> I think it's important to understand that Gerald Ford had the savvy, the moxie, to understand that he was not an elected President. He'd come into the Presidency due to these "extraordinary circumstances" as he said in his speech. Because of that, he understood that the Nixon White House had been a kind of a dark place . . . the American people really weren't welcome, and Nixon didn't want anybody taking pictures, and knowing what was going on. . . . I think Ford had a plan all along. He wanted someone to come in and help him open up the White House, photographically speaking, [that] was one of the ways he could do that.

The change from the sterile, official images of the Nixon Presidency, to the unposed, almost painfully candid images of the Fords is striking and has an elixir effect. For the first few days of his Presidency,

David Hume Kennerly had a unique relationship with both of the Fords and open access to the residence. "This photo (opposite, left) was a particular favorite of [Betty Ford's] because it captured the feeling that she was living in a fishbowl," Kennerly said. He made the second picture (opposite, right) the day before the Carters moved into the White House. "We were making a last tour of the West Wing," Kennerly said, when she told him she'd always wanted to dance on the Cabinet Room table. A former Martha Graham dancer, she slipped off her shoes, hopped on the table and struck a pose.

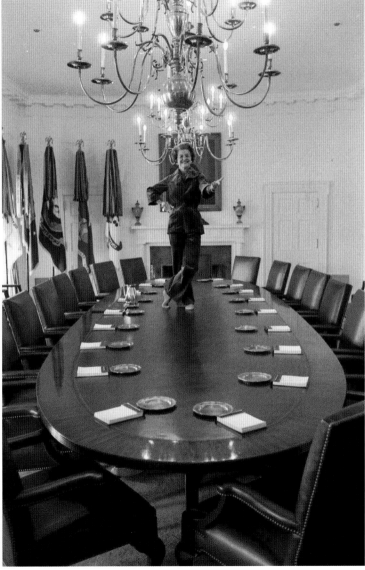

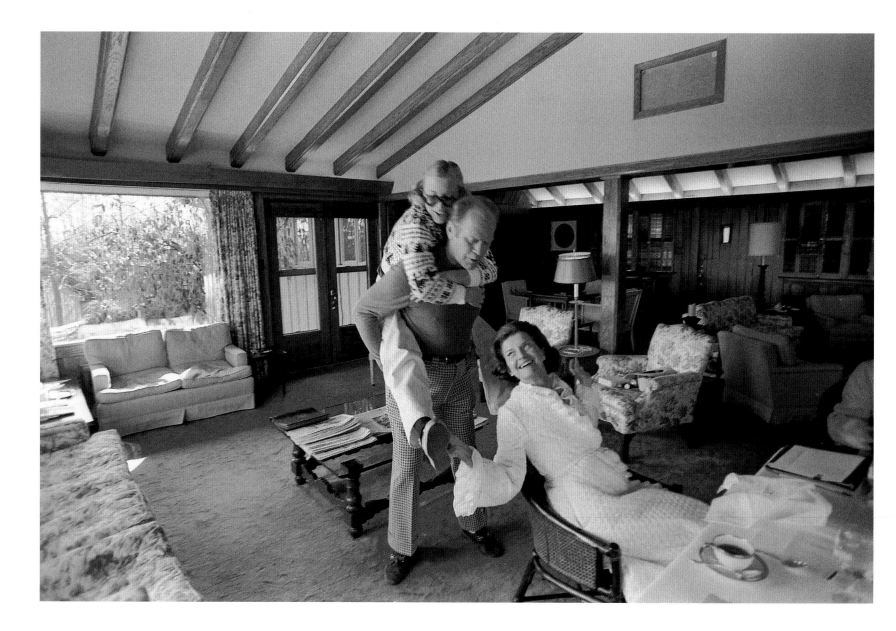

the Fords remained at their suburban home in Alexandria, Virginia. On one of these mornings, Kennerly joined them at the breakfast table, where the President is caught in mid-sentence, tie-less, saying something to the First Lady. For her part, Betty Ford sits, mid-bite, wearing a bathrobe with a not-very-flattering transparent shower cap covering her freshly set hair. This is about as pedestrian an image as you can imagine, an utterly American morning, right down to the round wooden dining table, with a condiment-jammed lazy Susan at its center. When will the teenager drag in and begin grazing?

The idea of substituting Richard and Pat Nixon into this tableau isn't just weird, it's a little scary.

So Ford was on to something. At some level, he understood that he and his solidly midwestern values were the medicine that the country needed. In Kennerly Ford found the ideal conduit. He seemed to see Kennerly as a trustworthy, entertaining, quasi-son. "I had such a perfect position. No one could tell me what to do, outside of the President of the United States." Kennerly could wander into any meeting he chose and freely enter the family's private quarters. "I had an equally good relationship if not better with Mrs. Ford and so I spent a lot of time in the White House residence. There just wasn't anything that I couldn't do, but certainly with a sense of propriety." On a few occasions, he even entertained the Fords at his own home.

For Kennerly, the move from a weekly newsmagazine where his work was seen by millions to a job where almost no one saw his work took some adjustment. "I did miss being published," Kennerly says, describing the competitive excitement of working as a wire photographer and the rivalry between *Time* and *Newsweek*. "It was kind of a Macy's and Gimbles thing. It was fun, great fun, and I liked getting scoops, being behind the scenes and getting things that no one else could see." For all that, the White House offered even more. "It was more than made up for with the satisfaction of being in the loop and being in the Oval Office, a place where others could only dream about going. Very few people had ever had that opportunity, particularly carrying a camera."

The uncanny relationship between Ford and Kennerly took an intriguing turn in spring 1975, when Ford dispatched Army Chief of Staff Gen. Fred Weyand to Vietnam to assess the rapidly deteriorating situation there. Kennerly asked to go too. Ford replied, "Sure. Besides, I'd be interested to hear your

The President and Mrs. Ford and Susan engage in a little family horseplay at Camp David in March 1975. Kennerly was not much older than the Ford children and almost became part of their family.

★★★ When he returned, Kennerly showed the President graphic photographs of what was happening. Ships and buses full of refugees, dying civilians in Phnom Penh and Cam Ranh Bay. Kennerly describes Ford as "devastated."

view of what's going on when you get back." According to Kennerly, he even hit up the President for some cash. This was before the automated teller machine, and by this time of day the banks were closed. Ford gave him 47 bucks, all that he had in his pocket.

Kennerly's unprecedented dual role, as both photographer and political-military fact-finder, was possibly the ultimate expression of a President's trust in his photographer.

When he returned, Kennerly showed the President graphic photographs of what was happening. Ships and buses full of refugees, dying civilians in Phnom Penh and Cam Ranh Bay. Kennerly describes Ford as "devastated."

It's common for the White House Photo Office to hang their photographs on the walls of the West Wing; in fact, they constitute most of the wall decoration in that part of the White House. Typically referred to as jumbos, they are oversize blowups. Kennerly took the bold step of replacing the existing images of state visits, official greetings, and candid pictures of the President and First Family with his coverage of Cambodia and Vietnam—refugees, casualties, and all. Some people complained, but when Kennerly asked the President if he should take them down, he replied, "Leave them up. Everyone should know what's going on over there."

Kennerly's access is a defining characteristic of his images, something that he credits as more important than his friendship with the Fords in doing the job well. "I don't think Oke was friends with LBJ," he says, adding that "access is the most important thing. A warm relationship is great. A professional relationship is fine. As long as you have the access, that's number one. If you throw friendship into the mix, that's helpful, but it's not essential. As long as you can get what you need." ★

President Ford's trademark pipe and backlit smoke lend an otherwise pedestrian image an iconic quality.

Moments of Impact

PART ONE: *The Outer Oval*

PART TWO: *Mundane and Momentous*

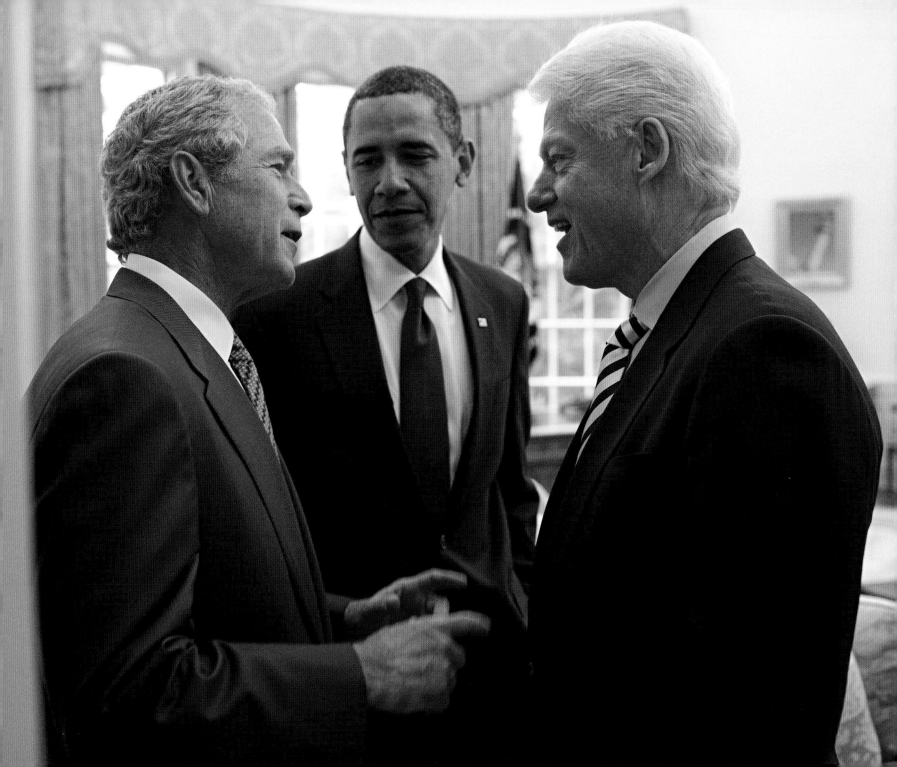

> **"** I feel like I'm the luckiest SOB photographer in the world. You know not only did I have a chance to do this once before but now I'm getting a second chance and I have tried to make the most of that. **"**
>
> —PETE SOUZA

PART ONE | *The Outer Oval*

9:20 A.M.

It would be interesting to hook up an adrenaline monitor to Pete and compare which is more heart-pounding: a trip with the President outside the White House, or just a typical day here?

A few days after the New York trip, Pete is walking around the West Wing of the White House with Jason Ransom, the photographer for Prime Minister Stephen Harper of Canada. In about 30 minutes, President Obama will welcome Harper and a Canadian delegation to the Oval Office. When a foreign head of state visits, Pete takes the official photographer of the other head of state under his wing and talks him through what's about to happen. It's Pete's nature to do this, but it's also smart, because he never knows when he'll need a return favor.

Ransom is 34 and knows Pete from several previous summit meetings. When you see them together and get a sense of their shared experiences, you realize there are numerous jobs in the White House that have counterparts in a kind of parallel "world leader" universe—President's chef, prime minister's chef, President's butler, prime minister's butler. Is there an online support group where they can all go and kvetch about their bosses?

Ransom respects Pete—and who wouldn't? Pete's position is the ultimate "head of state" photographer job and he basks in the reflected power that comes with the American Presidency. But Pete has also done this job before, and by doing so has earned the respect of his peers. He is also an excellent host. They start in the Roosevelt Room, the main conference room in the West Wing, so named for its paintings of

Pages 138–139: President Barack Obama shakes hands with a guest entering the Oval Office in May 2009. The power of the room can sometimes be overwhelming. Clinton photographer Bob McNeely remembers his first time shooting there: "I can literally still remember it, knees knocking, hands shaking, trying to take the pictures."

President times three. President Obama had asked the former Presidents to help with the situation in Haiti. "During their public remarks in the Rose Garden, President Clinton had said about President Bush, 'I've already figured out how I can get him to do some things that he didn't sign on for.'" Pete Souza reports. "Later, back in the Oval, President Bush is jokingly asking President Clinton what were those things he had in mind."

★★★ "My comings and goings are pretty much up to me," he explains. There aren't many people who have that kind of access, even at the upper levels. Most people at the White House have a specialty area and only relate to the President when they have to. Pete's specialty is *everything.*

both FDR and Theodore Roosevelt on the walls. He explains that before meeting with the President, the prime minister will first sign the guest book—a kind of quaint custom that seems a little odd for a head of state, almost like the West Wing is a bed-and-breakfast.

They move to a space near the Oval Office, which serves as a kind of on-deck circle for people waiting to meet with the President. The President is in his senior staff meeting right now, something Pete already shot the beginning of, so he and Jason consult their schedules to see what's going to happen next. Pete runs his finger down the schedule to the noon hour to see what his prospects will be for eating today. "Looks like the President will have about 20 minutes for lunch." That means Pete will have a little less. He happens to be eating an apple as he ruminates; when questioned about this, he explains that there is always a bowl of apples in the Oval Office and he tries to grab one every day. He doesn't like the odds for getting lunch. "It looks like it's going to be a two-apple day."

Pete walks down a short hallway from the waiting area and into an office space with three large, arched, Georgian-style windows that look out onto the Rose Garden. Sun streams into this office, known as the Outer Oval. This is where the President's personal secretary, Katie Johnson, sits, along with Brian Mosteller, who helps manage the Oval Office and who handles advance for the President's schedule.

Even though Pete has the day's schedule, he checks in and stays in close touch with Katie. For his purposes, when the President isn't traveling, Katie plays the role that both Reggie Love and Marvin Nicholson play on the road: She's on top of schedule changes and is more likely than most to know how the President's day will warp.

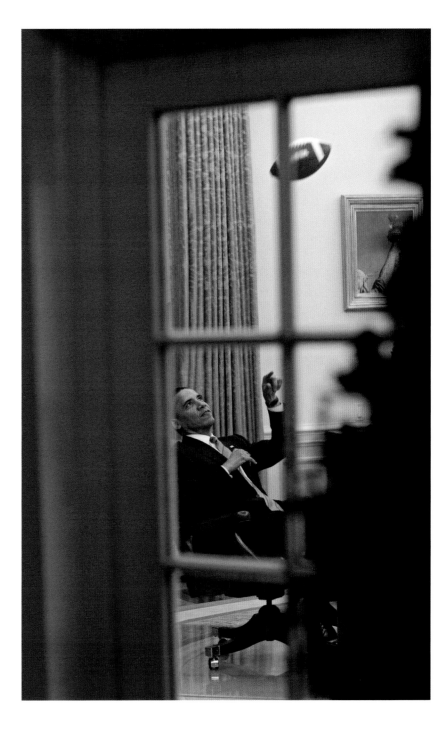

*President Obama, a lefty, throws a pass to an aide
before a meeting in the Oval Office in April 2009.*

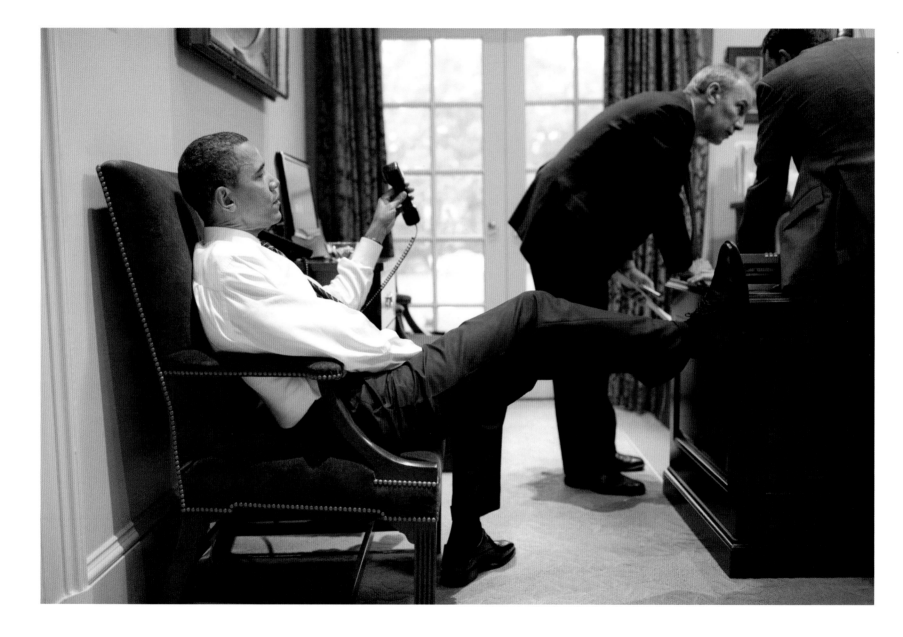

From Katie's desk, Pete walks a couple steps and looks through a peephole in the Oval Office door. This allows Pete to see what's going on in the Oval without interrupting. He wants to see how close this meeting is to breaking up so he can get in for the one-on-one with the Canadian prime minister. Pete has a delightful kind of freedom for a buttoned-up place like the White House. "My comings and goings are pretty much up to me," he explains. There aren't many people who have that kind of access, even at the upper levels. Most people at the White House have a specialty area and only relate to the President when they have to. Pete's specialty is *everything*.

But with a portfolio that big, he needs a lot of help. Katie keeps the President's schedule and consequently is an ideal source, a kind of human thermometer who monitors just about everything relevant to Pete's world—is the President on time, running behind, is it a frenetic day, more relaxed, and perhaps most important, even the mood in the Oval and the tenor of the day.

For Pete, Katie is a key member of what functions like a work family, one that Pete both plays with and treats with a great deal of respect. There's a lot of banter—this morning, Katie's sticking it to Pete, kidding him because he took a picture of her with George Clooney and it didn't turn out well. He had to make amends by getting an even better shot of her with Jake Gyllenhaal. At least he has the chance for do-overs. That is one of the great luxuries—and pressures—of photographing here: There will always be another star, a famous or powerful person, to come along, but you usually have just one shot. Katie laughs. Pete smiles. Pete retreats to the waiting area to see Jason.

In this retreat is one of Pete's great traits as a photographer—he is extremely polite. He has unfettered access to the Oval Office and, between trips in and out, he could hover in Katie's space. But he knows she gets precious little quiet—staffers often wait for their time with the President right at her desk and are always yakking. For Pete, this means careful listening at the end of the short hall leading to the waiting area and a lot of quick trips from the waiting area to the Outer Oval to check in.

When he comes back five minutes later, presidential speechwriter Ben Rhodes is sitting in Katie's space. Rhodes mentions to Pete that last weekend he was called in for duty as the President's photographer. He's got Pete's attention now. Pete is incredibly diligent and almost never takes time off.

The President ranges through a number of spaces in the West Wing while working. In addition to the Oval Office, in an adjoining space nearby, the President has a private study and dining room. But Souza often finds him in the Outer Oval where, in this case, he is making thank-you calls to Democratic leaders after passage of an energy bill in late June 2009.

★ ★ ★ "Looks like the President will have about 20 minutes for lunch." That means Pete will have a little less. He happens to be eating an apple as he ruminates and when questioned about this he explains that there is always a bowl of apples in the Oval Office and he tries to grab one every day. He doesn't like the odds for getting lunch. "It looks like it's going to be a two-apple day."

Last weekend though, he finally broke down and went for a bike ride.

Apparently, while Pete was on his rare break, Rhodes was in the West Wing giving his parents a tour. As he was walking near the Outer Oval, the President saw that he had a camera with him and beckoned him. Rhodes explained, "I thought, Great, I'll get to introduce my parents to the President and take a picture," and while the President did say hello and pose for a shot, he really wanted to tap Rhodes as a photographer. He was only too happy to oblige and dutifully snapped several shots of the President with some of the President's friends. He provided a little more detail, with a touch of faux bravado: "I've seen the shots, Pete, and some of them are really pretty good."

"I'm feeling the heat now!" Pete replies. But you could tell that something about this whole funny episode wasn't all that funny to Pete. He *lives* his job and is incredibly conscientious and approaches it not as an obligation but as a privilege. "I feel like I'm the luckiest SOB photographer in the world. You know not only did I have a chance to do this once before but now I'm getting a second chance and I have tried to make the most of that. I have got this incredible access to this historic Presidency. I'm not going to let these years go by without making the most of it, meaning, you know, really pushing the envelope as much as I can in terms of creating this visual archive."

Back in the waiting area, Pete and Jason are sitting on a red couch. Pete explains that the couch is new and that it's a little too low for him. He also mentions that no one talked to him first about replacing it. Soon it's quite clear that this space is really Pete's second office, the place where, when he's in the West Wing, he spends a lot of time. And he has a kind of pride of ownership. He pulls open one of the drawers of

Sasha Obama, younger of the President and First Lady's two daughters, hides behind a sofa in the Oval Office while sneaking up on her father at the end of a day in August 2009.

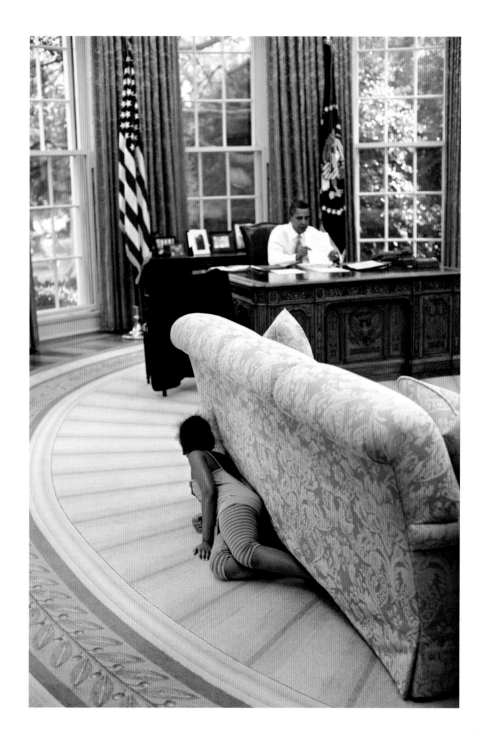

★ ★ ★ When one of the staffers opens the door, the still photographers push through, almost like the start of a horse race. They get about one minute to make a shot. Meanwhile, Pete and Jason continue to shoot all around the working press. One of the press staffers calls out, "Stills done," and all the still guys get up and leave.

the credenza and laments that he's being crowded out. "Look, there's microwave popcorn in here, a few PowerBars—this must be the Secret Service's stash," he says, eyeing the agent on duty nearby. He used to keep extra gear in here in the event of a breakdown. He's also upset about the arrangement of two wing chairs, placed to the side of the room. "They've got these chairs all wrong— see, they're straight! If they angled a little more, then two aides waiting here would sit and be more comfortable talking." He slightly shifts the chairs then remains on his feet, as he does most of the time.

There's a basket on the credenza and Pete keeps returning to it and reaching in for his Blackberry. You're not allowed to have a Blackberry in the Oval Office, the Cabinet Room, the Roosevelt Room, or the Situation Room, so there are tasteful baskets or bowls placed outside of these rooms in which people can place their digital tails. But Pete keeps retrieving his and punching in messages. In managing the Photo Office while making pictures, Pete operates with both sides of his brain, more than most of us.

As the meeting finally breaks up, a stream of top advisers flows out of the Oval—chief of staff Rahm Emanuel, senior adviser David Axelrod, director of the Office of Management and Budget Peter Orszag. As they pass through the Outer Oval, Pete and Jason slip into the Oval, where the President of the United States greets the prime minister of Canada, their respective photographers making pictures for history.

Back in Pete's second office after covering the President's meeting with the prime minister, there's a pause. Pete has time to call down to the mess—the Navy runs the food service in the West Wing—and orders lunch. Later, around noon, he'll race down and grab it, then eat it in his real office while the President is having his lunch.

Blackberrys and cell phones are tagged with Post-its and idle in an electronic limbo outside the Cabinet Room during a briefing on Afghanistan and Pakistan in March 2009. These devices are not allowed in the Oval Office, Cabinet Room, or Roosevelt Room.

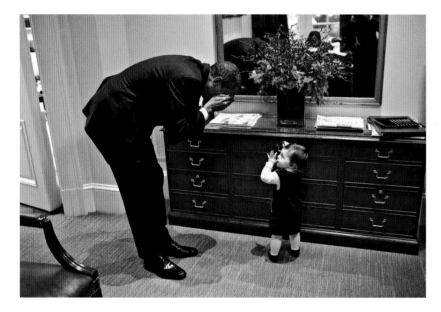

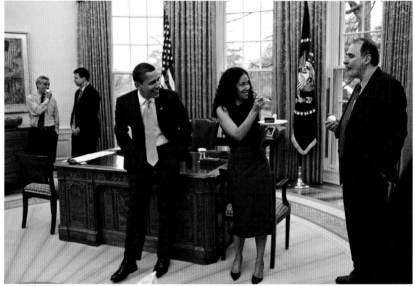

*Deputy chief of staff Mona Sutphen jokingly offers
a piece of cake to apple-eating senior adviser
David Axelrod (above right). Moments after leaving
the situation room, the President plays peekaboo
(above left) with the daughter of staffer Emmitt
Beliveau. Brian Mosteller, deputy director of Oval
Office operations, looks through the Oval Office door
peephole to monitor the progress of a meeting.*

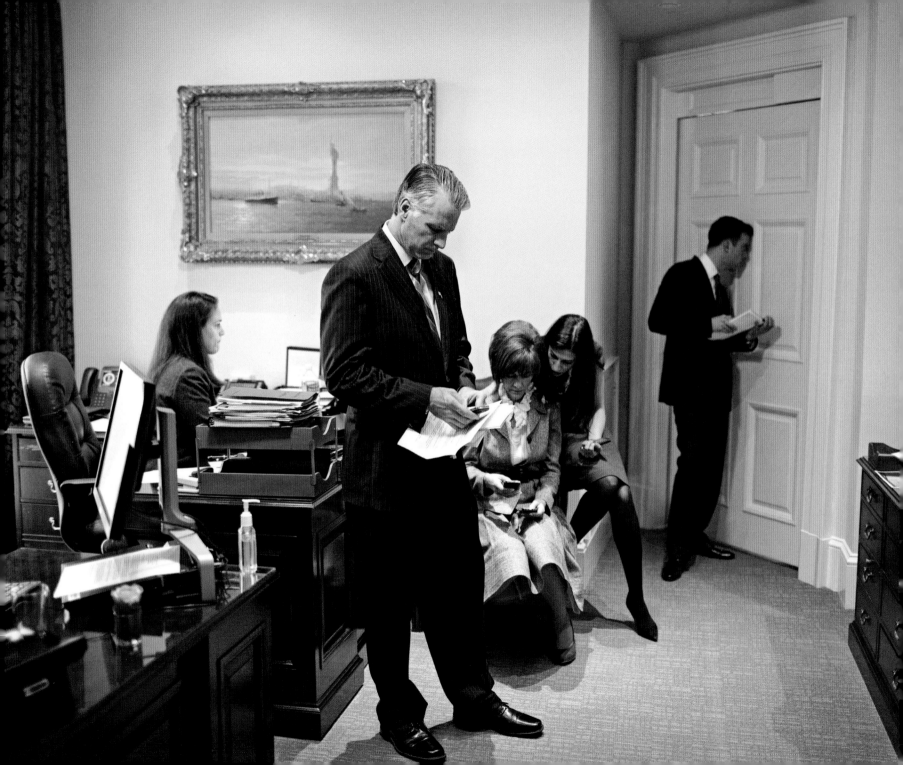

Shortly, a parade of Cabinet officers arrive for a meeting with the Canadians. They will join the President and the prime minister once the two have finished their one-on-one meeting. A curious little detail can be observed. As Secretary of State Clinton walks through the waiting area and toward the Outer Oval, Brian Mosteller walks alongside her and quietly tells her where she will be sitting in the meeting. This happens with each arriving Cabinet member, senior staffer, or guest—a kind of verbal place card so that all flows smoothly and according to protocol once they're in the Oval Office.

Meanwhile, outside the Oval Office near the Rose Garden, two press office staffers herd the press corps out of the press office and onto the flagstone colonnade that leads to the exterior doors of the Oval Office. This open-air passage has framed classic images of every president—JFK with Caroline, John-John, and a pony; Ford puffing on his pipe; Reagan feeding squirrels. Now it's crowded with people and gear: still photographers at the front of the line, followed by the video photographers, with a healthy dose of reporters and correspondents in the mix.

These journalists are preparing for what is affectionately called an "Oval Office Spray." It is the antithesis of what Pete's trying to get, but it's critical for the coverage required by major news outlets. When one of the staffers opens the Oval door, the still photographers push through, almost like the start of a horse race. They get about one minute to make a shot. Meanwhile, Pete and Jason continue to shoot all around the working press. One of the press staffers calls out, "Stills done," and all the still guys get up and leave through the opposite door. Now the video guys take over and both the President and the prime minister make brief statements, with the prime minister's in both French and English.

The difference in the type of coverage between what the press get and what Pete and Jason get is stark. It often comes down to two moments the working press almost never sees. "As usual," Pete says, "the best pictures are just before the meeting starts and just as it breaks up." These times are when informal conversations take place, when the President and his guest often become more expansive. If it's a larger group, people can engage without everyone in the group hearing, so they might be a little more expressive, emotional, emphatic. ★

Professional courtesy. While Pete Souza works a new angle for a photograph of a meeting between American and Canadian delegations in September 2009, his counterpart and friend Jason Ransom, Prime Minister Stephen Harper's photographer, made this picture.

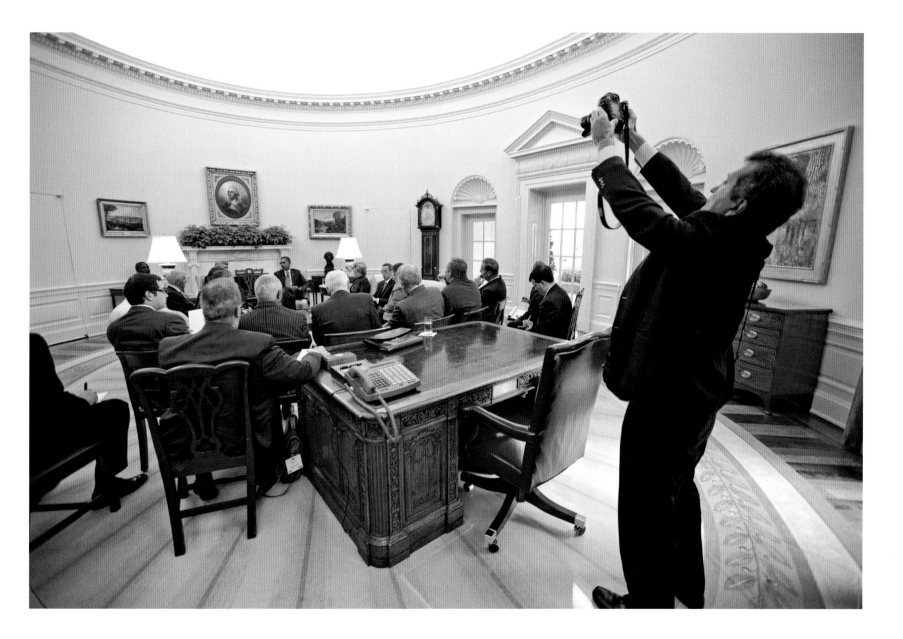

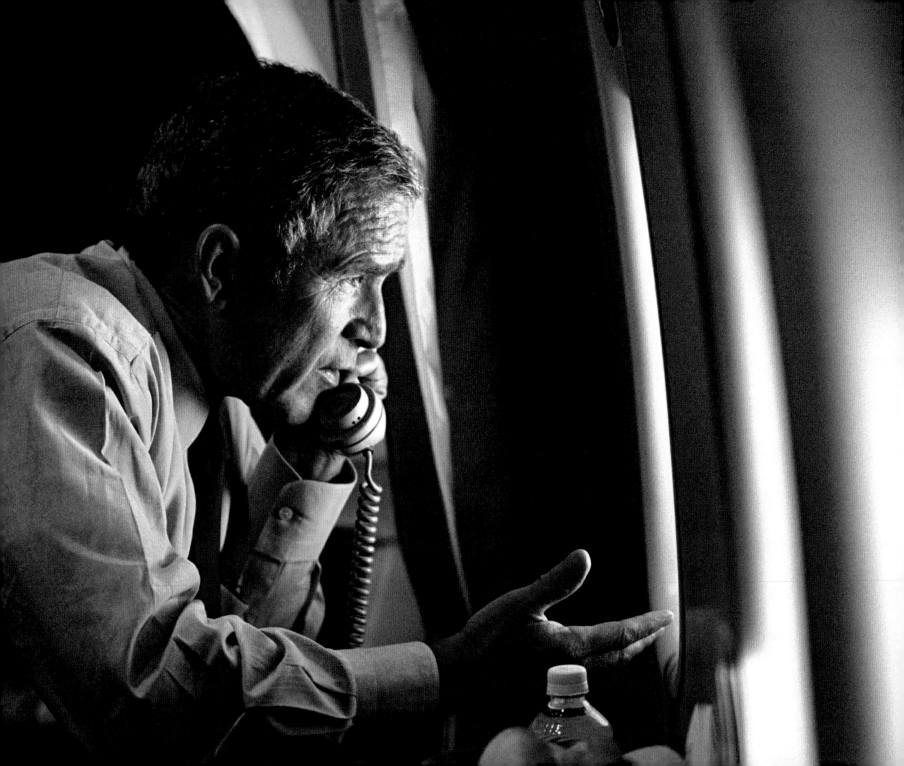

> " **That was a day that I truly felt invisible. . . .**
> I could stand just inches from the President and make pictures,
> **and he would look right through me.**
> It was almost like I wasn't even there."
>
> —ERIC DRAPER

PART TWO | *Mundane and Momentous*

Pages 154–155: Are things as they seem? Pete Souza's image of the press corps (left) is a picture most people immediately assume is upside down. It's actually a reflection from one of the glass-topped tables in the Oval Office, perhaps a subtle reminder that life in Washington always merits closer inspection. That was often the case whenever President Richard Nixon spoke to the press (right).

"9/11 is a good example of why there is a White House photographer," explained President George W. Bush. When chief of staff Andrew Card told the President that a second plane had hit the World Trade Center, a mundane visit to a Florida elementary school became, in a matter of seconds, a momentous day. "I knew it was going to be a very historic day," recalls Bush photographer Eric Draper, "so I tried to document every moment." He captured the President conferring with Vice President Dick Cheney from Air Force One after departing Offutt Air Force Base in Bellevue, Nebraska, September 11, 2001.

Even with a level of access that makes the working press salivate, the majority of moments any presidential photographer gets are pedestrian. But covering an administration "for history," as Souza likes to say, means you *get* the mundane and *hope* for the monumental.

Each administration has a handful of iconic moments, points where an administration, and history, turned for the better or worse, captured in the instant release of a shutter. These images can have such power that we often remember an administration more for a few of these indelible stills than for entire stacks of legislation. Try this: Ask a group of friends to tell you the first thing that comes to mind when you say Nixon, LBJ, JFK, and Reagan. What comes to mind: nose and victory sign; lined, elastic face; great hair; and great hair, respectively. All, of course, pictures. Memories are visual, whether recorded by our mind's camera or that of someone else—and the still image seems easily stored, readily retrieved.

We don't seem to have the same relationship with motion pictures. Don Carleton, the director of the University of Texas' Dolph Briscoe Center, thinks it's because of how our brains work. "A still photograph, it's a stopping of time, and you can literally analyze all the elements in that frozen image—the clothes that the person is wearing, where they are, what's their body language. You don't do that with a moving picture. Your brain has to process too many things. You can't freeze it."

But he also argues persuasively that the unobtrusive nature of the still camera makes it easier to capture unguarded moments. Many moments of great import are the by-product of overwhelming circumstances for the participants. We all know from our own experiences that moments of great intensity come

with blinkers. Presidents and those around him are much the same, laid bare and blind to those charged with capturing the moment.

But just because an event of great power unfolds, that doesn't mean someone will be there to photograph it. So how do these images come to be? At *National Geographic* magazine, a former editor, frustrated by the demands of an annoying photographer, belittled him by saying his portfolio wasn't the product of great talent, just the ability "to put the camera on 5.6 and be there," a reference to the aperture setting on the camera that's right in the middle of all the possible settings for light. As the experiences of Okamoto, Kennerly, and Souza have shown—as will others—both access and trust buy a layer of invisibility for the photographer.

It's critical that a President accept, as did Johnson and Ford, the idea of a photographer as a chronicler of history. Since the advent of official presidential photographers, only the Carter Administration did not name an official photographer. If you try the memory experiment with Carter, you'll likely get an image—mine is of the President flanked by President Anwar Sadat of Egypt and Prime Minister Menachem Begin of Israel, their hands all clasped together—but it wasn't taken by a White House staff photographer, but rather by wire photographers, either Bob Daugherty or Wally McNamee.

In many respects, Carter seems to have done himself, and students of history, a great disservice by not having a chief photographer. "If you look at the photographs that came out of the Carter White House, there's nobody trying to tell Jimmy Carter's story, there's no candid kind of revealing sort of stuff like the Ford Administration with David Kennerly. It's just sort of a kind of a chaotic accumulation of images that don't necessarily interconnect with one another," says Carleton. This is doubly baffling in Carter's case.

Much like President Ford, Carter was dealing with a country recovering from the closed Presidency of Richard Nixon. But Carter seemed to be allergic to the idea of having a personal photographer, especially someone like Kennerly. In fact, Kennerly is fond of recalling a famous remark by Carter's chief of staff, Hamilton Jordan: "There will be no David Kennerly in this White House." In Carleton's view, Carter missed out.

Presidential photographers aren't exclusively on the lookout for history—they'll happily capture any moment that further defines the personality of the President. In August 1986 Pete Souza made a picture of this quintessentially Reagan moment, tossing a paper airplane from the balcony of his Los Angeles hotel.

"I think that any President that does not have their administration photographically documented is really losing out in history. They're really shutting off a doorway, a pathway that people can take to understand their Presidency. And I think was a mistake that Carter made."

It's posterity's loss. The ability to look at candid images leading up to the signing of the Camp David accords would allow for a much deeper analysis of mood, tone, and atmosphere, critical elements to understanding turning points in history—some of these images exist, but they don't have the intimacy you see in administrations where an individual has a well-developed relationship with the President.

In spite of relationships like that with their obvious benefits of access, sometimes getting pivotal, history-making images is just a function of being in the right place at the right time.

President Reagan's photographer, Michael Evans, had previously worked as a news photographer for the Cleveland *Plain Dealer* and the *New York Times,* and had covered the Reagan campaign for *Time.* Like most successful presidential photographers, he'd established a relationship with Reagan over several years of coverage preceding his run for the Presidency. Hard to beat the credentials, but on the day that John Hinckley attempted to shoot the President, Evans had a lousy angle. In some ways, being close to the President put Evans at an immediate disadvantage; however, closer inspection of his frames that day reveals that they are valuable in their own right.

On March 30, 1981, Evans was covering the President giving a luncheon speech to the AFL-CIO at the Hilton Hotel in Washington, D.C. As the President departed the hotel, Hinckley fired six shots from a .22-caliber pistol, wounding press secretary James Brady, Secret Service agent Timothy McCarthy, D.C. police officer Thomas Delahanty, and President Reagan.

Evans, who is visible in video footage of the attempt, was trailing a few feet behind the President, initially too close and on the wrong side of the assault to make definitive frames. In a twist, Associated Press photographer Ron Edmonds, photographing the President from the opposite side of the limo, captured three critical frames revealing the moment of impact. For his coverage of the attempted assassination, Edmonds won the 1982 Pulitzer Prize for spot news photography.

In the video footage, Evans is right there after the shots, camera up and making images. But only

minutes later, when he saw Reagan go by on a gurney at George Washington University Hospital, his instincts as a news photographer failed him. "I froze," he wrote in a 2004 memoir for the online magazine *Digital Journalist,* "I knew I had come to respect Ronald Reagan, but I didn't realize how deeply my affection ran until that moment in the hospital. It came as a complete shock. I felt as if my own father had been shot. I just sat there for an hour, devastated. It never occurred to me to take any pictures."

After four years at the White House, Evans moved on, completing a landmark portrait project he'd begun while working for Reagan. Called *People and Power: Portraits from the Federal Village,* it featured almost 600 portraits of Washington power brokers, from the Chief Justice of the United States to the senior janitor at the Capitol.

It was Evans who hired Pete Souza in 1983. After Evans's departure, Pete shared the duties with four other photographers throughout Reagan's second term. That limited the quality of the access, Pete says. "I think access is better when there's one person," he explains. "It's the whole trust thing. If you are rotating four people in and out, it's hard to develop the trust you need, not just with the President, but with senior staff." Over time, Pete worked on his rapport and access, putting him inside right when Reagan and Soviet leader Mikhail Gorbachev began making major headway on ending the Cold War.

In October 1986, in Reykjavík, Iceland, the two leaders attempted to negotiate the most sweeping arms-control reduction in history. When Gorbachev tried to include the elimination of Reagan's Strategic Defense Initiative, colloquially known as "Star Wars," Reagan refused. The talks broke down.

Pete's images reveal critical moments as the aftermath unfolded. Prepared remarks, which envisioned a positive outcome, had to be torn up. One shot reveals Reagan and his top advisers intently scratching out and rewriting. "You could hear the military band outside playing music to fill time so they'd have time to finish his remarks."

The images Pete got, and some of what he heard, are critical tools for history. As Gorbachev escorted Reagan to his limo, Pete snapped several shots then heard Gorbachev tell Reagan through his interpreter, "I don't know what else I could have done." Pete heard Reagan's curt reply, "You could have said yes." "To me," says Pete, "that seemed like the height of the Cold War." Souza's images from their final moments

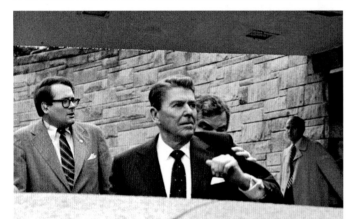

President Reagan's chief photographer, Michael Evans, was walking several paces behind as the President exited Washington's Hilton Hotel on March 30, 1981, when shots rang out. Associated Press photographer Ron Edmonds, standing on the opposite side of the presidential limousine, made three quick images (left), likely including the moment the President was struck by a bullet. Evans's picture (opposite) taken an instant later reveals the aftermath. White House press secretary James Brady, being attended to by White House aides, and Washington, D.C., police officer Thomas Delahanty, at bottom center, lie on the ground after being wounded. Edmonds later won the Pulitzer Prize for spot news photography for his work.

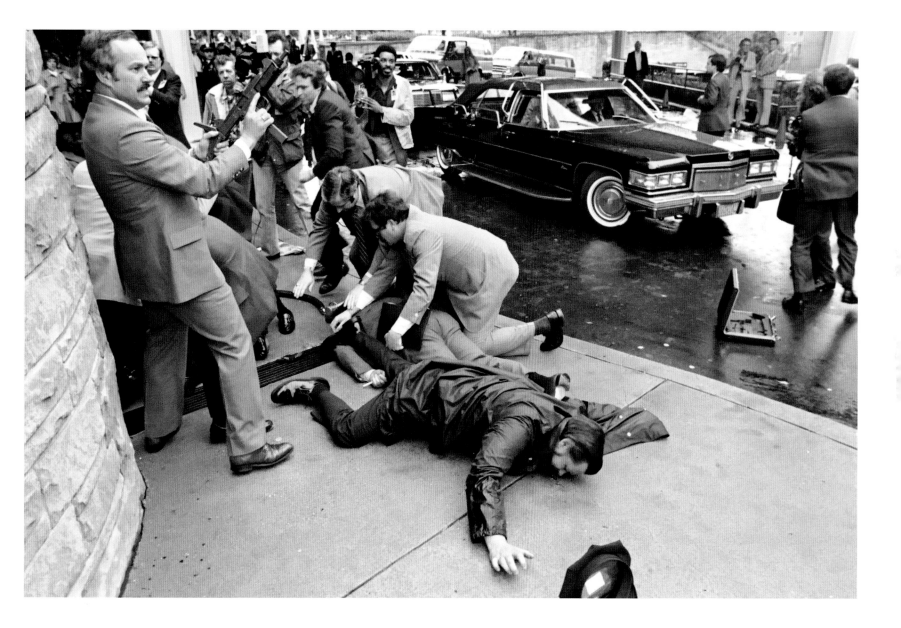

together show the two leaders, grim faced, and in Reagan's case, deeply upset. "I just don't think I'd ever seen Reagan that angry before," Pete remembers.

About a year later, Pete was able to make a remarkable picture, the antithesis of the anger sequence he saw in Iceland. Taken in the Oval Office, a series of images reveals the leaders again, no longer grim faced, working hard on a deal. Animated and caught up in the moment, Reagan is making a point that will resonate down the ages—reduce the number of weapons. During the same visit, in a far more public image, we see the leader of the Soviet Union extending his hand to the President of the United States in congratulations on securing the historic INF (intermediate-range nuclear forces) treaty. It was the beginning of the end of the Cold War.

The value of these images has to resonate with the President or they won't happen. President George H. W. Bush decided in favor of history when he hired his photographer, David Valdez. And like Ford, Bush didn't shy from a personal connection. "You've got to have a personal relationship with these people, I think, to make it really good, and that was easy to do with Dave Valdez," the former President says. "I think that's why his work, at least why Barbara and I loved it. It brought out what was natural, what we were about, what we thought, what we cared about, what we cried about, what we laughed about."

Valdez worked for the President throughout his White House tenure, but he started when Bush was still Vice President. As with other chief photographers who started by covering the Vice President, the smaller staff and less charged atmosphere allowed him to develop a stronger bond.

A pivotal moment for Valdez came on his very first day on the job. The Vice President was visiting his son Jeb, whose wife had just given birth to their first child. "We're in this hotel room in Miami, and Jeb comes in and I take a couple pictures, and Jeb has to leave, and he asks his dad if he could babysit, and so he takes the baby, and goes into the back bedroom." Valdez suddenly faced a choice that would come to define his relationship. "Well, it's just me and no one else and I'm thinking, Should I go in? Should I not go in? This is day one, if I don't establish it right now, it'll never happen. I'm thinking of all the other photographers that preceded me and what they had done, so I thought, Well, I've got to go into that bedroom." He went in—and took several shots of the Vice President with the baby. A few weeks later, Valdez got a note, and the keys

In October 1986 nuclear disarmament talks between President Reagan and Soviet leader Mikhail Gorbachev broke down. As the two men walked out of the meeting in Reykjavik, Iceland, Souza says he'd never seen the President so angry, a moment he describes as feeling like "the height of the Cold War."

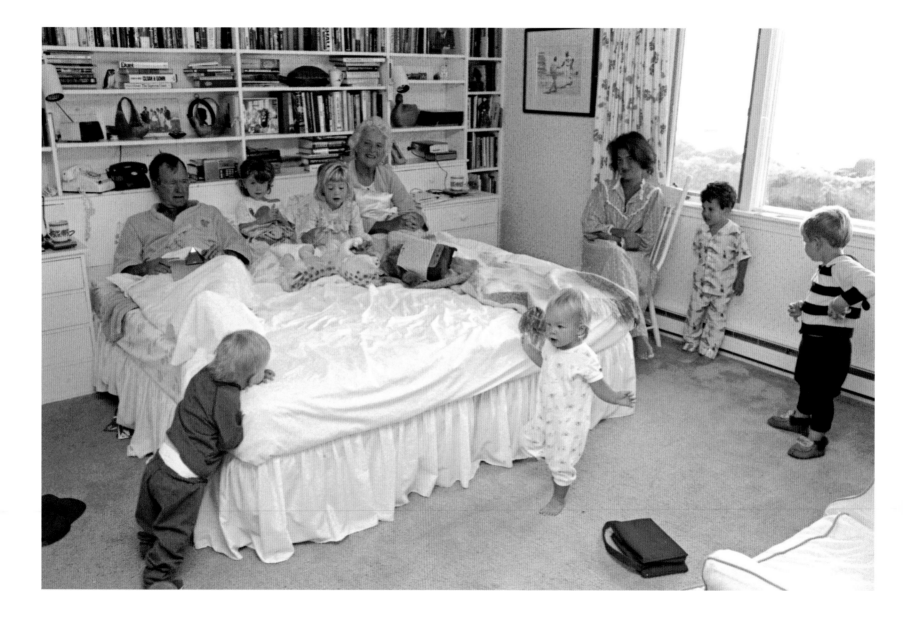

to the kingdom, from Barbara Bush. "And she says, 'Oh, Dave, I love the photos you took of George and little Jeb. As long as you take photos of my grandchildren, you can go anywhere you want to go.' "

The access and comfort level with Valdez helped him make key pictures around the opening of the first gulf war, including a shot he made immediately after the President made the decision to go to war. In it, the President walks alone on the path along the South Lawn, deep in contemplation. Valdez knew Bush well enough to understand what was going through his head. "He knows that he's going to have to put men and women into harm's way. And he's walking around, thinking about going to war and that young men and women are going to be lost, and how it impacted him when he was a Navy fighter pilot and had been shot down in combat."

"All those years of trust being built up to that moment paid off," Valdez says.

The Bushes were clearly comfortable with Valdez. His intimate relationship with both the President and Mrs. Bush is born out in perhaps his most famous photograph, an image he made one summer in the Bushes bedroom, when Bush was still Vice President. There, wearing jammies and robes, propped up in bed, the Bushes play host to six grandchildren who are running and crawling all over and around the bed. "We felt comfortable having David there," the President says of the bedroom scene. "It's kind of typical of the way our family operated then, and the way our family operates today. And it wasn't staged, it was just a moment that David captured, he saw them running around and just took some shots. I love that picture."

Valdez developed a closeness to the Bush family that placed him inside the fold. The pictures show that they obviously trusted and welcomed him—and the reward for us is a series of images that reveal a very human side of the Bushes, who clearly value their family life.

But the intimacy of his family coverage is less apparent in the images of life in the West Wing. Here things feel more distant, the coverage doesn't benefit from the same kind of proximity we have with the family. The photographer seems to show deference to power, but in some instances, as when President Bush was engaged in the first gulf war, we don't want to be deferential, we want to be right in the mix, to feel more of the intensity of moments when critical decisions are being made. An interesting exception is a shot taken in the Oval Office just a few hours before the end of the first gulf war. The President's desk

George H. W. Bush photographer David Valdez developed a warm relationship with the Bushes beginning when Bush was Vice President. He made this picture in the Bushes' bedroom at Kennebunkport, Maine.

is surrounded. President Bush and Gen. Colin Powell are both on the phone on opposite sides, north and south. Other senior advisers cover the eastern and western flanks. The photograph seems to be a curious representation of the battlefield at the end of the engagement, a view that could only be captured by a slightly wider frame.

The idea of stepping back for a better picture—it's usually the opposite in moments of great import—worked for President Clinton's chief photographer, Bob McNeely, though it was oddly serendipitous.

Moments before PLO Chairman Yasser Arafat, Israeli Prime Minister Yitzhak Rabin, and President Clinton announced a peace agreement on the South Lawn in September 1993, both sides were huddled in separate groups in the Blue Room. McNeely was getting great images in this room, a kind of prelude to peace, when he was suddenly overtaken by diplomatic events.

"I had made some pictures very close up of Clinton and Gore and Rabin and Shimon Peres, and, at one point the Vice President comes over to me says, 'Bob, the Israelis are very nervous, about a picture of, maybe, Arafat trying to hug Rabin or something before they go out, and they've asked for no more pictures in here.' "

The rare request to leave turned out to be a gift. At the last moment as McNeely was departing the Blue Room, he turned and snapped a single frame. In that picture is a far more accurate and nuanced picture of what was really happening that day. The prime minister and foreign minister of Israel and Clinton stand on one side of the room, while Arafat stands in a small group on the opposite side with a large table in between. Light streams in from tall, south-facing windows, a gulf the size of the sun divides the room. Yes, there would be a pronouncement of peace and agreement, but the reality of peace would be ever elusive. Carter's noble peace efforts lack this kind of documentation. Clinton's don't and the Clinton record is the richer for it, even if, for McNeely and for us, it was kind of a fluke.

"I just loved this picture. At the time, I thought to myself, 'Thank you, Mr. Vice President,' because I wouldn't have made this, I was too focused in, too tight." Still, McNeely's shot was exceptional. He was quick, technically precise, and, most important, he framed the shot with a kind of instant artistry. The picture is graphic validation of a decision President Clinton made to allow his photographer almost

Valdez captured the moment when, just a few hours before the end of the first gulf war, both Gen. Colin Powell, at left, and the President are speaking directly with Gen. Norman Schwarzkopf, the commander on the ground.

unfettered access to his Presidency. Most of it will be mundane, but unless you are always there, "taking pictures of everything," as McNeely says, you might miss something.

"You can't take great pictures every day in the White House," says David Kennerly, remembering how it was, how it is. "They are meeting, people talking, blah, blah, blah, all day long. That's what they do over there. The only time there are really good meetings is when there is some shit hitting the fan that makes it dramatic. The best pictures come then—there's an important event and you're inside it."

President George W. Bush's photographer, Eric Draper, had the bittersweet fortune of being inside just such an event. For roughly 14 hours on September 11, 2001, Draper shadowed the President on perhaps the most momentous day in modern American history.

Draper had covered candidate Bush and after the election, along with everyone else who had worked on or covered the campaign, he was invited to a party at the governor's mansion. "So I decided to take a page out of his playbook, which during the campaign, during the speeches, he would always say, 'I'm going to look you in the eye and ask you for the job. I want to be your President.' And that's what I did." When he had a chance to shake the President-elect's hand, he raised it. "I said, 'Thank you for inviting my wife and I—by the way, I want to be your personal photographer.' "

Draper is the only presidential photographer to cover an entire administration, from the day the President-elect left Midland to the day he returned. "I saw it as a long-term project, a photo story in my mind," he explained. "I made an image of him looking back at Texas for the very last time and just as he approached the door he saw me and he had a big smile on his face and he said, 'Eric, welcome aboard. We'll see the world together. You, me, and the doctor, the military aide, we'll see everything.' "

On the threshold of the next eight years, it could only be an understatement.

His most memorable day began in Florida with a routine visit to an elementary school. When the first plane hit the Trade Center, everyone thought it was an accident.

"Of course, when chief of staff Andy Card whispered in the President's ear, it changed everything, just dramatically," Draper recalls. "And at that moment, I knew it was going to be a very historic day, and I knew I was going to be making a lot of pictures that day."

"I remember calling, and I found Laura and she was fine. And our girls were fine," the former President said. "And I remember finding mother and dad and I said, 'Mother where are you?' And she said, 'In Wisconsin.' I said, 'Why are you in Wisconsin?' She said, 'Because you grounded our flight.' So that was probably the only moment of levity in that day."

It was initially very confusing because no one knew the scope of what had happened. Draper remembers that they spent a lot of time watching TV, a rarity for the presidential entourage, but everyone was trying to figure out what was happening and cable news was the best source. Draper's story was to capture a desperate struggle to get information.

"There were some days where I truly felt invisible, just a handful of days during my eight years, and that was a day that I truly felt invisible. I could stand just inches from the President and make pictures, and he would look right through me. It was almost like I wasn't even there."

For Draper, it was an unprecedented opportunity, the kind of situation most presidential photographers crave, though he describes it as "documenting a nightmare." With first the towers, then the Pentagon, then the fourth plane and the constant uncertainty of what might happen next. The hallmark of any presidential trip in any administration is precision scheduling. Everyone knows where to go, when to be there, who to meet with, where to eat, and often even what will be said. To suddenly have all that structure jettisoned was unsettling in the least. But it became far graver. Draper was so close to the President, he had the distinct feeling that he was part of the target.

"There was a point when we finally arrived on the plane and were taking off and Andy Card, the chief of staff, walked through the plane and said, everyone take your cell phone batteries out. You know, we don't want to be traced.' . . . [A]nd you know, those first few moments on the plane were very intense, because it was all about the physical safety of the President."

In spite of the danger the President wanted to return to Washington, but he was told it wasn't safe. Adding to the anxiety about their own safety, Draper explains that they started to pare back the staff and traveling press. On their first stop, all but essential personnel left *Air Force One.* Back up in the air, still grappling to get details of what was happening, it became, in Draper's words, "more surreal."

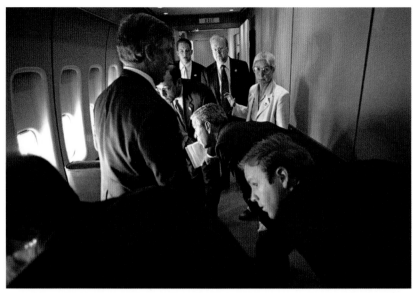

★ ★ ★ "It was kind of mesmerizing as we approached Washington. Looking across the horizon you can see the smoke rising from the Pentagon. And at that moment it truly felt like a war, it felt like we had been attacked. It really sunk in—to physically see that."

"There were these reports that the staff were talking about aboard the plane, including false reports when all this was breaking during the early moments, including, you know, 'a bombing at the State Department,' and oh, 'Sir, there's a fast-moving object headed toward the ranch.'" The emotional roller-coaster culminated with the most frightening rumor of all. "The eeriest moment was when the President stepped out of the cabin and he said, 'I heard that Angel is the next target.' And 'Angel' is the code word for *Air Force One*. And so that just made it, I mean, really, pretty intense and it was like a nightmare."

One of many striking things in the telling of both Draper's and the President's accounts, is how little was known.

"We were uncertain as to whether or not *Air Force One* was a target," the former President explained. "There was a caller with the *Air Force One* code name, Angel. He said, 'Angel is next.' And at this point in time people were taking every threat incredibly seriously."

Though they were dependent on TV for basic information, they couldn't remain on the ground where they could receive the signal because it wasn't safe. This was before the plane had satellite TV.

"So, in order to receive reception, we would have to fly over a major metropolitan city, and so that would make it even more surreal aboard the plane in listening to the reports and seeing the TV fade in and fade out."

For several hours, like everyone else traveling with the President, Draper was unable to make a phone call, unable to connect with his wife. When he finally did, he explained he'd be late coming home from work. She laughed. His excuse this time was, she supposed, pretty solid.

Toward the end of the day, the President was finally cleared to return to Washington.

"As we approached Washington, everyone started saying, 'Oh, look, the fighter jets are flying with us,'

George W. Bush chief photographer Eric Draper's sequence of 9/11 images tells a riveting story. Desperate for information, the President takes notes while TV news coverage of the burning towers plays in the background (top left). Later in the day, F-16 fighter escorts (bottom left) draw the attention of everyone on board Air Force One, *including the President (top right). Finally at the end of the day, the President recounts the events in the Presidential Emergency Operations Center, which some people call the Bunker, with Vice President Cheney (bottom right). It was like "documenting a nightmare" Draper says, partly because of "not knowing when we would return home."*

and, so everyone wanted to get a look out the windows. The jets were so close, you can see basically the whites of the eyes of the pilots. They are literally right on the wing." When the President looked out the window, he was surprised to see that the jets were from the unit he'd been part of at Ellington Air Force Base.

"It was kind of mesmerizing as we approached Washington. Looking across the horizon you could see the smoke rising from the Pentagon. And at that moment, it truly felt like a war, it felt like we had been attacked. It really sunk in—to physically see that and of course, it made for very dramatic images, everyone, looking, seeing that for the first time."

When thinking about the effects of being exposed to so much history, so much intensity, it's important to differentiate between experiencing these things and photographing them. When questioned about whether they remember anything that was said in important meetings or recall details of momentous events, presidential photographers often talk of a kind of camera-induced amnesia.

"You know, I don't think I really digested, in my mind, everything," Draper says in recollecting 9/11. "I think a lot of times using the camera as a distraction worked for me. Focusing on the moment and the technical parts of the job, I had the advantage of being totally distracted by that. I just reacted to things. I tried to use my gut, my instincts to try to capture moments that told a story. So, I was lucky. You know, I didn't have to think about it too much because of the camera."

A few days later, even the camera couldn't protect Draper from the full impact of what had happened. "To see ground zero for the first time, you know, to physically be there was very emotional."

"The destruction was incredible. It was like entering the gates of hell," the President said.

"People were carrying around pictures of their loved ones and just holding them out, to show people what they looked like, almost as if they were asking anyone and everyone, you know, Have you seen my father? Have you seen my brother? And it was just the saddest scene ever," Said Draper. Draper recounts that the President "hugged anyone" and everyone in what became an emotional roller-coaster for all involved. Eric Draper is a former Associated Press wire photographer, the kind of professional who releases the shutter as reflexively as he breathes, which makes his final word on the day all the more powerful. "It was very hard to lift my camera and take pictures." ★

"The destruction was incredible," President Bush said, describing his first visit to ground zero on September 14, 2001. "It was like entering the gates of hell." At one point, the President climbed onto the wreckage of a fire truck and, standing next to firefighter Bob Beckwith, gave an impromptu speech on a bullhorn. Eric Draper described it as one of his hardest days as a photographer.

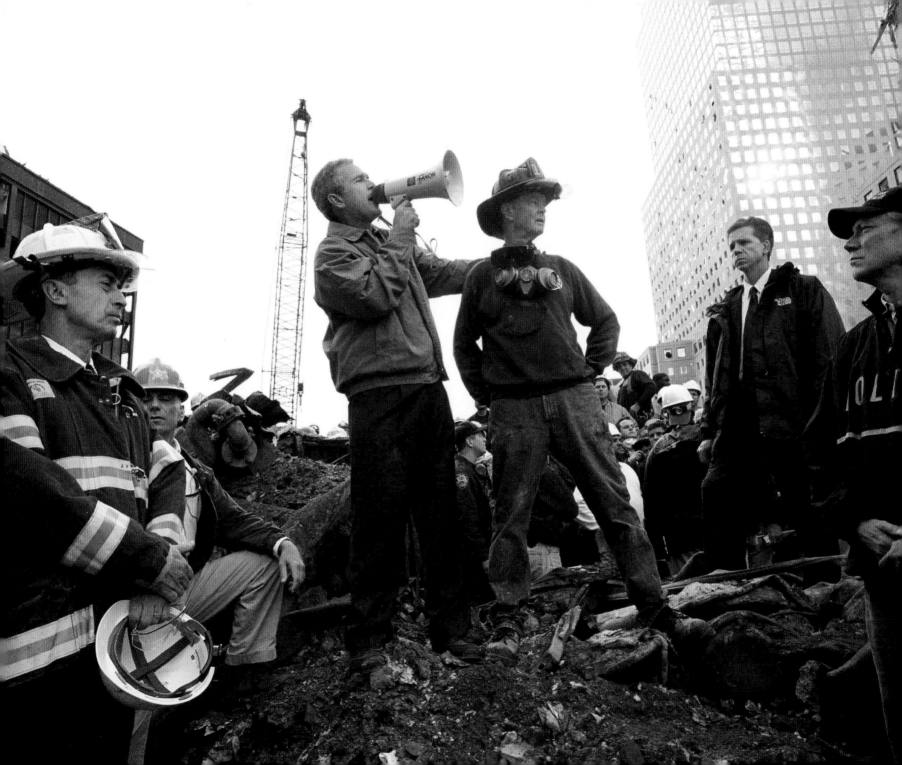

CHAPTER FIVE

20,000 Pictures

PART ONE: *Extreme Multitasking*

PART TWO: *Telling the Story*

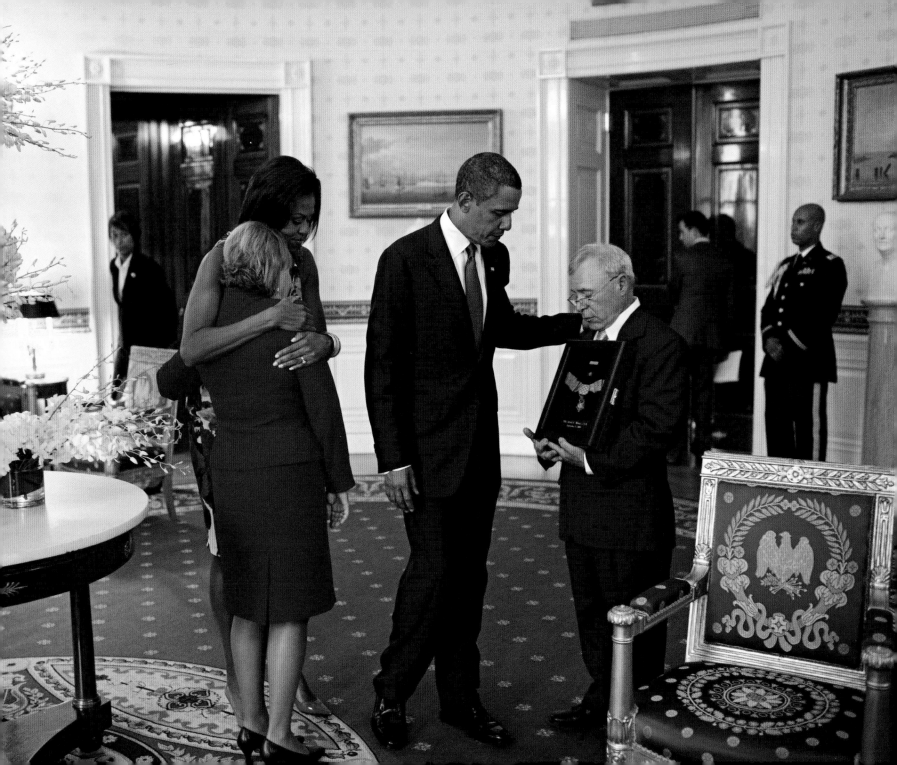

> ❝ And it's really sort of nice for me to hear people appreciate the photographs, and the *kind* of photographs that they don't see in the newspaper— that these are more real. ❞

<div align="right">

— PETE SOUZA

</div>

PART ONE | *Extreme Multitasking*

<div align="center">

11:57 A.M.

</div>

Besides blood pressure, another useful measure of the intensity of the White House photographer's life is the volume of images they produce. "I'd say a really busy day for me would be maybe 1,200 frames," Eric Draper remembers. "An extraordinarily busy day, like the Inauguration Day, I made nearly 2,600 frames." In a day that lasted roughly 16 hours, Draper probably spent about 10 of them patiently waiting to get his shots, which means for the remaining 6 hours, he was blasting away at a rate of over 400 frames per hour.

Souza and his staff have maintained about the same pace, averaging roughly 20,000 pictures per week. It makes a lot more sense when you see how stacked up a typical week is for Pete and his crew.

Immediately following his coverage of the visit of Prime Minister Stephen Harper of Canada, Pete faces an onslaught of action over the next 48 hours: An event with American Olympic athletes on the South Lawn, a speech at the annual Congressional Hispanic Caucus Gala, meetings with the president of the World Bank and director of the IMF, a Medal of Honor event where he will meet the family of a recent recipient, a two-hour National Security Council meeting, and a speech and rally in support of the President's health care initiative. This doesn't even count coverage of the comings and goings of VIPs and routine meetings with staff that happen every day.

"The schedule's not *too* crammed," Pete says, revealing where he is on the blood pressure issue (pretty low), "but you never know what's going to happen. Like yesterday, they had to add some phone calls to a couple world leaders and that kind of messed up the schedule." You'd think this would generate a little

Pages 176–177: Framed by the historic colonnade that connects the Residence with the West Wing, the President heads back to the Oval Office for an evening's work in February 2009. The slight ramp at the end of the walkway was put in place so President Franklin D. Roosevelt could access the building in his wheelchair.

The President and First Lady console Paul and Janet Monti, parents of Army Sgt. 1st Class Jared C. Monti in the Blue Room following a Medal of Honor ceremony at the White House in September 2009. Roughly three years earlier in Afghanistan, in June 2006, Sergeant Monti, without hesitation or concern for his own safety, left the safety of cover and under heavy enemy fire attempted to recover one of his men, wounded in battle. Initially turned back by withering fire, Monti made two additional attempts to reach his man before being mortally wounded.

★ ★ ★ Because the West Wing is fairly small, things that don't seem to go together are jammed cheek by jowl. At the bottom of the steps, you're standing in the White House mess, but go five feet to the right and, assuming you have the proper security clearance, you'd be standing in the Situation Room.

stress. "The taking of the pictures isn't stressful, it's all the other stuff," Pete says, referring not just to the management side of the job, but to the mundane things that people with spare time don't even think of. "It's coordinating dropping off your dry cleaning and picking it up," he says, knowing he'll be working late tonight. "The dry cleaners close at seven. So, you know, I can't pick up any dry cleaning today. Now tomorrow, since we're in town, I should be able to swing by the dry cleaners."

And then there's food. Pete placed his order about an hour ago when he was upstairs, outside the Oval. He'll have 20 minutes to eat it. He walks out his office door to the right, heads down the hall, turns left, and drops down a few steps. Because the West Wing is fairly small, things that don't seem to go together are jammed cheek by jowl. At the bottom of the steps, you're standing in the White House mess, but go five feet to the right and, assuming you have the proper security clearance, you'd be standing in the Situation Room.

The White House mess consists of a pickup window and a number of different dining rooms, some reserved for senior staff. While waiting in line to pick up his order, Pete sees Chuck Kennedy, the assistant director of the Photo Office, and talks strategy with him about how they'll cover the upcoming Olympic event on the South Lawn. All four photographers will be on this one, covering from a variety of angles. Pete reaches the window and is served by someone wearing an apron that's decorated with the seal of the President and reads "Presidential Food Service." He picks up a very nice looking piece of salmon on a bed of vegetables, nabs his cutlery, and heads back to his office. Judging from the number of to-go containers being handed out, all of which are biodegradable, a large number of White House staff dine at their desks.

There is life beyond work. Moments outside the official day often give Souza unique insights into the man he's covering. On his way back to work, the President runs into his daughters after they've returned from school (opposite, left). A competitive cager, the President blocks the shot of his personal assistant, Reggie Love (opposite, right). No small feat, and no wonder it's one of the President's favorite pictures: Love was a member of the 2001 NCAA Championship Duke basketball team.

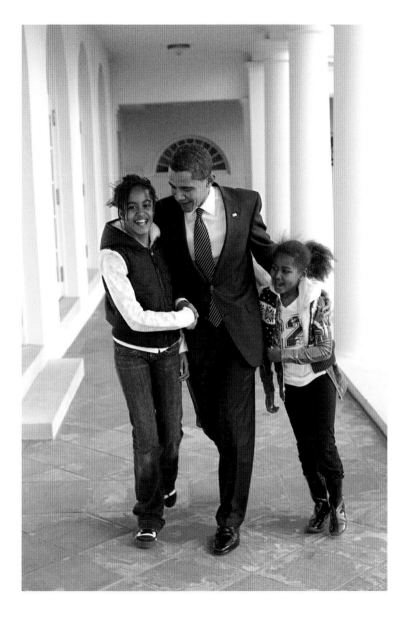
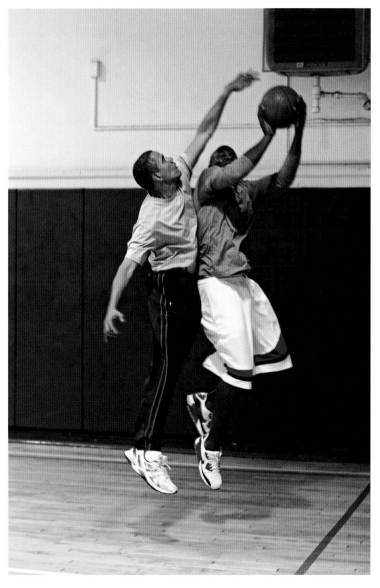

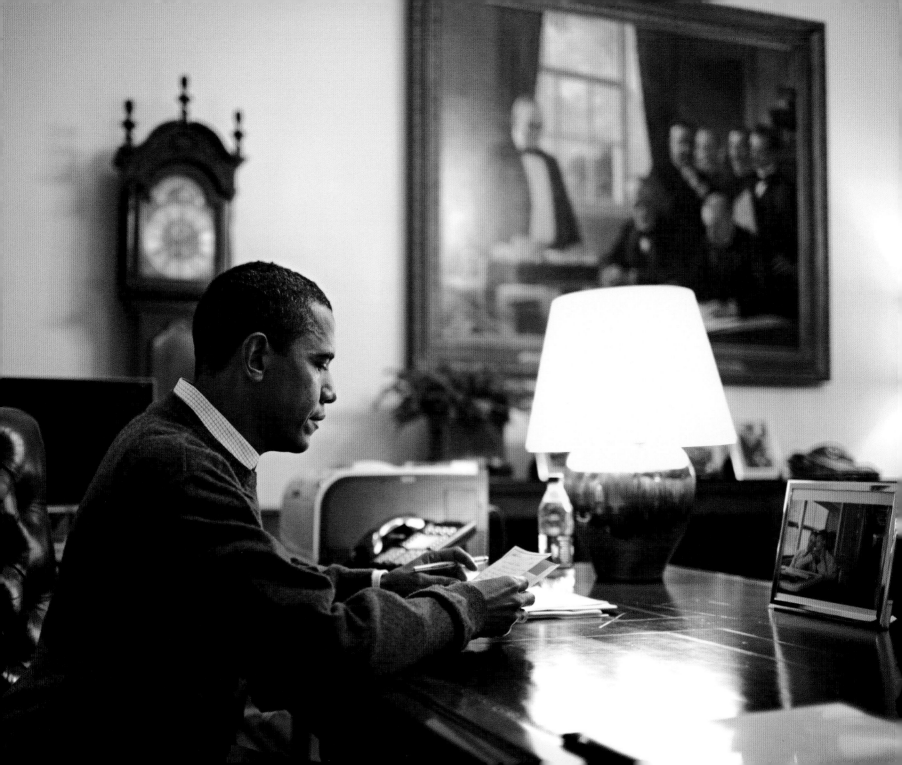

Back at his, Pete continues talking to Chuck, finishes eating, packs up his bag, and then heads out the door. He climbs the stairs to the main floor and heads toward the colonnade that runs along the Rose Garden, the main thoroughfare from the West Wing to the Residence. As he exits the door, he explains that the ramp he's walking down was built so that FDR could access the Oval Office in his wheelchair. Always walking through history at the White House.

It was FDR's cousin, Theodore Roosevelt, who built the West Wing. We take it for granted today, since it's been immortalized in pop culture via the TV hit *The West Wing* and by way of daily news coverage, but prior to 1902, it didn't exist. Up until then, the President lived and worked on the second floor of the Residence. The west end of the second floor was reserved as the presidential apartment, but his main office and those of all of his staff took up the rest of the floor. With the arrival of the Roosevelts and their six children, there would be major changes at the White House. Not only would the young President officially change the name of the mansion to the White House, he would oversee a complete renovation of the mansion and the construction of an office building to the west designed to house the President's staff and office.

Built in only six months, it was originally envisioned as a temporary structure. After a century as the symbolic focal point for national life, no sane leader, certainly not Roosevelt, wanted to distance themselves from the White House and its legacy of Lincoln, Jefferson, Madison, and Adams, who was the first to move in, in 1800. In fact, many congressmen angrily objected to being received by President Roosevelt in the West Wing as it had none of the cachet of the White House itself. After the renovation, Roosevelt preferred to conduct most of his business in his office in the Residence. Taft, who followed Roosevelt, did the same.

When the West Wing was built, officially called the Executive Office Building, there was no Oval Office, but simply something called the President's Room, connected by sliding doors to another room for Cabinet meetings. Taft created the first Oval Office in 1909, borrowing the oval shape from the three oval-shaped rooms that grace each of the three floors in the Residence. Over the next hundred years, it gradually earned its iconic status as the symbolic source of burgeoning American power.

President Obama reads one of ten letters from the public selected each day from the thousands he receives. He sits at his desk in the Treaty Room, which he uses as an office in the private Residence. The room is so named because President William McKinley signed the peace treaty with Spain ending the Spanish-American War of 1898 in this room, an event commemorated in the painting behind.

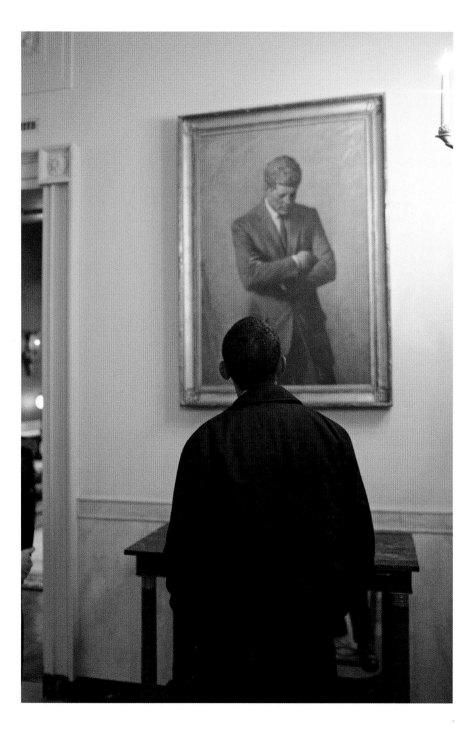

Burden of history, affairs of state. On his fourth day living in the White House, the President stops for a moment beneath the Aaron Shikler portrait of a similarly contemplative John F. Kennedy (left). The portrait hangs just outside the State Dining Room where the President, fortified by all that thinking, sits with Blue Dog Democrats to talk about coalition building (opposite).

Pete enters the Residence on the ground floor, making his way down the wide cross hall, turning right into what's called the Map Room. Here, during World War II, Franklin Roosevelt and his commanders conducted the war, communicating with battlefield generals and plotting strategy on large maps, many of which had been prepared by cartographers at the National Geographic Society. The room is now decorated like an elegant living room, but it still has some maps on the wall. Today the Map Room is serving as a holding room for VIPs who are about to launch an event marking Chicago's effort to secure the 2016 Summer Olympics.

In more casual situations like this, when the President and First Lady can interact out of the eye of the working press, the hunting is fruitful for Pete. He gets the President kidding with U.S. gold-medal heptathlete Jackie Joyner-Kersee: "Now, Jackie, maybe you could explain why the American team dropped this? What's so hard about, you know . . . ?" as he reaches back for a baton. A few minutes later Pete circles the President and Chicago Mayor Richard Daley, who are quietly talking strategy.

After a quick briefing about the sequence of events, the VIPs and staff head out to the South Lawn, leaving only the President, the First Lady, and Pete. He stands about 15 feet away, giving them plenty of room as they have a conversation. Pete makes a picture of a nice moment when the President gives Mrs. Obama a little kiss on her ear just before they head out to the event.

When Pete gets out onto the South Lawn, he surveys the situation and realizes there's a problem. An out-of-town photographer who has special access to cover the event for the organizers is standing right behind the podium, putting him in the press pool's shot. Pete knows that video and still images of the President, First Lady, and other speakers at the podium will be marred by having a photographer in the shot; he had warned the visiting photographer to be careful of this, but the guy is pushing it. It's rare to see Pete get angry, but he is; he shoos the guy from behind the podium, grabbing him by the arm and pulling him away: "Get out of there! You can't be in the press shot!" Pete's intervention reveals the level of respect he has for his colleagues in the working press—he knows what they need and what they consider a "clean" shot. He also knows he'll likely one day be back there as a working photojournalist, dependent on being treated the same way.

★ ★ ★ Pete is down on his stomach, in his suit, getting a low angle: Judo masters foreground, President background. They ask if he'd like to try one of the throws, the President demurs, "That would be on YouTube for months."

After the speeches, the President and First Lady work their way around a variety of stations where different athletes demonstrate their sport. This is productive for Pete—far more dynamic than most staff meetings or greetings with heads of state. For starters, there's some action to cover and a lot of it inspires repartee between the President and First Lady, who both seem good at it. At the judo demo, the two athletes take turns throwing each other, their bodies slamming down on the padded mats. "Oh, *you* should try that!" Michelle says, and almost simultaneously, the President responds, "*I'm* not trying that!" Pete is down on his stomach, in his suit, getting a low angle: Judo masters foreground, President background. They ask if he'd like to try one of the throws. The President demurs, "That would be on YouTube for months."

Next it's fencing, where one of the athletes, Tim Morehouse, was a silver medalist at the Beijing Olympics. He's showing the medal to some of the kids who are part of the event. The President has a look at the medal: Silver, inlaid with jade, and hanging from a silk ribbon. He's genuinely impressed. "That's pretty cool. So where do you keep your silver medal?" he asks Morehouse. "In my sock drawer," the fencer replies. Obama is incredulous. "Sock drawer? Come on!" But Morehouse explains that he brings it to various events and needs quick access. For Pete, it's a great opportunity—unscripted, sincere.

A few minutes later, back in Pete's office, the superintendent of the White House grounds, Dale Haney, comes by with Bo, the Obamas' new dog. He's a Portuguese water dog, about the size of a standard poodle, with a soft black coat with patches of white fur. Bo often stops by the West Wing for a visit. Just the day before, when the President was out of the Oval Office, Pete caught Bo playing fetch in the Oval. Brian Mosteller explained that the longest throw he could make was from the Outer Oval near his own desk, through the Oval Office door, and down the length of the Oval Office. Bo chased the chew toy into the Oval, nabbed it, and raced back out, oblivious to how many lobbyists would have happily done the

Page 188: "Do you remember?" The President sings along to Earth, Wind, and Fire while dancing with the First Lady at the annual Governors' Dinner, their first formal social function at the White House, held in February 2009. Page 189: The Obamas first met their dog at a secret greet. After playing with him for about an hour, they decided to keep him, but the Obamas were about to depart for their first international trip so the dog returned to the trainer for a while. "I had to keep these photos secret until a few weeks later, when the dog was brought 'home' to the White House and introduced to the world as Bo," says Souza. Of the Portuguese water dog, Souza continues, "We're both Portuguese, so there's something happening here."

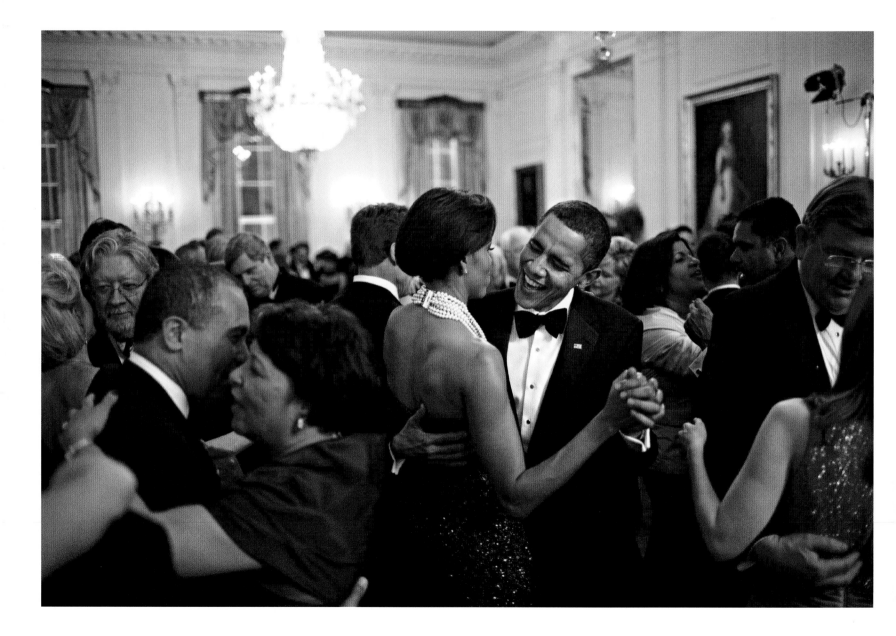

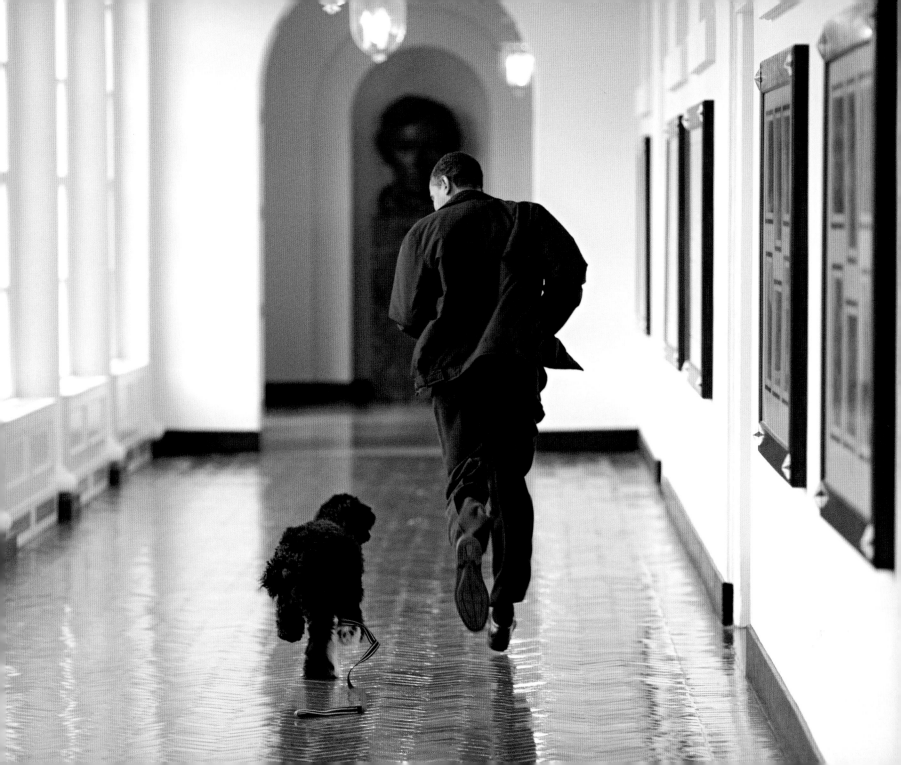

same. Pete seems to connect with the dog, petting him and playing with him a little bit. "See, we're both Portuguese, so there's something between us," he quips.

An hour later, Pete is heading back over to the Residence. He passes through one of the oval-shaped rooms, the Diplomatic Receiving Room on the ground floor, and out the doors to the South Lawn, where he is confronted by the first car in the motorcade line—the presidential limo, nicknamed "The Beast."

Although it boasts the crest of a Cadillac, the limo is really a rolling fortress about which the Secret Service is not at liberty to disclose any details. Consequently, the vehicle the President rides in is the subject of a great deal of curiosity. Security and automotive analysts suspect it probably ranges in weight from five to eight tons and is built on a GM truck chassis. That bulk comes from several inches of military-grade armor, which protects both the undercarriage and the rest of the car from attack. Its AC and heat are likely enhanced by a closed-air system to protect against chemical and gas attacks. The oversize wheels probably ride on roll-flat tires. It rides about as high as an SUV, though it's pretending to be a Cadillac DeVille. The windows are so thick, it's impossible to get a good photograph of the President through them without it seeming like he's in some kind of high-security aquarium.

In a curious way, one of Pete's jobs is to counteract the isolation represented by the RPG-proof insularity of The Beast. Bystanders watching as the President's motorcade passes by see a phalanx of black vehicles and possibly a fleeting glimpse of him, the man we, apparently, also elected to be protected.

Moments after the motorcade leaves the White House, it rolls under the Washington Convention Center, where the President will give a speech at the annual Congressional Hispanic Caucus Gala.

For security purposes, the President and First Lady often make their entrance through the absolutely least glamorous part of most buildings. In this case, it's the basement loading dock, where cinder-block walls and concrete floors meet exposed pipe and fluorescent lighting. For Pete, the starkness of the setting can enhance the image. The Obamas and their entourage enter a large freight elevator, the exact spot where Pete took one of his most memorable images of the First Couple on Inauguration night.

Pete looks over at Reggie and Marvin who, ever the jesters, have recognized the elevator and, remembering Pete's picture, are reenacting their poses in the shot from that night. Marvin explains their antics

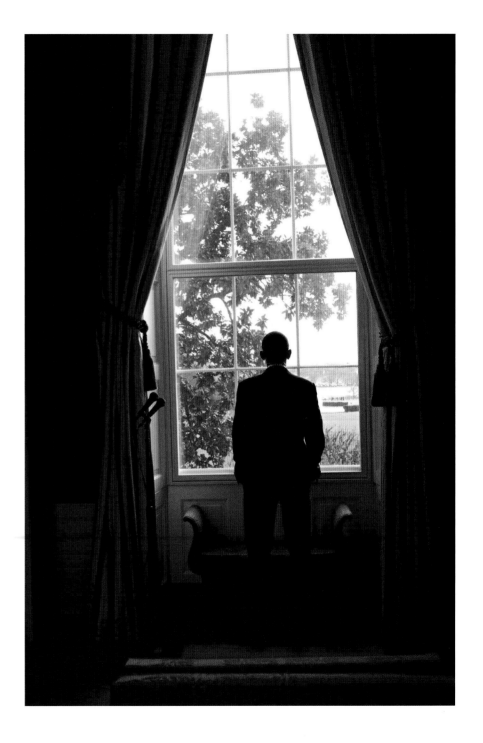

While waiting to be introduced for an event in the East Room of the White House, the President looks out a window in the Green Room toward a view of the Washington Monument and Jefferson Memorial.

★ ★ ★ "And then he didn't want to leave the East Room, up till 2:30?" Pete adds, referring to the President. "That's because he didn't have on heels," she replies. "I wasn't wearing heels," the President adds simultaneously. "He wasn't wearing stockings without pants for the whole parade," she adds, archly. "This is true," the President admits, thankful.

to the President and First Lady. "Man, that was a tiring night," the President says. "My feet were killing me," the First Lady chimes in, laughing, "Oh, that's all I think about now, the pain . . . I was all cheery at the beginning." "And then he didn't want to leave the East Room, up till 2:30?" Pete adds, referring to the President. "That's because he didn't have on heels," she replies. "I wasn't wearing heels," the President says simultaneously. "He wasn't wearing stockings without pants for the whole parade," she adds, archly. "This is true," the President admits, thankful.

A constant in the President's entourage, and a sobering counterpoint to anything lighthearted, is an officer from one of the armed services, carrying a hefty briefcase. This is the storied "football," a collection of communications equipment, decision guidelines, and nuclear launch codes at the ready in the event of a surprise nuclear attack on the United States. The "football" is never more than a few steps from the President's side. It was developed in the aftermath of the Cuban Missile Crisis in the 1960s when President Kennedy worried about the United States' ability to respond quickly to a sudden threat.

The officers who carry the "football" receive special training and must pass a special security investigation, purported to be the most demanding of any in the U.S. government. The responsibility rotates periodically through each of the five branches of the armed forces. Tonight, it's in the hands of the U.S. Navy.

Prior to the President's entrance into the event, he and the First Lady will pose individually with about 20 VIPs. Earlier in the day, Chuck Kennedy set up lights and he's ready to begin taking the official pictures, starting with an image of the First Couple with J-Lo and Marc Anthony.

The same routine is a prelude to most major speaking events. The following morning, at the University of Maryland, the President, and this time Pete, are once again in a photo line, just prior to the President delivering a health care speech. They marshal through it, the President with his eye on the bigger prize of health care reform, Pete looking forward to somehow making another major speech look interesting.

"The faces of these people really tell the story," he says quietly during some applause. "They tell you more about him than a picture of him at the podium," he explains as he works with his back to the President. This is a supportive crowd, and it is hard to discern whether people watching simply love the President or are passionate about health care reform, or both. Either way, Pete's pictures record some brand of passion.

Back at the White House at the end of the day, it is what is affectionately known as "Jumbo Night," a weekly tradition that allows Pete and his staff to share some of the emotion of their work with the White House staff.

Every week, Pete and the chief White House picture editor, Alice Gabriner, select 10 to 15 new pictures to be blown up and then hung on the walls of the West Wing. There are roughly 100 of these 20-inch-by-30-inch images on display. Over the course of a few months, the entire collection rotates out. For Pete and Alice, who actually do the hanging, it's a rare but essential opportunity to take stock in their own work.

"I've tried to introduce more variety and not just show what looks like a photo op. I try to really show the behind-the-scenes pictures, but also the working staff. Because I think people like to see pictures of key staff on the walls and I think it gives a better rounded view." Pete is conscious of his daily audience, staffers and visitors to the West Wing, but he knows that many hundreds of people tour the West Wing after hours.

"Tours start at 7:30 at night and I'll be sitting in my office at 8 and hear people talking about the photos as they're going through. And it's really sort of nice for me to hear people appreciate the photographs, and the *kind* of photographs that they don't see in the newspaper—that these are more real."

Pete's comment reveals one more unexpected aspect of being the President's photographer: When you are shooting for history, you have to realize some of your best work won't and can't be appreciated

Page 194: The President and First Lady share a laugh as they leave the state dinner held in honor of Prime Minister Manmohan Singh of India in November 2009. The East Room can hold about 220 dinner guests, the State Dining Room far fewer, so for large state dinners, the White House often uses tents on the South Lawn. Page 195: There's no better place in Washington to watch Fourth of July fireworks than from the roof of the White House.

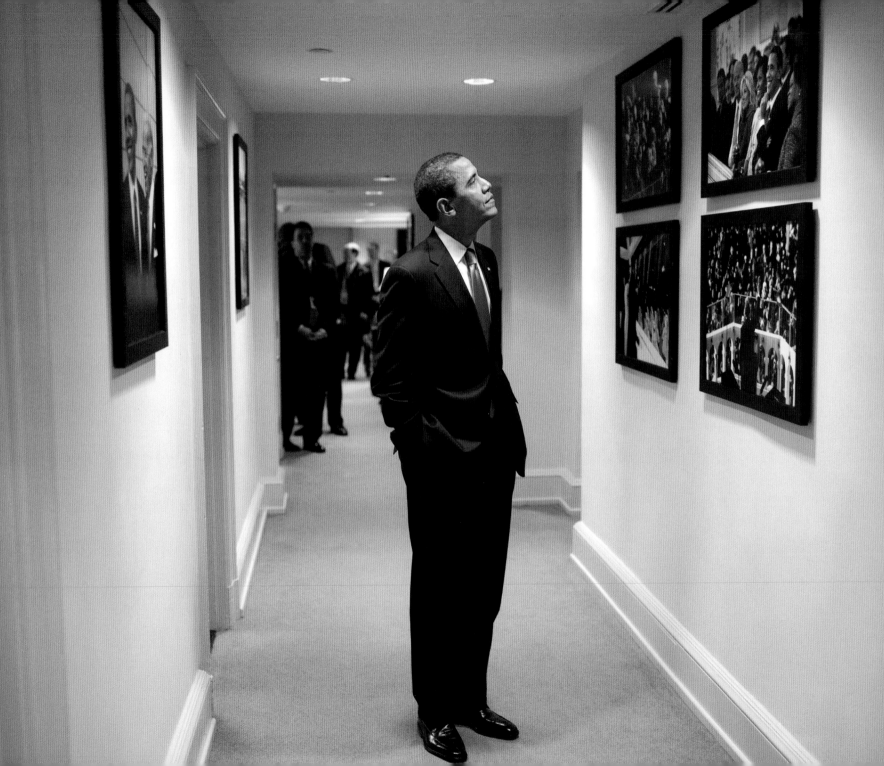

for years. As Kennerly pointed out, this is hard to swallow when you've been a photojournalist, with the public seeing your stuff routinely and the response often immediate.

Still, President Obama takes notice. Occasionally he'll visit on Jumbo Night, and one time, he flipped through each of the new images before they were put in the frames, delighting in the moments captured there. "Oh, absolutely I do. I think everybody does. Partly because Pete has a wonderful artistic eye so he's seeing things from angles that you just wouldn't expect. I think my favorite pictures are always the ones that are of little details that you would have missed in the swirl of events," the President explains. "One, I think, of people's favorite pictures is me going over a speech with my speechwriter Jon Favreau, with my scrawl all over the place. And it's just a picture of the page, and that's something that you take for granted," he says, describing a plain piece of yellow legal paper that is marked, top to bottom with revisions, additions, and notes. "When it's suddenly blown up, you realize that that sends to the public a sense of the day-to-day activities of the White House."

For the President, they also seem to reinforce the family-like relationship he has with much of his staff. "The one that is my absolute favorite, though, is the one that Pete took of me blocking Reggie Love's shot playing basketball, which I signed and we left up there I think a little longer than usual. Usually there's a rotation but through a presidential directive, I think that stayed up for two or three months."

The President routinely asks Pete for copies of particular shots, like the one of Reggie, which he signs and sends to the staffers featured. "He stopped by the other day and told me he has a new favorite in this latest batch," Pete says, pointing from his desk to a jumbo hanging on the wall across the hall. The President had just made a visit to a high-tech electronics company where they'd given him a newly published manual about their work. The jumbo shows Marvin Nicholson in the back of the limo reading a book entitled *Lithium Ion Batteries,* his arched eyebrows betraying his view on the subject.

Jumbos serve as a de facto visual journal, a way to keep track of the intense experiences and the myriad work that goes on in any administration. They remind the people who work here, and many who only visit, of the scope, intensity, gravity, and often delight in the work that is done here. ★

The President looks at prints hung just outside the door of Pete Souza's West Wing office in January 2009. The pictures, known among the staff as jumbos, make up the primary adornment in many parts of the West Wing. About 15 new images rotate in each week or so. Those that come down are highly coveted by the staff, who can sign them out for temporary display in their offices.

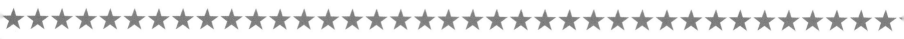

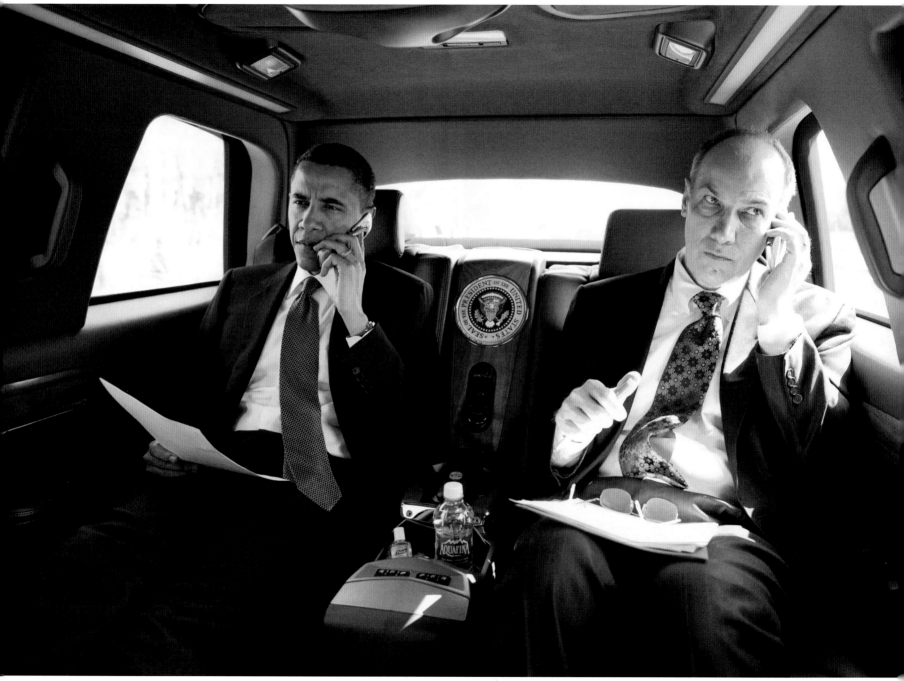

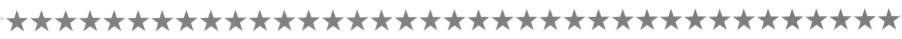
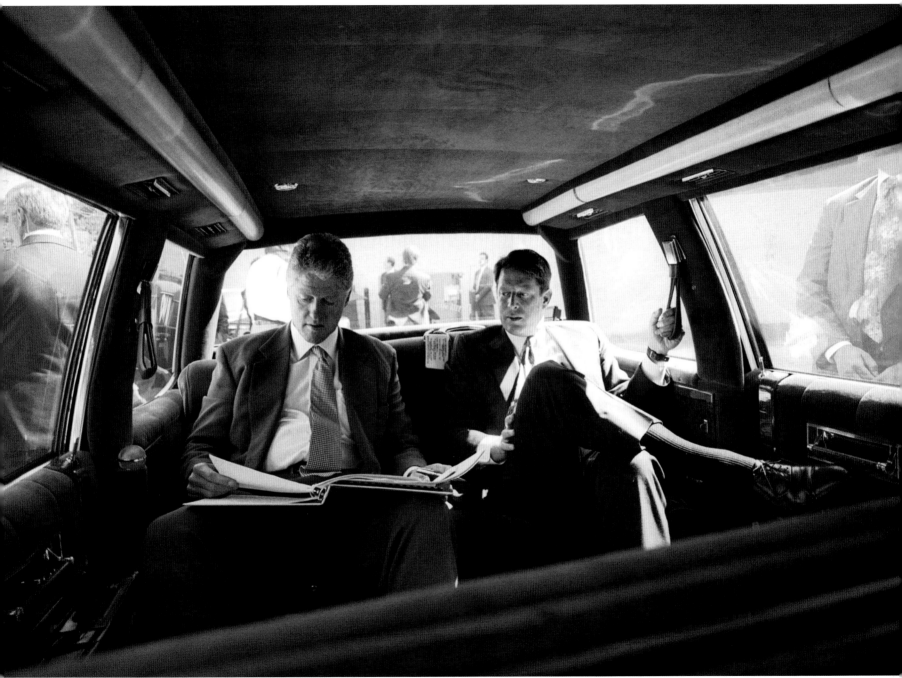

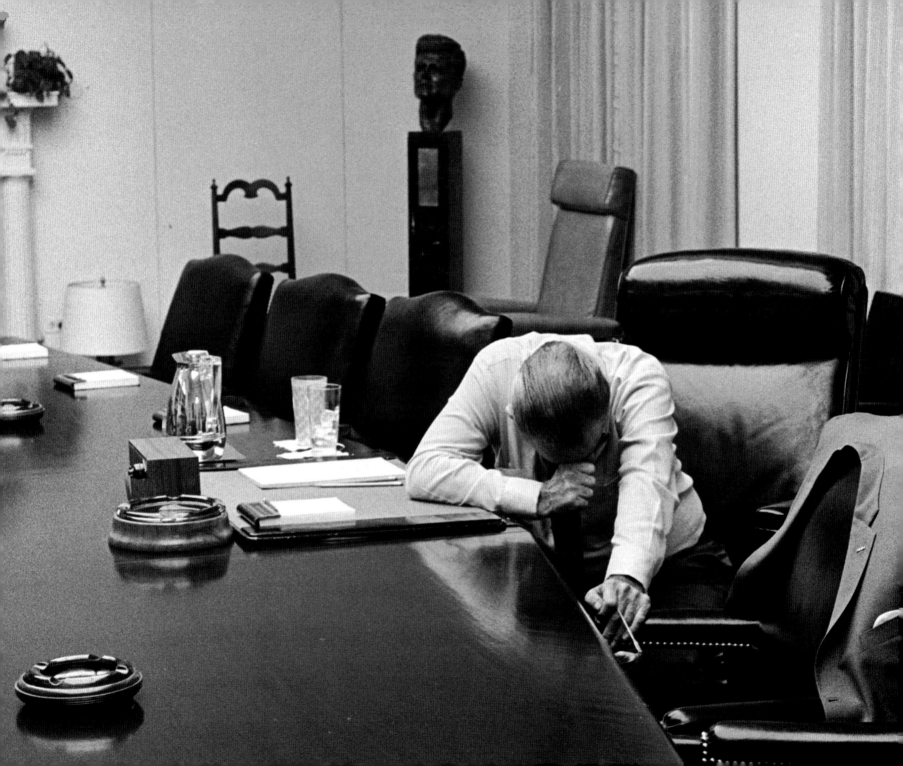

> **"He let me walk in on him at any time.**
> There were only two people at the White House, Marvin Watson,
> the appointments secretary, and myself, who had permission
> to walk in on the President of the United States at any time."
> — YOICHI OKAMOTO

PART TWO | *Telling the Story*

For the photographers, telling the story of those cumulative experiences is the primary objective. Every Presidency has multiple narratives, but one thing presidential photographers try to capture is something that runs through all of them: Not just the story of what happened, but what the President was like as it happened—a portrait of the man in power.

This type of coverage, something that really started with Okamoto, is what Clinton's photographer, Bob McNeely, refers to as telling the story of "how it worked." It's made up of the big arcs of a Presidency—legislative challenges, managing wars and crises, and other major events—further colored by coverage that evokes the character of the man in the crucible.

It typically starts with informal ground rules that each photographer establishes with his President. In some instances, there weren't any. When Lyndon Johnson understood what his photographer, Yoichi Okamoto, wanted to do, he gave him a remarkable gift, which Okamoto explained in a slide lecture he delivered in 1970.

"He let me walk in on him at any time. There were only two people at the White House, Marvin Watson, the appointments secretary, and myself, who had permission to walk in on the President of the United States at any time. Well, once he let me do that, I figured out that the responsibility would be to the historian 500 years from now." Okamoto was essentially saying he was going to shoot it all then let the historians decide what it all meant. He wasn't referring to the public relations shots he often had to do or the images the President would give as gifts to dignitaries, but rather to images that Okamoto described

Page 198: Full court press. With only three days to go before the final House vote on the President's health care bill, the President and Phil Schiliro, assistant to the President for legislative affairs, work the phones, attempting to persuade members of Congress. Page 199: The President's schedule is so packed, often scheduled in increments as small as five minutes, that it means squeezing in preparation whenever possible, as President Clinton and Vice President Gore do in October 1993.

President Johnson listens to a tape recording from his son-in-law Capt. Charles Robb at the White House on July 31, 1968. Robb was a U.S. Marine Corps company commander in Vietnam, and like many servicemen, he sent audio recordings made in camp describing his experiences. Snapped by Yoichi Okamoto's deputy, Jack Kightlinger, it shows the depth of the President's involvement in the war.

★★★ Okamoto's coverage of LBJ making decisions is priceless. It's not just humorous or humbling, it is poignant. Few faces in American history have worn the burden of power more nakedly than LBJ.

as "honest." "If you had important people discussing the important issues of the day that are going to influence the people of the world and they are oblivious to the camera, and you can get an honest picture of a crucial moment, then I figure you'd be doing something."

Okamoto had a fundamental understanding of how the Presidency operated and so he spent a lot of time photographing Johnson doing the essential task of the Presidency: making decisions.

"Lyndon Johnson made anywhere from 200 to 300 decisions a day," Okamoto explained. "He had a stack of what we called his 'reading file' when he went to bed at night, that was from a 100 to 200 pages, and each one was a decision and on the bottom was 'yes,' 'no,' or 'see me.' And don't forget the President doesn't get easy decisions. If it's a 45 to 55 decision, a Cabinet member or even a staffer could make that one. He only got the 49 to 51 decisions, where 49 percent of the people or the advisers disagreed with it or 51 percent of the people disagreed with it. So any President is going to alienate a lot of people over a long period of time because a lot of them don't agree with the decisions." Okamoto's coverage of LBJ making decisions is priceless. It's not just humorous or humbling, it is poignant. Few faces in American history have worn the burden of power more nakedly than LBJ.

But Okamoto didn't leave off coverage there. "After he made the decision he had a problem of selling the decision. You just don't make the decision. You've got to get people to agree to it and explain why he did it," Okamoto said while showing an image of one of LBJ's small press gatherings around his desk. "He saw correspondents all the time, privately like this," referring to a shot of the New York Times' Arthur Sulzberger chatting with the President while LBJ had his hair trimmed in the West Wing barbershop (now Pete's office). "He must have had an average of two appointments like this every evening."

So Okamoto's coverage can be broadly seen as a portrait in decision-making, where clearly some were far more agonizing than others. Most of the images he took can be understood in this context—they

LBJ talks with the New York Times' Arthur Sulzberger while getting a trim from White House barber Steve Martini. "He saw correspondents all the time, privately like this and in small groups," Johnson's photographer, Yoichi Okamoto, explained, "He must have had an average of two appointments like this every evening."

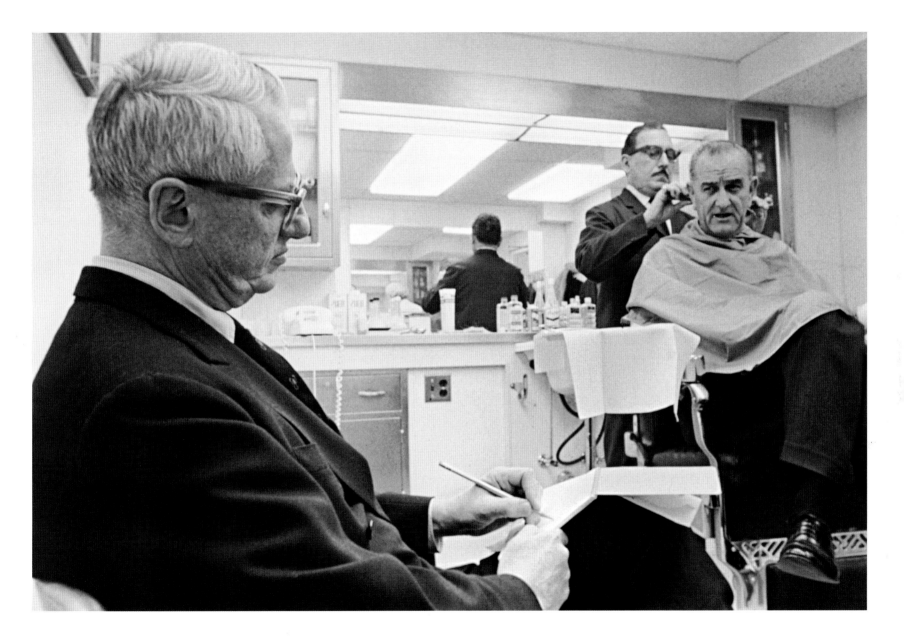

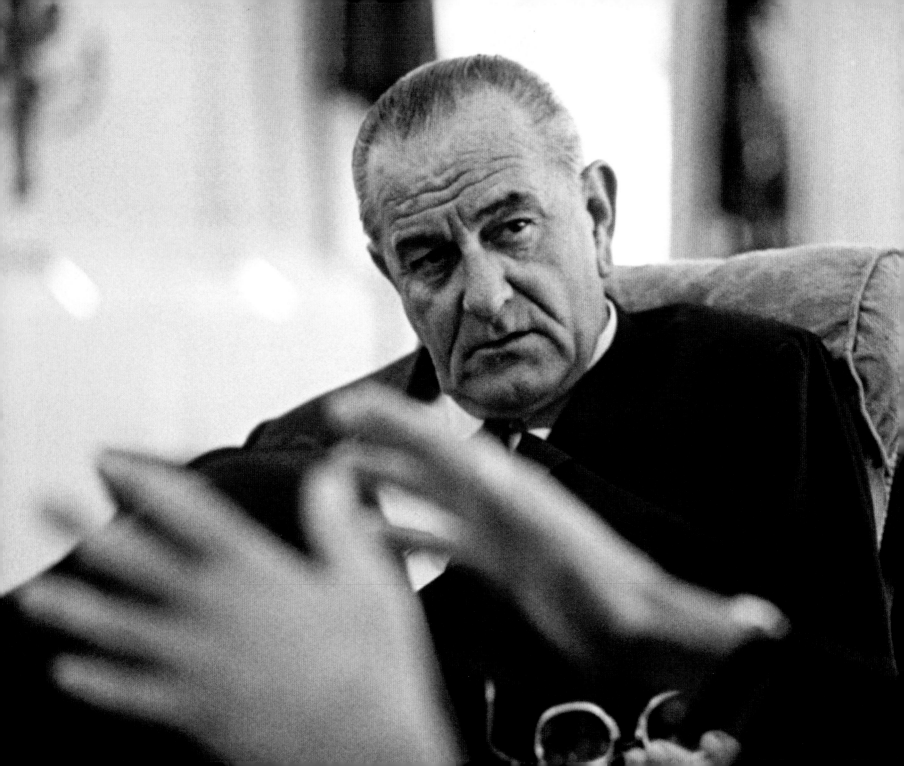

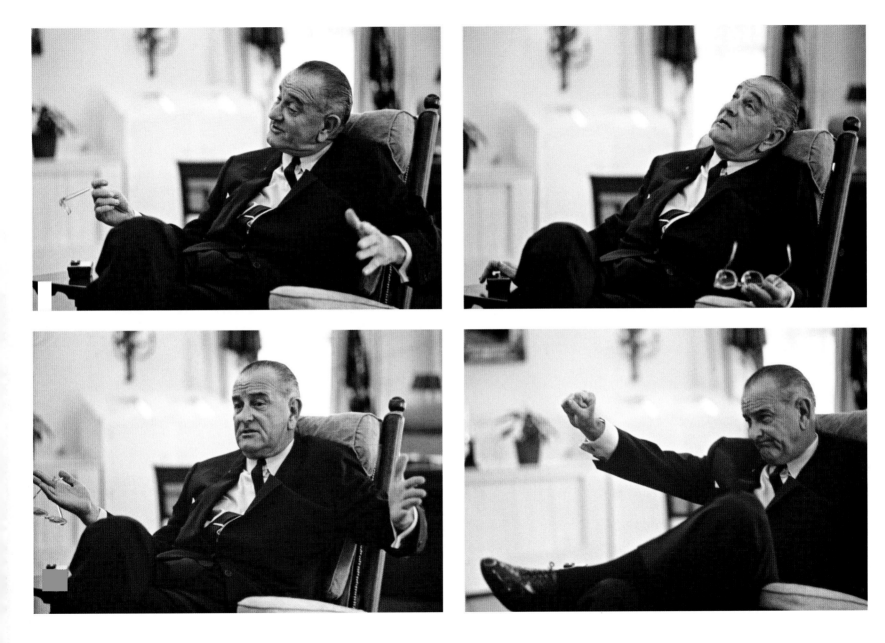

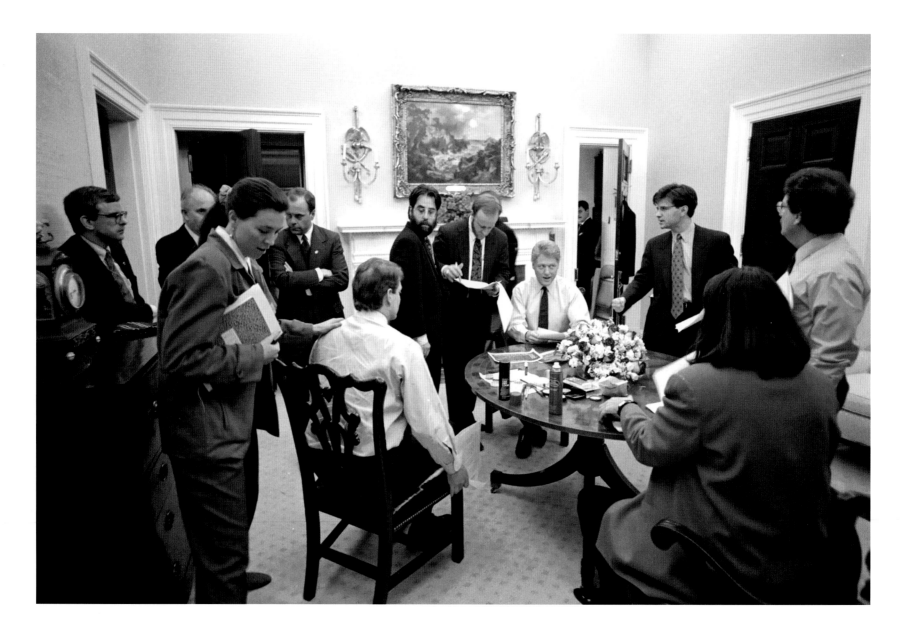

feature the discourse prior to a decision, the decision-making itself, or the persuasive strategies at work after a decision has been made, all of them with the pliable-faced LBJ at the center of it.

For Bob McNeely, much of the most interesting coverage of the Clinton years comes from a similar vein. Initially, McNeely explains, Clinton wasn't entirely comfortable with the idea of shadow-like coverage.

"There was a little bit of a tough moment [at the beginning], because everybody else falls away. The campaign's over, there are no more bands; you're in the White House. It's him at his desk—and you. Or one or two other people and you're there all the time. So there was kind of a moment where he was like, 'Are you going to be taking pictures every minute, of every day?' And I sort of said, 'Well, yeah, actually, I am.' And I explained, 'It's the history and if it gets too much, just ask me to back off a little and I will.' And he thought about it for a second and he said, 'OK.' " McNeely recalls that there were only a couple of instances in his six years at the White House when the President asked him for some space. "He was firing somebody, and it was kind of like, 'Just make a picture and get [out]. You know, I'm not going to be able to focus.' And then one other time after a military mission and there'd been some casualties, and he was uncomfortable in the meeting, and I said, 'Yeah, that's fine, Sir, I'll take one frame and I'll be out of there.' "

McNeely became fascinated by Clinton's ability to focus and how he could work, often in the middle of a maelstrom. He describes one picture made in February 1993, when the President was about to make his first televised address to the nation. In the room where he was making last minute changes to the speech, there were nine people weighing in on the final edits. "And then in the back corner you have the steward, sort of looking in there, like, 'Jesus, look at all those people, what are they. . . ,' and it's just chaos." Clinton was brilliantly oblivious. "What made it good was he was very able to be involved in the moment and let it happen around him, let things happen around him, and we see that in pictures where there's a lot of people on the periphery, but he's focused on what he's doing. He'd forget you were there, which is great."

Like LBJ, Clinton was at ease with himself and, perhaps, supremely confident that history would be on his side. Consequently, McNeely caught unexpected moments that help define the man. Clinton had an explosive temper. When an occasion arose, McNeely was able to capture what he thought was an

Pages 204–205: Okamoto focused on Johnson's decision-making to great effect, revealing one of the critical aspects of being President. "He had a stack of what we called his 'reading file' when he went to bed at night, that was from 100 to 200 pages, and each one was a decision and on the bottom was 'yes', 'no,' or 'see me.' He never had a carry over."

Clinton photographer Bob McNeely marveled at the President's ability to focus in the middle of a storm. Surrounded by 11 staffers, he makes final adjustments to a speech in the dining room just off the Oval Office moments before a nationally televised address in February 1993.

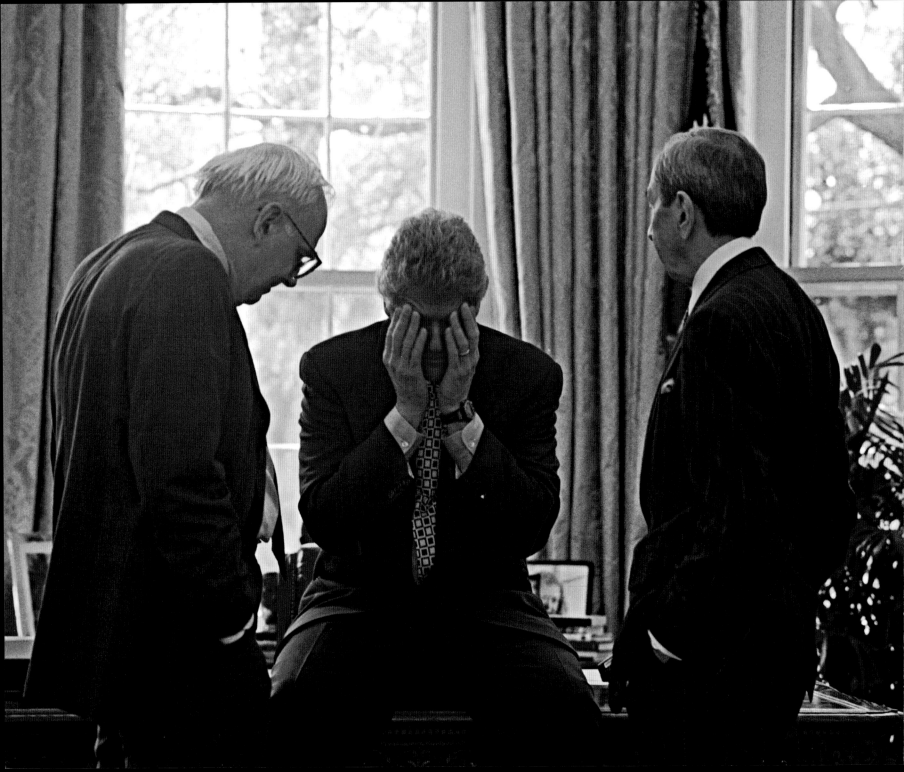

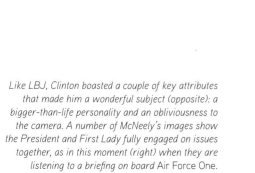

Like LBJ, Clinton boasted a couple of key attributes that made him a wonderful subject (opposite): a bigger-than-life personality and an obliviousness to the camera. A number of McNeely's images show the President and First Lady fully engaged on issues together, as in this moment (right) when they are listening to a briefing on board Air Force One.

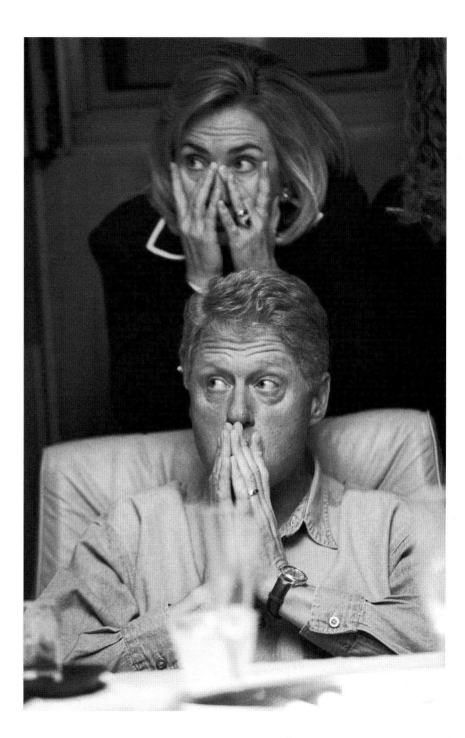

important part of Clinton's story. In one instance, Clinton is irate about something the press has reported and the senior adviser George Stephanopoulos is bearing the brunt of the President's anger.

"I was very, very careful taking that picture, and I wouldn't have made that without anything but a Leica," McNeely explains, referring to a very small and silent 35mm camera, a favorite of documentary photographers trying to be unobtrusive. "He was off on one of his upsets with George, about the press. He would always start slow, and we, after our first couple times you knew where he was going. So I'm standing over George's shoulder. It's not personal, you know, he's pointing to the press room, 'those guys out there,' so as he's in the middle of a very slow boil, you know . . . [McNeely mimes putting the camera quickly up to his eye to snap the shot]. I put it back down, it was like, phew. He never noticed. I think that's important imagery. A hundred years from now, that picture tells historians . . . about Bill Clinton."

Clinton's story is also one of unprecedented enthusiasm for the job, a kind of passion that came through in his body language. McNeely's coverage is remarkable for its range in revealing this—Clinton playing the sax for President Boris Yeltsin of Russia, negotiating knee to knee with Newt Gingrich, bent over laughing with Vice President Gore, standing in awe before the Christmas tree in the Blue Room.

While his focus was on telling the story, in one critical instance, McNeely's images became the story. One of the key events in the Clinton Administration was the 1995 government shutdown, the result of a deadlock between House Speaker Newt Gingrich, and President Clinton. In the middle of the shutdown, Prime Minister Yitzhak Rabin was assassinated in Israel. The President, at the head of an American delegation that included Gingrich and Senate Majority Leader Bob Dole, flew to Israel on *Air Force One* and McNeely documented it all. "We flew to the funeral. And on the flight over, Clinton went back and spoke to everybody, 'Welcome,' you know, talked about it. Rabin's death hit him hard. Because Rabin had done what he asked. Clinton had wanted the agreement [the Oslo Accords], and [Clinton felt] it signed his death warrant."

McNeely describes the trip on *Air Force One* as cordial, but quick. Eight hours over, 12 hours on the ground in the hot sun, 8 hours back. A couple days after the trip, with the shutdown still in effect, a new

"It was never personal—here, it's those guys, the press," says Clinton photographer Bob McNeely, describing the President's irritation, not with aide George Stephanopoulos but with the press. He quickly made the shot with a small 35mm Leica, a silent camera made for situations like this.

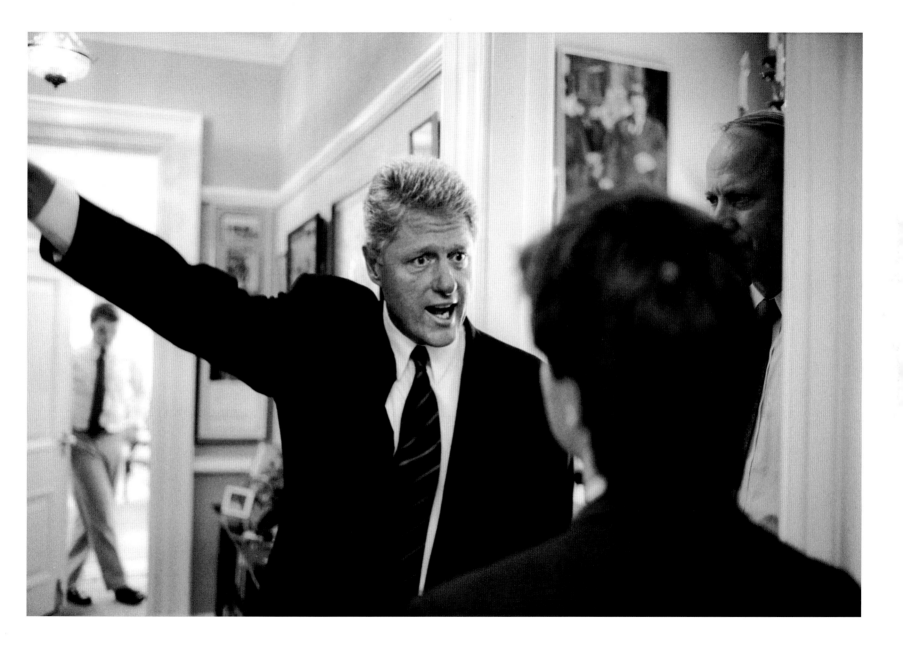

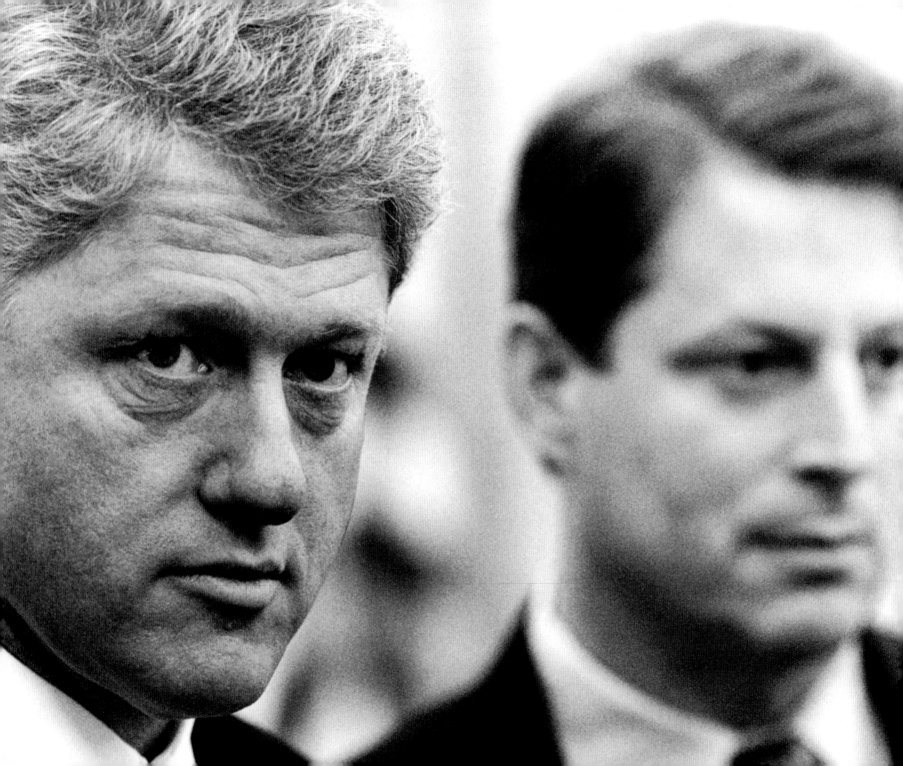

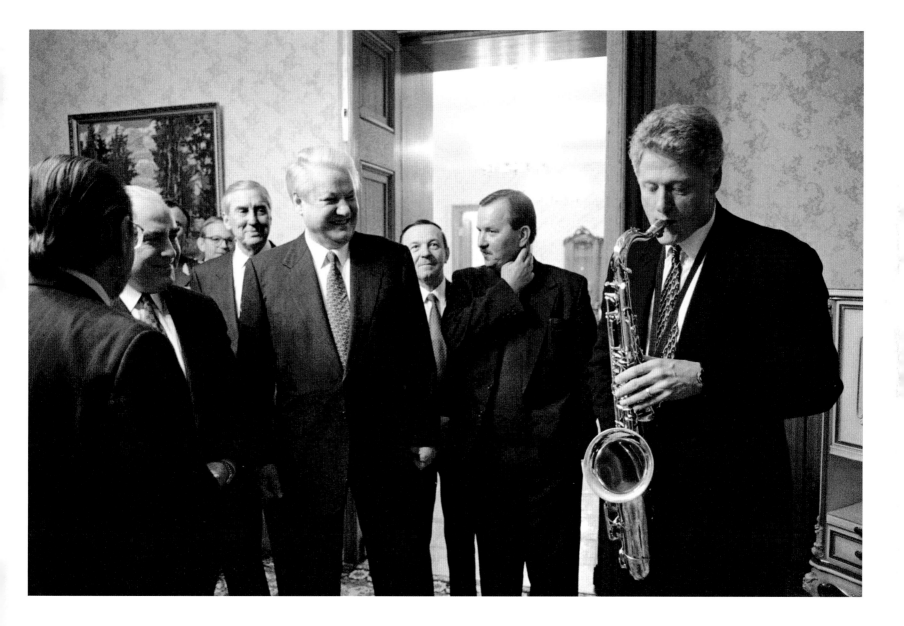

story broke. "Newt made a statement that the reason he's shut down the government was that he and Bob Dole had been ignored on the flight. They'd been ignored and stood up, and that's why they shut down the government."

McNeely went to press secretary Mike McCurry and told him he had several photographs of the President cordially welcoming and chatting with both the Speaker and the majority leader. "And [McCurry] said, 'Well, why don't you print them up and see if anybody in the press office wants them.' He said, 'I'll just sort of let you do it.'"

McNeely printed them up and they announced that the photos would be available in the pressroom. "It had become a huge story now, that Newt had shut down the government, 'Why had Clinton been so rude and not talked to him?' And I can still remember walking into that pressroom, these two stacks of pictures, and just all these arms. Pictures are flying every which direction. . . . And by the time I walked into my office, Wolf Blitzer was on the North Lawn, out of breath, holding the picture up live on CNN."

Mary McGrory, the late columnist for the *Washington Post,* immortalized the event in a December 1995 column entitled "Newt-mare Come True."

> Can a White House photographer, silently snapping, change the course of history? We're about to find out. Staff lensman Bob McNeely got a shot of the speaker of the House lolling comfortably on the Israel-bound Air Force One with the president at the other end of the table—and promptly turned the No. 3 man in the republic into a monster headache for the Republicans.

"For me it, in a very instant way justified my job," McNeely explained. "I mean, I'm there serving history, but also I'm trying to serve truth."

It also points up a different and more intriguing kind of truth: Ostensibly, the President's photographer is covering the administration for history, but there are times when that coverage is critically important in serving the current needs of the administration. As the Presidency and press coverage of it have changed over the past 20 years, the dynamic, similar to what prompted the release of McNeely's pictures, has grown more powerful. ★

Pages 212–213: Clinton photographer Bob McNeely elected to shoot primarily in black and white because "black and white captures the humanity of people in a way that color can't. Color becomes distracting." The picture of President Clinton and Vice President Gore (left), taken early in the administration, may not have had the same gravity in color. On the other hand, when the President wailed on a new sax given to him as a gift by Russian President Boris Yeltsin (right), it might have had a livelier feel in color.

President Clinton, alone on Omaha Beach, Normandy, France, June 6, 1994

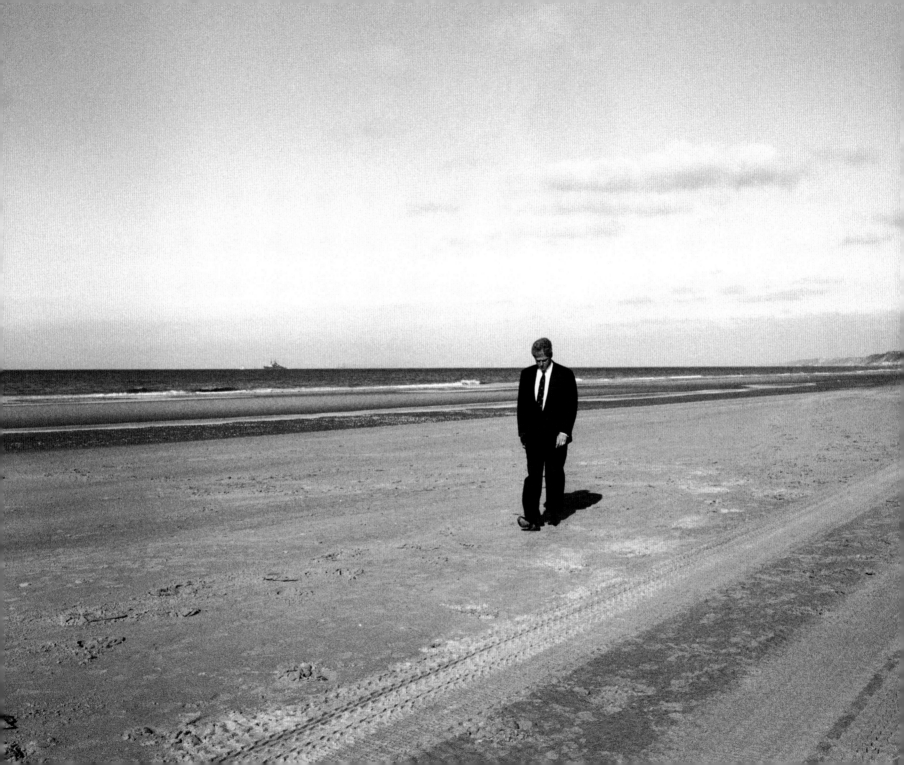

The Signing

PART ONE: *Shooting History*

PART TWO: *Sign Off to Flickr*

> **"** It wasn't just Sunday night, it was those last few days. I took this job for those last three days. You really felt that you were documenting history.**"**
>
> —PETE SOUZA

7:40 A.M.

"I don't usually eat breakfast here," Pete says, blearily acknowledging the early hour, a hint, over toast and fruit, at the monumental nature of the day. There's a lot of adrenaline flowing in the West Wing right now. Two days before, late on a Sunday night, the House passed President Obama's health care bill and in a couple of hours, he'll sign it into law in the East Room of the White House.

Pete is still in recovery from a marathon weekend spent covering the President and his staff in their push to the final vote on the bill. "Sunday was one of those days where I almost saw four Secret Service shifts," Pete recalls. "You work late you see three of them, but I almost went into the fourth one!"

Upstairs from Pete's office, Lisa Brown, the White House staff secretary, is preparing for the signing. Brown's title is a little misleading—she doesn't typically do anything secretarial, in fact she's an attorney in the position that manages the flow of all paper into and out of the Oval Office, effectively controlling the communications that get to the President. Today there's a particularly large amount of paper moving through; the health care bill tops out at 906 pages, which Brown describes as a record for this administration. It sits on a side table in Brown's office, fresh from the Government Printing Office in a dark blue, leather box a foot long, nine inches wide, and about a foot thick—a cube of legislation. On its lid, in bold embossed gold script, it reads "United States Congress, Enrolled Bill."

Brown explains that to make things more elegant at the signing, they have prepared a thin leather folder with both the first page and the signature page of the bill. This is what the President will see laid out on

Pages 216–217: President Obama gestures during a morning meeting in preparation for a phone call with a member of Congress, in the Oval Office, December 24, 2009.

President Obama escorts Senator Edward Kennedy to the motorcade from the Oval Office en route to a national service event where the President signed the Kennedy Service Act. Kennedy's longtime commitment to providing universal health care gave him a special place in the President's effort to pass a bill.

the table in the East Room. She opens the folder revealing that, at the top, it already bears the signatures of both the Speaker of the House and the President of the Senate. The bottom of the page is empty, ready.

"It's become a tradition for the President to use a number of different pens when he signs," she says, referring to the blank space on the signature page, "and the pens are given to people that generally worked particularly hard on the bill or who sponsored the bill." The more momentous the bill, the more pens for the ceremony. "Today is also a record on that, we have 20 pens that the President is going to use to sign it." They later added two more pens just in case, for a total of 22. That would explain what Brown has been doing throughout this explanation. She is opening a series of what look like sunglasses cases, but from each of these, she removes a custom Cross pen. Black with silver trim, each bears the presidential seal and the signature of President Obama.

This raises an interesting question: How do you sign a bill with 22 different pens? "It was a little bit more of a challenge when he first started doing it," Brown says. "He's joked about how good he's gotten at signing with a number of different pens. But today will be a new challenge for him. I think the most that we have done so far has been 10 or 11 pens." Adding, in an understated coda, "A skill most of us do not have to acquire." This feat demands that the President breakdown his signature into 22 separate parts so that each pen is actually used to sign the bill. Peter Rundlet, the deputy staff secretary, actually calculated that President Obama would have to use each pen for approximately two centimeters!

In the East Room, Chuck Kennedy is staring at a blank canvas of sorts. He's holding a remote camera that he hopes to perch somewhere in the higher reaches of this, the largest room in the White House. The formal space, which boasts the famous Gilbert Stuart full-length portrait of George Washington and huge crystal chandeliers, is in disarray. Two-hundred-plus chairs are packed in the middle, the carpet is rolled up, and porters and electricians are moving in every direction, pulling cable, setting up risers and light stands. "There's like three or four ways this room gets set up and you're always looking for those little nooks and crannies where you can eke out a different picture. Otherwise everything ends up just kind of looking the same," says Chuck. Once the lights for the TV cameras are set and the signing table is placed, Chuck plays with the idea of putting a remote camera on a 20-foot-high light stand to get

The President said the image of one of his speeches, seen here in the throes of creation, gives the public "a sense of the day-to-day activities" of the White House far more graphically than ceremonial photographs ever could. Head speechwriter Jon Favreau is at the forefront of that kind of work, which sometimes involves a little presidential cryptology. One day he was surprised to see the President show up at the door of his basement office. "He just goes, 'Hey, I just wanted to make sure you could read my writing on a few of these edits.' " He could.

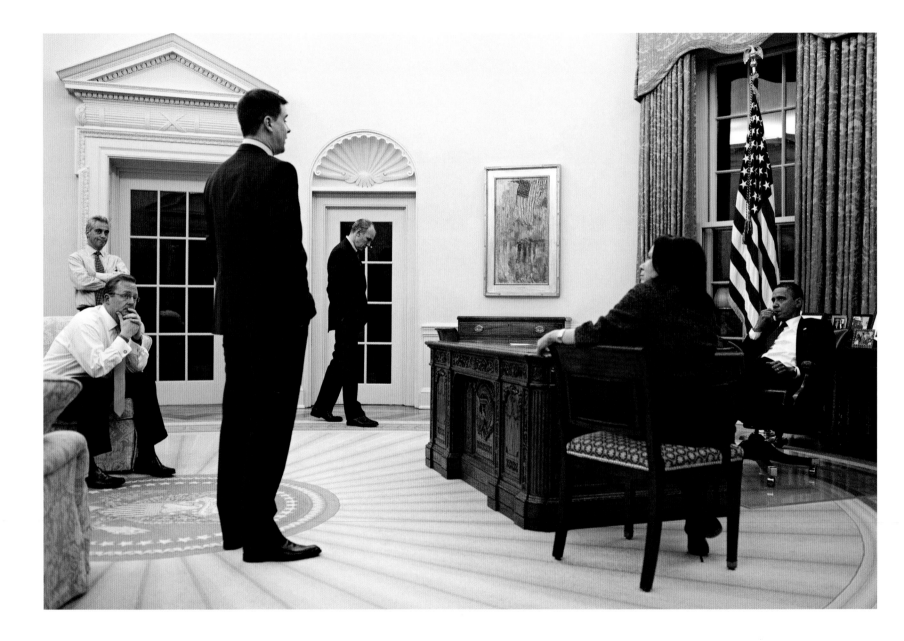

an indoor bird's-eye view of the signing. He's struggling with a problem a first-time visitor to the White House might never think of: How could photographing this historic, even spectacular place possibly get old? "The most difficult thing about the job?—I think it's keeping fresh eyes," says Lawrence Jackson, one of the three photographers on Pete's staff. "You walk into the East Room five times and the sixth time it's still the East Room. So you've got to look at it in a different way and try to come up with something."

If Kennedy and Jackson—two of the more ironically named photographers in White House Photo Office history—are worried about getting stale, their plight pales next to that of Alice Gabriner, the photo editor who looks at the pictures of not just one photographer, but of all four photographers' work. "I look at so many images and have been looking at so many images over the past 25 years as a photo editor—part of what I'm looking for is an image I haven't seen before, so it needs to feel fresh, it needs to feel surprising—and that's harder and harder to do."

Still, Gabriner, who works across the street from the West Wing in the Eisenhower Executive Office Building (formerly known as the Old Executive Office Building), feels the stakes are too high to slack off and knows her colleagues share the sentiment. "We care about creating this serious documentary archive. We have the opportunity to create, if we want to, the best archive of any President that's ever existed. So, I think that we're all pushing each other to keep that in mind. Every day, you can challenge yourself to create something new, to see something in a different way—that you have to keep your eyes open, and look. This is history happening across the street, and we're here to document it."

In their quest to do this, the photographers work everywhere, recording the work of a variety of staff, from senior counselors in the West Wing to butlers working in the pantry of the Residence. They are unique among White House staffers in reaching across so many different working groups. "We're some of the only people who interact with everybody at some point in some way," Samantha Appleton, who primarily covers the First Lady, explains. "The other day I was walking through the West Wing and I had my lunch and a bowl of French fries and somebody was like, 'Hey, how are you?' and they took a fry. And I had no idea who that person was, no idea. And then I realized, they always see us and we're always around, so in a way I think we have a strange dynamic because we interact with everyone in this place. And I love that."

A tough blow. The President meets with senior advisers about health care strategy on January 20, 2010. The day before, the Democrats had lost their 60-seat majority in the Senate, and Republican Scott Brown's surprise victory looked to have derailed the President's push for health care reform. Mr. Obama looks at coverage of difficult moments like these with trademark equanimity. "Years from now people hopefully will be able to take a look and see a record of what we did right and occasionally what didn't go so well." Two months later, he signed the health care bill into law. From left, chief of staff Rahm Emanuel; press secretary Robert Gibbs; Dan Pfeiffer, director of the Office of Communications; Phil Schiliro, assistant to the President for legislative affairs; and Nancy-Ann DeParle, director of the White House Office for Health Reform.

★ ★ ★ "The most difficult thing about the job—I think it's keeping fresh eyes," says Lawrence Jackson, one of the three photographers on Pete's staff. "You walk into the East Room five times and the sixth time it's still the East Room. So you've got to look at it in a different way and try to come up with something."

But in the Eisenhower Executive Office Building, where the main office of the White House Photo Office is located, this familiarity is flipped on its head. Here, where Gabriner spends most of her time reviewing pictures, the experience is more "surreal." On a daily basis Gabriner looks at images of key people, learning their expressions and tics and tracking their ups and downs. "You develop a kind of a personal sense of who these people are. You get a sense of whether, you know, the President is happy or sad or what he's feeling and. . . and the same for everybody around him." So she has an odd familiarity with them—after all, these are the people with whom she's spending the bulk of her day. But unlike Sam Appleton and the other photographers who are recognized everywhere, there is a strange disconnect for Alice. "The story is right across the street. It's right in front of me, so when I leave my office to go to the bathroom, I mean, you see these people and you feel like you know them. But I don't know them. And they don't have any idea who I am."

Back in the East Room, Chuck has abandoned the light-stand idea for the moment and is working on a position for Lawrence. He's following one of the White House electricians, walking toward the main entrance to the East Room, a broad doorway that leads to the red-carpeted cross hall famous as the backdrop for televised presidential addresses. "Being a photographer, especially in Washington, you study the nuances of ladders," he says with only a slight rise of the eyebrows. "And the White House had a couple of custom, very elegant white ladders built that have this really nice stable platform. So when you need one, you just call up the electricians and suddenly it appears. It's amazing." True, for all the challenges of working and living here, the tenants report that the service is pretty good. "It's not bad, for government housing," President Ford once quipped. "And you could always get a good plumber," added Mrs. Ford.

Think of the minds that have been changed in this office. In mid-March 2010 the President began an all-out effort to persuade congressmen to support his health care effort. Presidents have often leveraged the power of the historic Oval Office, along with their own persuasive ability, to garner support. Here the President meets with Representative Kurt Schrader of Oregon (top left), Representative Brian Baird of Washington (top right), Representative John Barrow of Georgia (bottom right), and Representative Jim Costa of California (bottom left).

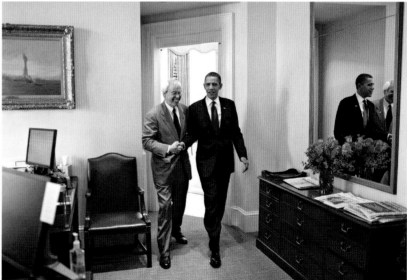

At the entrance to the East Room the electrician pushes in on what would otherwise appear to be a part of a very wide door jam and, voilà, it opens, revealing a kind of secret compartment. Except that it's a storage closet—though, like everything here, one with some history.

By the late 1940s, when Harry Truman lived in the White House, it had been nearly 50 years since the White House's last renovation, under Theodore Roosevelt. In the intervening time, the house had been used hard and it showed. The floor of Truman's second-floor study swayed under the weight of visitors and on an August night in 1948, the leg of Margaret Truman's grand piano broke through the floor of her third-floor sitting room. A structural survey revealed a house, as Truman put it, "falling down." The situation required more than a renovation. The entire house would have to be completely reconstructed. The Trumans moved out.

Over the course of a four-year rebuild, the house was completely gutted; only the exterior walls of the house were retained. New foundations were dug and a steel superstructure installed. Every salvageable piece of the original house was saved and reinstalled and, importantly, the historic interior rooms were rebuilt to their original dimensions. But the new structure created a windfall: space. The rooms were the same size, but the walls between them were no longer solid masonry. Since the house was now supported by steel columns, there was plenty of room inside the walls for storage closets, just like the one holding Chuck's ladder.

About an hour later, the remote camera is set high on a bar behind the signing table, Lawrence is perched on an elegant white ladder, Sam and Chuck are arrayed in two other spots in the East Room, and Pete is standing in one of the aisles, surrounded by 280 congressmen and senators who are filing in to take their seats.

There is a remarkable buzz in the room, a reflection of the momentous achievement this landmark legislation represents to the people gathered here. First sought by Theodore Roosevelt in the early part of the 20th century, health care reform has been a legislative holy grail for almost a hundred years—and the delight of having attained it is written on faces and heard in the raised voices throughout the room.

As the President and Vice President are announced, the crowd erupts. When he finally gets going on his speech, the President recognizes the effort it took in Congress, acknowledging that they "had taken

The Fist-Bumper in Chief connects with a medical professional in the Green Room prior to the start of a health care event in March 2010.

their lumps in the process." In a pause that follows, one congressman pipes up loud enough for the entire room to hear, "Yes, we did!" Huge laughter and applause follows and you can almost hear the relief come rolling off their shoulders.

The signing will represent the end of a long haul for the President, Congress, and for Pete. And while the pictures of this moment are important, for Pete, images of the end result are less interesting than images revealing what it took to get there.

"Today is a ceremonial day and I rely a lot more on my staff in terms of making sure that we get good pictures of the signing itself. But for me the more important day was probably Sunday," Pete says, referring to the previous weekend when the final vote in the House was cast. "It wasn't just Sunday night, it was those last few days. I took this job for those last three days. You really felt that you were documenting history."

Starting on Friday, March 19, the White House went into overdrive, reaching out to representatives who were still on the fence. Pete followed the President around the West Wing as he strategized with his senior staff. Then photographed him making what Pete described as an "incessant number of phone calls" to individual congressmen. "He used the Oval Office phone, he used Katie Johnson's phone, he used Rahm's phone. He used Rahm's cell phone. You know, he's in the limo making calls." Pete was caught up in covering a presidential full-court press. "The all-in-focus of 'let's get this done.' You know, 'Who can I call?' So it was making pictures of all those last-minute lobbying efforts."

But a man on the phone is a man on the phone, even if it's the President of the United States. So Pete was trying to photograph the underlying emotions that were coming through on the calls. "The optimism—you know it was [going to be] a close vote and yet I think he realized he was on the verge of history. And he wanted to do whatever he could to make sure that they had the votes."

Of all the stories Pete has covered in his time at the White House, health care has been the biggest, and in January he knew it was coming to a head. He wanted to commemorate the long, tortured battle in a way that would reveal each critical stage, the dramatic swings both up and down. Pete hit on the idea of creating a photo book that documented every twist and turn. This would be a book produced in-house with a very limited distribution—as a memento, just for senior staff.

Though the President is, in Pete Souza's words, "not the kind of guy who throws his arms up in the air" in celebration, he delivers a fist-pumping acknowledgment that his health care effort is gaining critical momentum hours before the final vote in the House on Sunday, March 21, 2010.

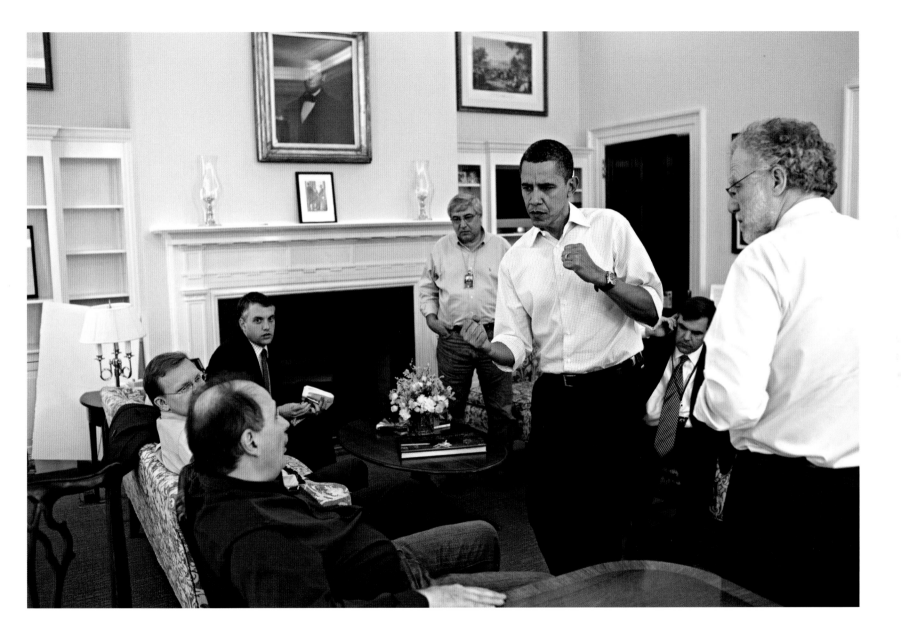

President Obama holds a lucky charm given to him
during the campaign (left), while on the phone with
a member of Congress in the Oval Office, March 21,
2010, the day of the final health care vote. He made
hundreds of calls in the week leading up to the vote,
punctuated by strategy sessions with senior staff as
the vote approached (opposite).

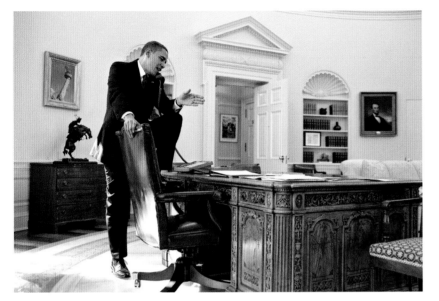
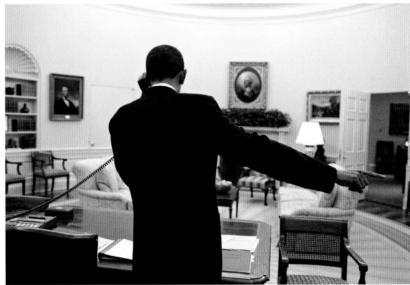
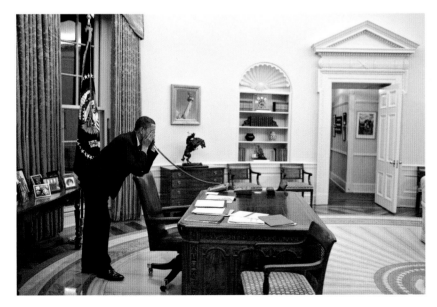
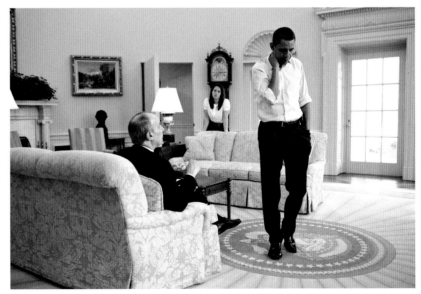

The President's plan had gained momentum over the summer and in November the House passed a bill. The Senate followed, passing their bill on Christmas Eve. Things looked good. The administration assumed the two bills could be reconciled and then the Senate would vote again, confident that their 60-vote majority would hold, even after a January special election to fill Senator Ted Kennedy's seat. But the Democrats miscalculated badly when Kennedy's Senate seat went Republican. The President's long slog seemed all for naught, and for a time it appeared that the President set health care aside. But in late February, the President made one last push. Today, a month later, he was on the verge of signing the bill in the East Room.

Pete estimated that roughly 20,000 pictures had been taken related to health care and somewhere in these was a collection of critically revealing images. "This is something that I just worked out with the President. We sort of started it before [the health care battle] ended," Pete explains. The day before the signing ceremony he presented the photo book idea to Obama. "I went up to him and I said, 'Mr. President what would you think of [this idea]?' and he goes, 'That's great!' And I go, 'We kind of already have it going but I didn't want to say anything to you earlier because I didn't want to jinx it.'" Pete, a Red Sox fan, understands the power of a jinx and his wariness was rewarded.

The most remarkable images in the book tell the story of the last three days of the fight. A two-page spread of 40 images, eight frames wide by five frames high, features the President meeting with 40 different congressmen—in each frame, the President and congressman sit in front of the fireplace, Obama on the left, congressman on the right. In each one, the President is making his point. It occurs to you that, to be successful in this job, one needs not just a little patience.

Another photo grid takes the phone call as its theme. "I was trying to make each one a little different, which is not easy to do. Especially in the Oval Office where the phone's in the same place," says Pete. He mixed up angles and focal lengths, but then drilled down on the calls themselves. "Trying to capture the atmosphere of the individual phone call. I mean, I guess he's part psychologist right? Cause you've got to know the person you're talking to and you've got to say the right things and sometimes you do it a different way than you did the other guy. And so [I was] trying to capture that difference, without audio."

He's got the President gesticulating on the phone, yelling into the phone, laughing on the phone, and leaning over the back of his chair, phone tucked under his ear, weary from yet another call.

By Sunday night there was nothing left to do but watch the vote. The senior staff involved had all gathered in the Roosevelt Room, the large conference room in the center of the West Wing. "When they started the roll call for the vote, he wanted to be with the staff," Pete says. "There was a big-screen TV in there. It was emotional. He walked in the room and everybody just started applauding. Loudly. And, you know, he said a few words and then he sat down next to the Vice President and he watched the vote. I think that's when it really hit people how historic this was. Here's something they had worked for basically since day one of his Presidency and it was finally coming to fruition, so it sort of all came together that night."

When the clinching vote came, the President stood up with the Vice President and started applauding as the room erupted around them. "And Jim Messina [the deputy chief of staff] is in the background with his arms over his head, Rahm's hugging Phil Schiliro [the director of legislative affairs]. I tried to frame it with the Roosevelts in the background. The paintings of the Roosevelts. Teddy Roosevelt was the first one to try to get health care passed, so I was trying to frame it in such a way."

The President was ebullient. "He's not one of these guys that jumps up and down and throws his arms in the air, but he was definitely happy. He was high-fiving people, hugging people," Pete says.

It was an urge to celebrate that welled up from deep inside the President. "The health care vote was probably the most gratifying moment that I've had in public life," President Obama said. "More than my election as President. Because you run and hopefully win elected office not just for the sake of being something but for the sake of doing something."

Thrilled with the outcome, the President invited all the staff who had worked to get it through up to the Truman Balcony to celebrate with a glass of champagne. This invitation included not just the senior staff, but a lot of very junior staff who'd put in long hours trying to make it work. Though he's obviously taken by the thrill of covering such a powerful historical moment, Pete's real delight seems to be in watching people as it dawns on them that they have just played a critical role in history and that they are standing, or in this case, are sipping champagne, at the nexus of power.

Pages 234–235: Promise delivered. After more than a year of often bruising work, the President, Vice President Biden, and senior staff react in the Roosevelt Room of the White House as the House passes the health care reform bill, March 21, 2010 (left). Later that evening, the President's subtle grin reveals a deeper satisfaction as he reads a congratulatory e-mail in the Treaty Room office in the Residence (right).

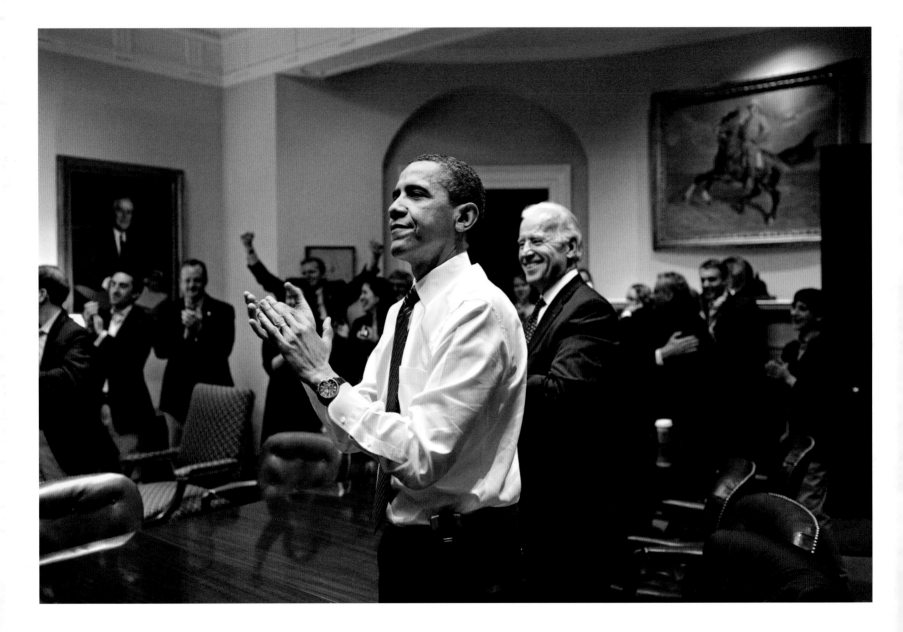

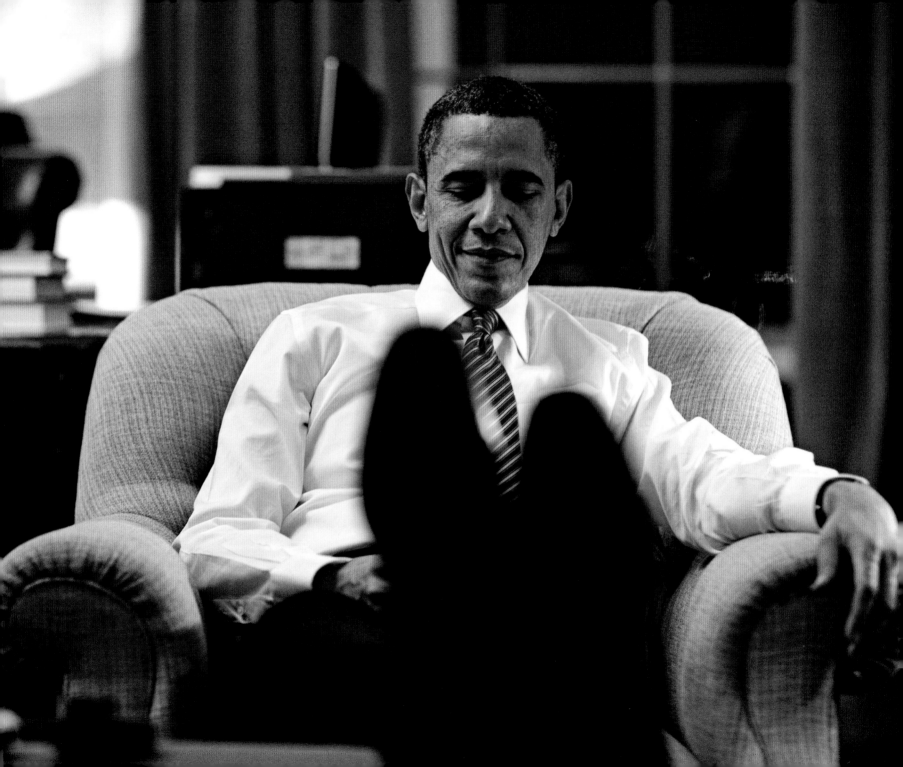

The President celebrates with staff on the Truman Balcony of the White House, early March 22, 2010, following the House vote to pass health care reform (opposite). "It was one of those moments that reminds you of why you got into politics in the first place," the President said. A day later, the President signed the bill (above). As is customary with momentous legislation, he used multiple pens to sign, in this case, 22 in all, which made his signature seem a little less fluid than it usually appears.

"There were like 120 people and what was interesting to me is a lot of the assistants were invited too. For them it was so huge to be a participant in that. I guess maybe I get a little jaded," he says, explaining that he'd been on the Truman Balcony many times. "But it's so nice to see that. Staff people like this appreciated—and to feel the weight of history on a night like that. On the Truman Balcony. I mean they were truly, truly touched to be a part of it and that was just so nice to see."

Because so much happens in such a compressed period of time, it's hard to keep track of your experiences. "I don't know how to quite describe it," Pete says, when trying to sum up coverage of the entire health care journey. That elusive feeling is common on the staff. Pete explains that one day he showed a photo from a health care event to Phil Schiliro, one of the President's lead advisers on the effort, "He said, 'You know, I didn't even remember that. It's all a blur to me.' And I guess that's the way it is for me too. It's all a blur."

Pete and Alice Gabriner did create a slide show of health care images, and editing the pictures down, focusing on those that mark key beats in the story, has given Pete some sense of the endeavor. They took many of the same images and today, the day of the bill signing, posted them to their website. "This morning we posted a year's worth of photos: behind the scenes, his involvement with health care reform. So it's satisfying to me to see it all put together in one slide show. That sort of tied it all together for me."

The tying of the figurative bow is under way in the East Room. The President has moved from the podium over to a small signing table loaded up with both bill and pens. He begins signing, moving quickly through the 22 pens, and as he does, the clicking of cameras sounds like a small wave washing up on the shore. Applause punctuates the use of the final pen.

As things break up, Pete moves into cocktail-party mode, covering the President and every imaginable congressional figure shaking hands, embracing, and congratulating each other. At some point, Robert Gibbs, the press secretary, suggests they get a shot of the President's handiwork on the bill. President Obama's signature, struggling under the demands of using 22 different pens to make its mark, looks vaguely like a dot to dot. If you didn't know the man was so brilliant, you might think there was an issue here. ★

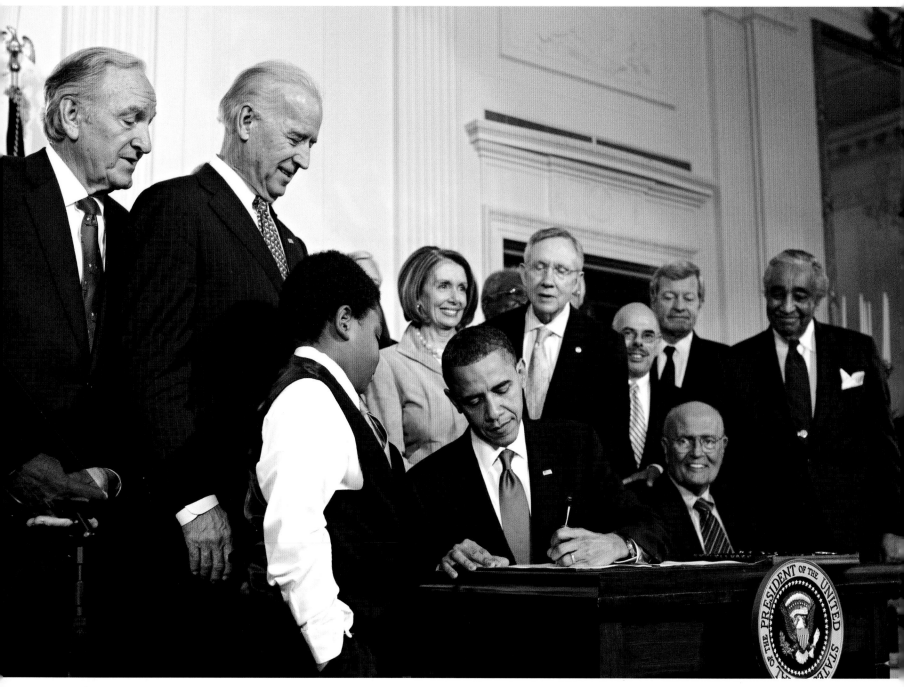

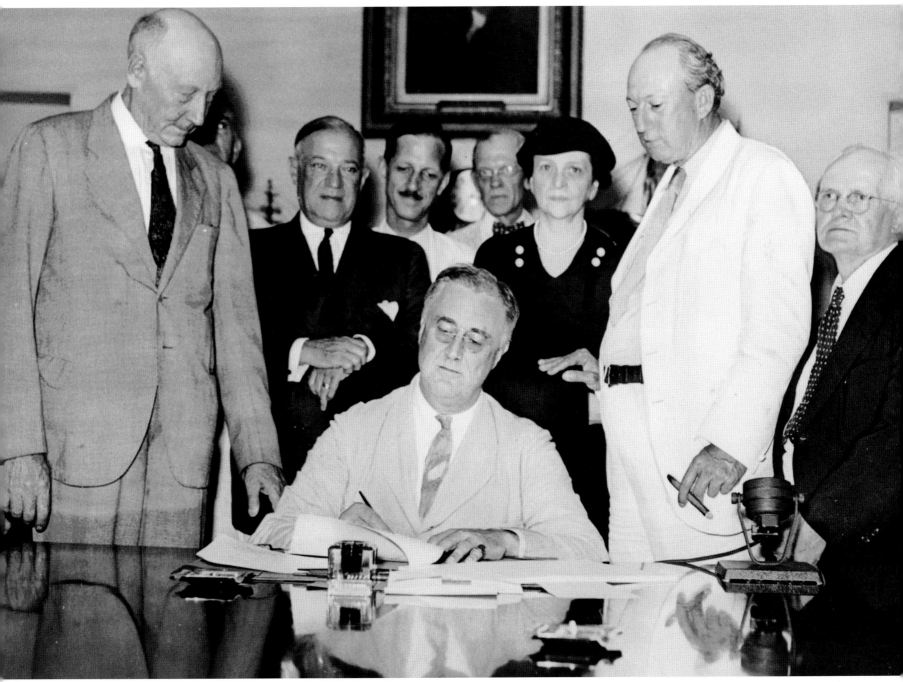

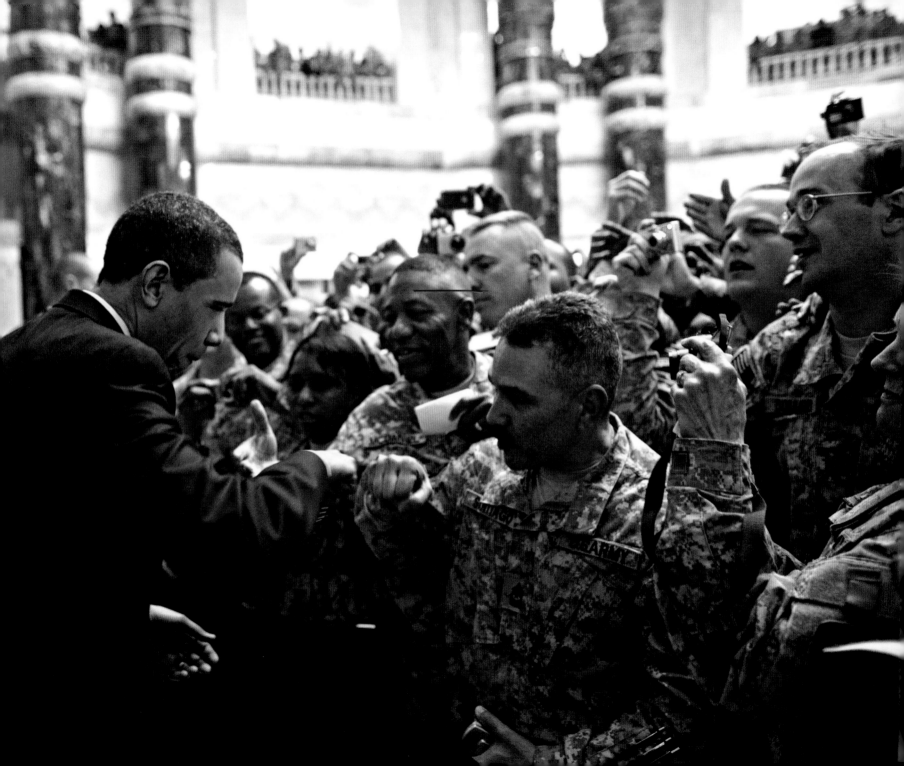

"**A lot of those moments, I didn't know that they would** be historic, you know, but I had to be there, that was part of the job, **and I didn't want to miss it.** I didn't want to miss anything."

—ERIC DRAPER

PART TWO | *Sign Off to Flickr*

The image of that historic, albeit crabbed, signature could be seen shortly after the health care bill was signed by dint of the Internet. In an unprecedented effort, the Obama White House makes a selection of their images accessible on a public photo website called Flickr. Invented in 2004, Flickr technology allows the White House to upload photos taken by Pete and his staff to a continuously accessible photo stream that anyone anywhere in the world can access.

Beginning with Cecil Stoughton during the Kennedy Administration, White House photographers have perceived themselves less as photojournalists and more as photo historians, so, initially, the idea didn't sit that well with Pete. "I fought it at first because the concept of behind-the-scenes pictures being shown right away, I wasn't sure that it was a good idea." Pete explains that during the campaign, before he was working with the Obama team, the press office routinely released behind-the-scenes images. They brought this same strategy to the White House.

In some ways, this can be seen in the same vein as Ford wanting someone like Kennerly to help open the White House up after the isolated, dark days of Nixon. There was strong public sentiment that the Bush Administration had been overly secretive and this was one way to counter that.

"What we try to do is every couple weeks, show a new batch of behind-the-scenes photos," Pete says. Alice will make a first edit, Pete will follow, and when they are both happy they show it to Josh Earnest, a key deputy to Robert Gibbs.

"I would say probably 95 percent of what Alice and I edit ends up on the Flickr photo stream. There's a

★ ★ ★ On a slow day, they'll have just 30,000 page views, but the number has gone as high as one million views in a day. few pictures here and there sometimes for different reasons that Josh doesn't want us to post. It could be things like we've got great pictures of the President greeting a Make-a-Wish child. Those are more private and unless we have the family permission we're not going to put those out there."

A lot of people are seeing the photos that do make it. On a slow day, the White House Flickr page will have just 30,000 page views, but the number has gone as high as one million views in a day. This type of access to behind-the-scenes images is a huge departure from the past when Presidents like LBJ signed off on every image leaving the Photo Office.

The White House use of the Flickr site comes as journalism in general and the White House press corps in particular is undergoing a sea change. The news business, particularly the print side, has been in an economic free fall for a few years, resulting in reductions of both reporters and photographers. There are several reasons, including the fact that more people get their news for free on the Internet, making traditional news business models crater, and the advent and proliferation of social networking sites like Flickr, Facebook, and Twitter, which are eroding the reach and dominance of traditional news outlets. And as if that isn't enough, these technological and economic forces seem to have accelerated a trend in White House–press relations that started back with Johnson and Nixon.

During the Kennedy Administration reporters like the late Hugh Sidey of *Time* had much more latitude on the White House beat. "We used to gather around an old table in the entry hall of the West Wing in those days and watch who was coming and going," Sidey explained in an interview with National Geographic in 1996. "I'd often just wander the halls of the West Wing and when I saw a senior staffer I knew, I'd just stick my head in and chat."

But by 1969 the size of the press corps and the surging importance of television made the existing setup untenable. President Nixon moved to create a larger, but separate press area.

The new pressroom, which is today in the same location, was built on top of FDR's swimming pool. Before its most recent renovation, during the Bush Administration, it was possible to go to the camera

President Obama receives a briefing from Gen. Raymond T. Odierno, center, joined by National Security adviser Gen. James Jones, background left, at Camp Victory in Iraq, in April 2009.

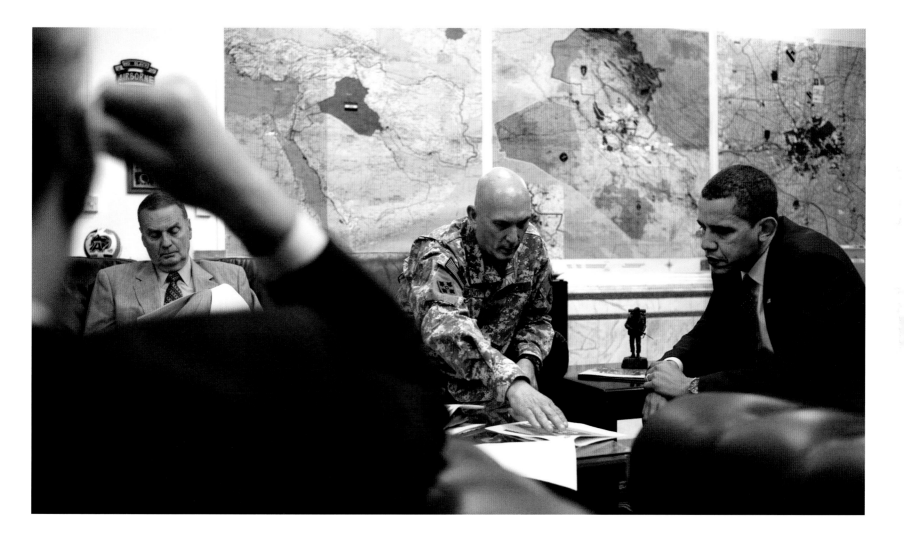

risers at the back of the room, lift a hatch, and climb down a ladder that placed you, surprisingly, in the shallow end of the pool. The pool was never removed on the off chance that a future President might want to have a place indoors to swim. It is one of the more surreal, only-in-Washington spaces: Surrounded by the green-hued pool floor, blue-green tile around its edges and underwater lights still intact, you could look up through the hatch and see a monitor featuring the daily briefer, with "The White House—Washington" legible just behind his head. Curiously, the podium where the press secretary gives his daily briefing is situated just above the deep end.

Although the new pressroom was ostensibly designed to ease overcrowding, in light of the Nixon Administration's well-documented animosity toward the press, it's easy to see the new room as having a far more cynical purpose: keeping the press in a controlled space. Whether intended or not, the easy access Sidey enjoyed with JFK's administration was gone. Not only would the press be at one remove from those entering the West Wing, the setup further limited their ability to wander the halls. This constituted a dramatic change in the way reporters and photographers could cover the beat.

Regardless of cause, it's clear that reporter/photographer access has diminished over the past decades. "Back then there really was a more active press corps. *Time, Newsweek, U.S. News* [were] traveling with the President, there was a lot more imagery being made by the press, and there's not now," says Bob McNeely, recalling the 1990s. In this sense, the White House Flickr site is filling a void.

The role of the White House photographer, therefore, has grown more significant. Through the use of technologies like Flickr, millions of people have access to the photographer's images. Before Flickr, the vast majority of images taken by presidential photographers could only be seen after the President had left office, and usually only after his library had been built and his archive organized. Now people can look at them just a few weeks after the shots are made. While it's appealing to the public at large, it raises questions about how it's used.

"The White House's photo stream," as it is titled, seems generic. Brief, just-the-facts captions accompany the images along with the date the images were uploaded and a link to public comments for each picture. There are currently more than 2,000 images available—recent uploads plus themed folders

The President leaves a presidential coin at the grave site of 19-year-old Medal of Honor recipient Specialist Ross McGinnis, one of two Medal of Honor recipients from the wars in Iraq and Afghanistan laid to rest at Arlington Cemetery.

with images related to the President's first year, health care, arms-control talks, the State of the Union address, and more. The free flow of public commentary about the images is for the most part succinct and superficial—but importantly, free flowing. These aren't images that are necessarily charged with political meaning beyond the fact that President Obama is in nearly all of them, shown, for the most part, doing his job. There is nothing controversial revealed here, then again, it's a Flickr site and not the Associated Press or CNN.

Still, these images are unfiltered, released directly by the administration. Like so much other unfiltered information, this has a tendency to put the traditional news media on edge. Journalists specialize in putting images and quotes in context and feel that without that context, danger lies ahead. In a column for the online magazine *The Daily Beast,* Lloyd Grove raised questions about the risks, quoting CBS News correspondent Bill Plante: "In the end, who gets the decent information? The people who rely on trusted filters, whether they're online or on the air. If you do it all yourself, you're gonna get a load of crap!"

Curiously, the Flickr site magnifies some issues that aren't new, just much more visible. In his 1979 book, *Shooter,* Kennerly touched on the topic. "The editors . . . who accept and use a constant stream of official White House photographs as part of the daily coverage are doing their readers and viewers a great disservice and are failing to provide true and objective journalism."

The danger—to both the future of presidential photographers and news gathering in general—is not the release of images on the Flickr site, but the temptation to release official images in lieu of regular news coverage. Obviously, the lure of using behind-the-scenes or other useful images for free has always been strong to news editors and must be close to irresistible in today's cash-strapped newsrooms. But official White House photographers, who have always been wary of being perceived as flacks—most were news photographers after all—have been and continue to be able to reckon with the demand for behind-the-scenes images by facilitating access for outside photographers who want to shoot exclusives.

Almost every administration since JFK's has allowed this. In fact, some of the most intimate coverage of the Nixon and Carter White Houses came through outside photographer Harry Benson. Typically a

newspaper or publisher approaches the White House for an exclusive. Their photographer then works under the wing of the chief White House photographer, effectively leveraging their access, their trust. This is the best of both worlds—it allows an objective third party to cover the President from the inside while keeping the president's photographer free of any potential taint as a publicist. The practice, which continues today—Souza hosted five outside photographers within the first year of the administration—broadens journalistic coverage.

Because the Internet is a social fixture and because White House press operations will always try to go directly to the public, the White House photo stream on Flickr is probably here to stay. But to some, like Kennerly, it presents a different kind of problem, separate from the journalism issue. The gush of photographs from behind the scenes, he thinks, risks making the Presidency seem too pedestrian. "Barack Obama is not an everyday guy. He's the President of the United States and I think some of the mystique of the power of the Presidency means holding a few cards close."

It's true that one appeal of the White House and the Presidency is that not everyone can go there, not everyone can meet him. There is an unquestionable mystique about the White House and about particular presidencies. The trove of presidential photos, many quite revealing, can often add to this aura, especially since they typically only come out after a President has left office.

It is also true that the photographers who have been "shooting for history" since the early 1960s have done a monumental job of it—there are literally millions of images of these Presidents, making analysis and study daunting. So one of Flickr's greatest appeals is that it lets the public have a glimpse into the archive, even as it's being filled. That seems to be in line with the ideals of a republic.

That growing archive is one of the richest repositories of American presidential history we have. That it exists at all is due as much to the willingness of the Presidents who let themselves be covered as it is to the photographers who continue to make fascinating pictures whether they seem historic or not.

As Eric Draper wisely put it: "A lot of those moments, I didn't know that they would be historic, you know, but I had to be there, that was part of the job, and I didn't want to miss it. I didn't want to miss anything." ★

Page 248: The Inauguration Day Marine One *photo has become a set piece marking the end of every recent Presidency. Clockwise from top left: Ronald Reagan, George H. W. Bush, George W. Bush, and Gerald Ford. Page 249: The wistful, day's-end images stand in distinct contrast to the picture of President Obama in the middle of his first year in office, aboard* Air Force One *en route to Beijing.*

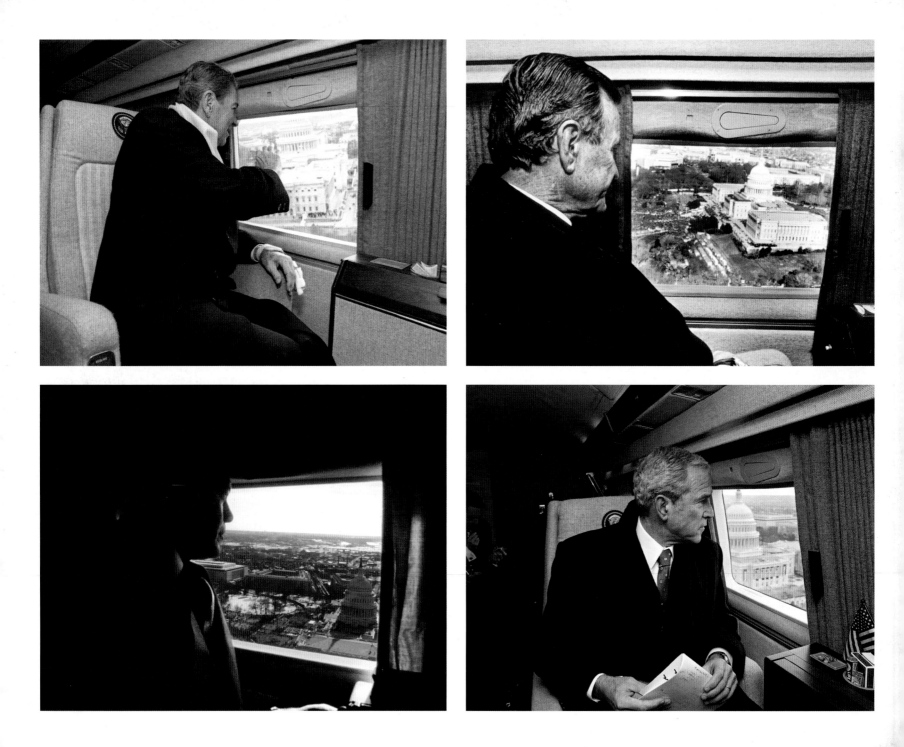

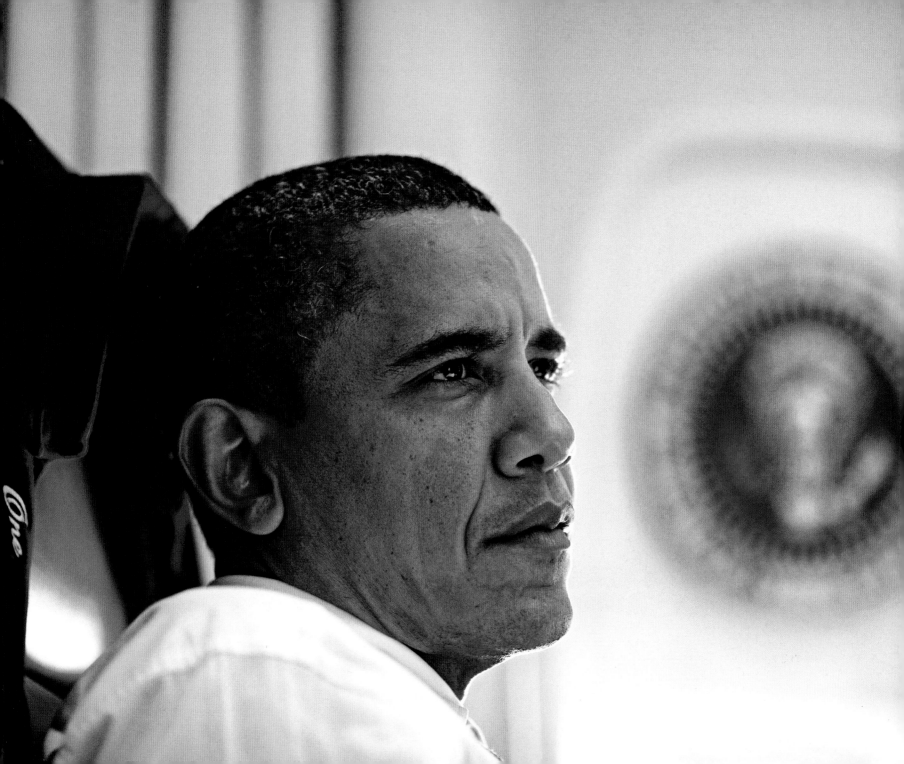

250

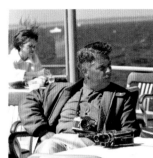
Cecil Stoughton

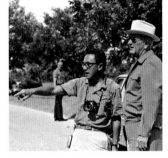
Yoichi Okamoto

Ollie Atkins

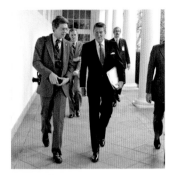
David Hume Kennerly

Michael Evans

Presidents' Photographers

CECIL STOUGHTON (1920-2008) A lieutenant in the U.S. Army Signal Corps when he began at the White House, he rose to the rank of captain, serving President Kennedy from January 1961 to November 1963.

YOICHI OKAMOTO (1915-1985) Okamoto also worked as a U.S. Army photographer, assigned to Gen. Mark Clark throughout the Italian campaign in World War II. He moved on to work for the U.S. Information Agency, and covered Lyndon Johnson on two trips to Europe when he was Vice President. He served the President for about four months, from late 1963 to February 1964, when Johnson fired him. Johnson rehired Okamoto after the election in late 1964, after which Okamoto continued covering the President until the end of his term in January 1969.

OLLIE ATKINS (1917-1977) Atkins began working as a photojournalist for *The Saturday Evening Post,* covering World War II. He later became a staff photographer and spent the bulk of his career there (1946-1968). He began covering Richard Nixon during the 1968 campaign, and after the election, he was hired as the President's photographer, serving from 1969 until the President's resignation in 1974.

DAVID HUME KENNERLY (1947-) was born in Roseburg, Oregon. In 1972, Kennerly won the Pulitzer Prize for feature photography for his coverage of the Vietnam War. He was 25. Two years later, he left *Time* magazine, where he'd been covering Vice President Gerald Ford, to become Ford's photographer. He covered Ford from August 1974 until January 1977. Kennerly continues to work actively as a photographer, most recently producing *Barack Obama: The Official Inaugural Book* with Bob McNeely.

MICHAEL EVANS (1944-2005) Evans was a photojournalist working for *Time* magazine when he was assigned to cover Ronald Reagan's first bid for the Presidency in 1975. He maintained his link and was hired as the President's photographer in January 1981, serving throughout the first term until 1985.

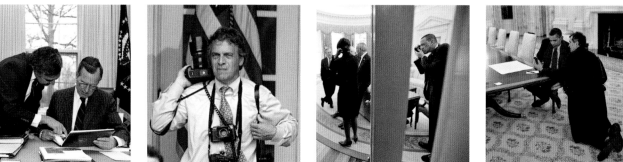

David Valdez *Bob McNeely* *Eric Draper* *Pete Souza*

DAVID VALDEZ (1949-) was trained as a photographer in the U.S. Air Force. He later became the chief photographer of the U.S. Chamber of Commerce. In 1983, he began working as Vice President Bush's photographer, and after the election in 1988, he remained on the job, now working as photographer to President Bush. He continued in that role until 1993. Since 2003, Valdez has worked as director of visual and electronic information in the office of the assistant secretary for public affairs at the Department of Housing and Urban Development.

BOB MCNEELY (1945-), a Vietnam veteran, worked as a freelance photographer in Washington, D.C., before going to work as a White House photographer during the Carter Administration from 1977 to 1980. Thirteen years later, in 1993, he was hired as President Clinton's photographer, a position he remained in until 1998. In 2000, McNeely set up a project documenting the 2000 political campaigns from the local level through national campaigns for the Presidency. In 2009, along with David Kennerly, he photographed and produced *Barack Obama: The Official Inaugural Book*.

ERIC DRAPER (1964-) Prior to joining the White House, Draper was West regional enterprise photographer for the Associated Press. His many assignments included the 2000 Summer Olympics in Sydney, Australia; the Kosovo conflict in 1999; and the 1998 World Cup in France. He also covered the 1996 and 2000 presidential campaigns, when he came to know candidate George W. Bush. Draper is the only chief presidential photographer to cover two complete terms, working for President Bush from 2001 until 2009. Draper was responsible for converting the White House Photo Office from film to digital.

PETE SOUZA (1954-) Before coming to the White House for the first time, Souza worked for several different papers in Kansas and for the *Chicago Sun Times*. He worked on the White House photographic staff during the Reagan Administration from 1983 until the last day of the Presidency in 1989. Later, Souza worked as a freelancer for *Life* and *National Geographic* and as the national photographer for the *Chicago Tribune*, a time when he came to know Senator Barack Obama. He photographed, wrote, and produced the *New York Times* best-selling book *The Rise of Barack Obama*, a book that ultimately helped prepare him to become the current chief White House photographer.

Illustrations Credits

KEY: JFK = John Fitzgerald Kennedy LC = Library of Congress

All photographs by Pete Souza, The White House, unless otherwise noted:

4, LBJ Library/Yoichi Okamoto; 8, Cecil Stoughton, White House/JFK Library, Boston; 9, Robert McNeely/William J. Clinton Presidential Library; 10, Pete Souza/Ronald Reagan Library; 11, Eric Draper/George W. Bush Presidential Library; 28, Callie Shell; 37, John Plumbe, Jr./James K. Polk Memorial Association, Columbia, Tennessee; 38, LC (LC-DIG-cwpb-04326); 40, LC (LC-USZ62-110115); 41 (left), LC (LC-USZC4-1807); 41 (right), Southworth, Albert Sands and Hawes, Josiah Johnson, after Philip Haas. Image copyright The Metropolitan Museum of Art/Art Resource, NY; 44, The Gilder Lehrman Collection, The Gilder Lehrman Institute of American History; 47, LC (LC-DIG-stereo-1s02132); 48, LC (LC-USZ62-65041); 49, LC (LC-DIG-hec-10787); 50-57 (all), Cecil Stoughton, White House/JFK Library, Boston; 79, LBJ Library/Yoichi Okamoto; 80, LBJ Library/Yoichi Okamoto; 83, Pete Souza, Chicago Tribune; 84, Francis Miller/Time & Life Pictures/Getty Images; 87-92 (all), LBJ Library/Yoichi Okamoto; 98, Chuck Kennedy, The White House; 117, Bettmann/CORBIS; 118, LBJ Library/Yoichi Okamoto; 121, LBJ Library/Yoichi Okamoto; 125-126 (all), Ollie Atkins/National Archives; 129-137 (all), David Hume Kennerly/Gerald R. Ford Presidential Library; 153, Jason Ransom; 155, Ollie Atkins/National Archives; 156, Eric Draper/George W. Bush Presidential Library; 159, Pete Souza/Ronald Reagan Library; 162, AP Photo/Ron Edmonds; 163, Michael Evans/Ronald Reagan Library; 165, Pete Souza/Ronald Reagan Library; 166, Dave Valdez/George Bush Presidential Library and Museum; 169, Dave Valdez/George Bush Presidential Library and Museum; 172-175 (all), Eric Draper/George W. Bush Presidential Library; 199, Robert McNeely/William J. Clinton Presidential Library; 200, LBJ Library/Jack Kightlinger; 203-205 (all), LBJ Library/Yoichi Okamoto; 206-215 (all), Robert McNeely/William J. Clinton Presidential Library; 237, Chuck Kennedy, The White House; 239, LC (LC-USZ62-123278); 248 (up left), Pete Souza/Ronald Reagan Library; 248 (up right), Dave Valdez/George Bush Presidential Library and Museum; 248 (low left), David Hume Kennerly/Gerald R. Ford Presidential Library; 248 (low right), Eric Draper/George W. Bush Presidential Library; 250 (Stoughton), Robert Knudsen, White House/JFK Library, Boston; (Okamoto), LBJ Library Photo; (Atkins) National Archives; (Kennerly), Sanford Smith, Courtesy David Hume Kennerly; (Evans), Ronald Reagan Library; 251 (Valdez), George Bush Presidential Library and Museum; (McNeely), William J. Clinton Presidential Library; (Draper), David Bohrer, National Archives; (Souza), Callie Shell.

Acknowledgments

This book was the happy spawn of a documentary film, *The President's Photographer*, a National Geographic Special for PBS. Without the film, you wouldn't be reading this, so my heartfelt thanks and appreciation go to documentary filmmaker and friend Jody Schiliro, whose coverage of chief official presidential photographer Pete Souza forms the key part of the research for the book. The roughly 23 hours of footage, beautifully shot by director of photography Erin Harvey, provided a comprehensive and riveting basis from which to tell Pete Souza's story and the story of presidential photographers overall.

Only nine photographers have served two or more years as the chief photographer, or personal photographer, as it has variably been called, and we were lucky to interview the five that are alive (and still working) along with several assistants of those who have passed as well as other former White House photographers—my thanks go to Frank Wolfe and Mike Geissinger, David Hume Kennerly, David Valdez, Bob McNeely, Eric Draper, and David Bohrer for their time and insight and to the current photographers who work with Pete, Samantha Appleton, Chuck Kennedy, and Lawrence Jackson, for their time and patience with the project.

I'm also very thankful for the invaluable assistance we received from chief White House photo editor Alice Gabriner, who along with Pete helped us narrow down from thousands of amazing photographs, some of the very best for this volume. In addition, at critical stages of the process, Lauren Paige of the White House Communications Office stepped up to give gentle but essential pushes to help the project along and I appreciate her levelheaded help.

I'd especially like to thank Pete Souza for his deep patience with the process and his willingness to help us make the best book possible. Part of Pete's success is due to a strong desire to avoid attention and so being featured in both a film and a book was, I think, anathema to him. I'm doubly grateful to him for his forbearance on this front.

I'd also like to thank my editor, Susan Straight; photo editor, Jared Ragland; and art director, Melissa Farris, for helping to create such a beautiful book in such a short window of time.

Finally, thanks to Jol, Hannah, and Henry for doing without a husband and father for the several months of weekends and evenings I spent away from them in order to work on the book.

254

Indexes

Photographers Index

THE
PRESIDENT'S PHOTOGRAPHER
FIFTY YEARS INSIDE THE OVAL OFFICE

John Bredar

PUBLISHED BY THE NATIONAL GEOGRAPHIC SOCIETY

John M. Fahey, Jr., *President and Chief Executive Officer*
Gilbert M. Grosvenor, *Chairman of the Board*
Tim T. Kelly, *President, Global Media Group*
John Q. Griffin, *Executive Vice President; President, Publishing*
Nina D. Hoffman, *Executive Vice President; President, Book Publishing Group*

PREPARED BY THE BOOK DIVISION

Barbara Brownell Grogan, *Vice President and Editor in Chief*
Marianne R. Koszorus, *Director of Design*
Susan Tyler Hitchcock, *Senior Editor*
Carl Mehler, *Director of Maps*
R. Gary Colbert, *Production Director*
Jennifer A. Thornton, *Managing Editor*
Meredith C. Wilcox, *Administrative Director, Illustrations*

STAFF FOR THIS BOOK

Susan Straight, *Editor*
Melissa Farris, *Art Director*
Jared Ragland, Kevin Eans, *Illustrations Editors*
Al Morrow, *Design Assistant*
Lisa Walker, *Production Project Manager*
Judith Klein, *Production Editor*
Matt Propert, *Illustrations Specialist*
Lindsey Smith, *Design Intern*
Jessica Louchheim, *Archival Researcher*
Samantha Foster, Andrew Tybout, *Editorial Interns*

MANUFACTURING AND QUALITY MANAGEMENT

Christopher A. Liedel, *Chief Financial Officer*
Phillip L. Schlosser, *Vice President*
Chris Brown, *Technical Director*
Nicole Elliott, *Manager*
Rachel Faulise, *Manager*
Robert Barr, *Manager*

Special thanks to the following for their invaluable assistance:
Alice Gabriner, White House Photo Editor; Janet Philips, White House
Photo Archivist; Jodie Steck at the George W. Bush Presidential Library;
John Keller at the William J. Clinton Presidential Library; Mary Finch at the
George Bush Presidential Library; Michael Pinckney at the Ronald Reagan
Presidential Library; Ken Hafeli at the Gerald R. Ford Library; Margaret
Harman, Kristen Lambert, Sarah Haldeman at the Lyndon Baines Johnson
Library; Laurie Austin at the John F. Kennedy Presidential Library

The National Geographic Society is one of the world's largest nonprofit scientific and educational organizations. Founded in 1888 to "increase and diffuse geographic knowledge," the Society works to inspire people to care about the planet. It reaches more than 325 million people worldwide each month through its official journal, *National Geographic,* and other magazines; National Geographic Channel; television documentaries; music; radio; films; books; DVDs; maps; exhibitions; school publishing programs; interactive media; and merchandise. National Geographic has funded more than 9,000 scientific research, conservation and exploration projects and supports an education program combating geographic illiteracy. For more information, visit nationalgeographic.com.

For more information, please call
1-800-NGS LINE (647-5463)
or write to the following address:

National Geographic Society
1145 17th Street N.W.
Washington, D.C. 20036-4688 U.S.A.

Visit us online at www.nationalgeographic.com

For information about special discounts for bulk purchases,
please contact National Geographic Books Special Sales:
ngspecsales@ngs.org

For rights or permissions inquiries, please contact
National Geographic Books Subsidiary Rights:
ngbookrights@ngs.org

ISBN: 978-1-4262-0676-4

Printed in the United States of America

10/WOR/2